IMAGES
of Rail

RAILROADS OF THE COLUMBIA RIVER GORGE

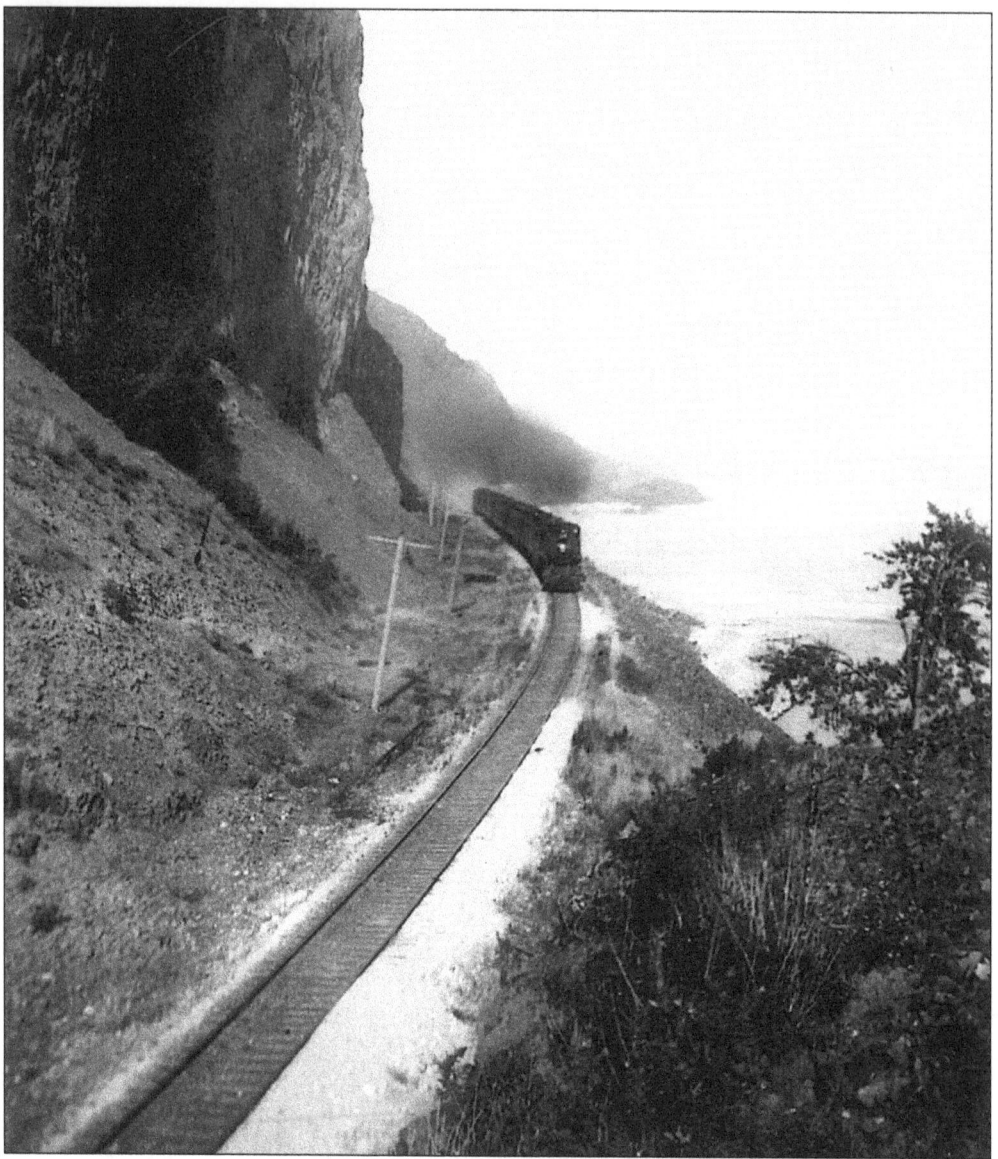

THE NORTH BANK ROAD. A sleek Spokane, Portland & Seattle Railway passenger train glides westbound around a rocky corner east of Bingen, Washington. The SP&S, built in 1907–1908, was often referred to as the "North Bank Road" due to its geographic location on the north shore of the Columbia River. (Courtesy of the Gorge Heritage Museum.)

IMAGES
of Rail

RAILROADS OF THE COLUMBIA RIVER GORGE

D.C. Jesse Burkhardt

ARCADIA
PUBLISHING

Published by Arcadia Publishing
Charleston, South Carolina

Library of Congress Catalog Card Number: 2004107312

For all general information contact Arcadia Publishing at:
Telephone 843-853-2070
Fax 843-853-0044
E-mail sales@arcadiapublishing.com
For customer service and orders:
Toll-Free 1-888-313-2665

Visit us on the Internet at www.arcadiapublishing.com

For Major Robert E. Burkhardt

CONTENTS

ACKNOWLEDGMENTS

The following individuals and organizations contributed to this project: Christine Talbot of Arcadia Publishing; Bruce Barney of the Spokane, Portland & Seattle Railway Historical Society; Elaine Bakke of *The White Salmon Enterprise*; Dan Spatz and Rodger Nichols of *The Dalles Chronicle*, The Dalles, Oregon; Gus Melonas of Burlington Northern Santa Fe Railway; Lucy Kopp of the Oregon Historical Society, Portland, Oregon; Jason Spadaro and Ken Bales of SDS Lumber Company, Bingen, Washington; Marie Davis of Klickitat Historical Preservationists, Klickitat, Washington; Janet Holen and Ruth Winner of the Gorge Heritage Museum, Bingen, Washington; Joanne Ward and Juliana Chase of the Columbia Gorge Discovery Center, The Dalles, Oregon; Michelle Marquart of the Mount Hood Railroad, Hood River, Oregon; Connie Nice of the Hood River County Historical Museum, Hood River, Oregon; Jim Johnson of the Wasco County Pioneer Association in The Dalles, Oregon; Jim Weeks of the Wasco County Historical Society, The Dalles, Oregon; Suzi Conklin and Mark Cherniack of the Wildflower Café in Mosier, Oregon; Michael Whiteman; Dan Work; Bill Manly; Walt Ainsworth; Cam Thomas; Bob Stanton; Art Bain; Bob and Josephine Towers; Warren Wing; Robert W. Johnston; John Wood; Father Richard Conway; Bob Koch; Thomas Robinson; Sally Newell; Alex Chisholm; Chris Jaques; Zach Tindall; Mike Federman; Gil Hulin; Sam Lowry; Ken Marvel; Scott Sparling; Leslie Burkhardt; Clare Burkhardt; Ron Burkhardt; Chris Connolly, for saving the April 2000 e-mail; Bob Dobyne of Mirror Image Photo in Bingen, Washington, whose expertise, assistance, and contributions are greatly appreciated; and Keith McCoy of White Salmon, Washington, a local historian who provided a wealth of reference material.

My sincere thanks and appreciation to all of you.

—D.C. Jesse Burkhardt
White Salmon, Washington

INTRODUCTION

The Columbia River originates on the west slope of the Rocky Mountains, in the Canadian province of British Columbia. From there, it rolls for more than 1,200 miles on its way to the Pacific Ocean, including the 85 miles that form the centerpiece of the Columbia River Gorge National Scenic Area of Oregon and Washington, one of the world's most striking landscapes.

Humans, naturally, have put their own imprint on this scenic landscape. One such imprint was the building of an impressive rail transportation network. On both sides of the Columbia River Gorge, railroads move a mix of merchandise—everything from automobiles to grain to scrap steel to woodchips—east and west. The constant rush of freight requires a highly efficient railroad system and armies of experienced employees working day and night to run the trains, maintain the track, and keep signal equipment operating smoothly.

Railroad operations in the Gorge represent a tremendous technological achievement, to be sure. But, to many of us, the passage of trains over the landscape has a soulful aspect as well. Perhaps that—combined with the dreamy romance of wondering where those trains are headed—is what touches people and sparks affection for the endless rails that stretch far beyond the horizon.

The trains of the Columbia River Gorge seem to connect in a magical way with the land: blasting out of raw, rock-faced tunnels, gliding under bridges, snaking along the edges of towns and beside the big river, always rolling somewhere distant; symbolic of our national connectedness—and our restlessness.

I recall one warm April night in 2000, when I slept in the back of my open Ford pickup truck just a few feet from the Burlington Northern Santa Fe mainline in Roosevelt, Washington. I could see the railroad's distant, alternating red and green signal lights through the rural blackness, and hear the sound of Union Pacific trains clanking as they worked along the opposite shore of the Columbia River at Arlington, Oregon. That night, every hour or so, I was awakened by another roaring BNSF freight.

The origin of the rail lines through the Columbia River Gorge goes back more than 150 years, and the story—which features the machinations of business titans such as Henry Villard, James J. Hill, and Edward H. Harriman—is rich and filled with intrigue.

The first railroad in the Columbia River Gorge was built in 1851. It was a wooden-rail portage railroad just west of Stevenson, Washington, and donkeys pulled the freight at first. This rudimentary railway was fashioned to get people and goods around the Cascade Rapids, which formed an unnavigable barrier to boat traffic on that part of the river.

In Oregon, trains have moved along portions of the Columbia River shores since 1862, when the Oregon Steam Navigation Company built a 12-mile "portage railroad" to move passengers

7

and freight around river rapids and waterfalls between The Dalles and Celilo. Sternwheelers met the railroad at either end of the portage line.

Mainline rail service between Portland, Oregon, and Walla Walla, Washington, began in 1882, soon after Henry Villard purchased the Oregon Steam Navigation Company and formed the Oregon Railway & Navigation Company. In 1900, the OR&N became a subsidiary of the Union Pacific Railroad. The name was changed to the Oregon-Washington Railroad & Navigation Company in 1910, and the railroad was subsequently merged into Edward Harriman's Union Pacific, which serves the gorge to this day.

In Washington, mainline trains started rolling on a water-level route completed through the Gorge in 1908. The railroad company doing the building was called the Spokane, Portland & Seattle Railway, under the direction of James Hill, the famed "empire builder." The company's slogan later became "The Northwest's Own Railway."

Among its other benefits, the SP&S provided an outlet to logging railroads on the Washington side of the gorge. Log trains worked in the Willard area, as well as out of Klickitat, bringing logs to mills and shipping finished products out via the SP&S.

The last logging line in the gorge served the St. Regis mill at Klickitat, but the trains stopped running there in 1964. The SP&S itself faded into history when it became part of the newly formed Burlington Northern Railroad in 1970.

Although serving a relatively tiny geographic area when compared to the UP and SP&S, the shortline Mount Hood Railroad—based in Hood River, Oregon—also played a significant role in the area's history. The origin of the Mount Hood Railroad, like that of so many Northwest railroads, was tied closely to the logging industry. The trackage from Hood River to Dee was built by the Oregon Lumber Company in 1906 to serve its Dee lumber mill. Soon thereafter, the Mount Hood Railroad was created to serve other shippers along the route, as well as to carry passengers. The line was extended from Dee to Parkdale in 1910. Among the Mount Hood Railroad's charms were its wood-burning "jitneys." The jitneys carried passengers and mail from 1916 until the early 1940s.

Today, the diminutive Mount Hood Railroad exists primarily to run slow-paced excursion trains that carry sightseers through 21 miles of the scenic Hood River Valley. But the Mount Hood remains a vital freight hauler and still interchanges freight cars with Union Pacific in Hood River.

Conversely, contemporary mainline operations by Union Pacific and Burlington Northern Santa Fe are fast and dramatic, with trains often "racing" each other on opposite sides of the river. It is not uncommon to stand on a bluff somewhere in the gorge and see a Union Pacific freight moving on the Oregon shore, while a Burlington Northern Santa Fe train glides along on the Washington shore.

It's a bit rare these days when two major railroads exist basically side-by-side, as line abandonment and consolidations across the nation have reduced the once-common proliferation of parallel trackage. But that's definitely not the situation beside the waters of the Columbia River. Throughout the Columbia River Gorge, freight trains—and daily passenger trains on the Washington side—operate over well-maintained, efficient rail lines that run parallel, separated only by the wide river and the demands of competition.

Here's a look at how it all got started.

One

THE EARLY ROUTES

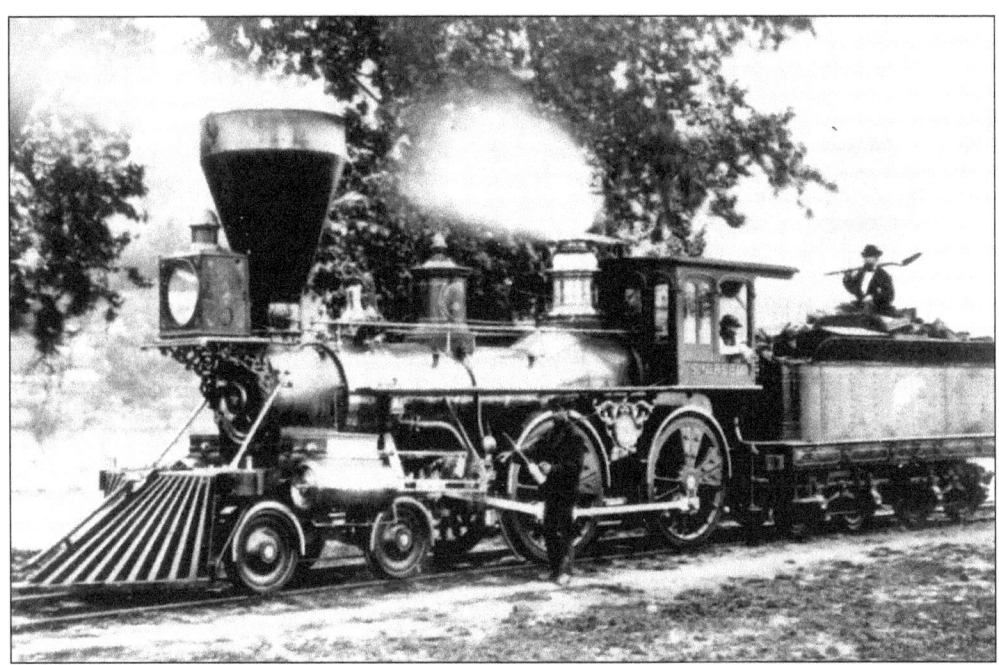

S.G. REED. The wood-burning *S.G. Reed*, named for one of the founders of the Oregon Steam Navigation Company, is pictured near Celilo. In 1862, the OSN opened a short railroad line as a portage to allow steamboat passengers and cargo to bypass rapids on the Columbia River at The Dalles. Henry Villard purchased the OSN and subsequently formed the Oregon Railway & Navigation Company. The OR&N was incorporated on June 13, 1879, with Villard as president. (Courtesy of the Gorge Heritage Museum.)

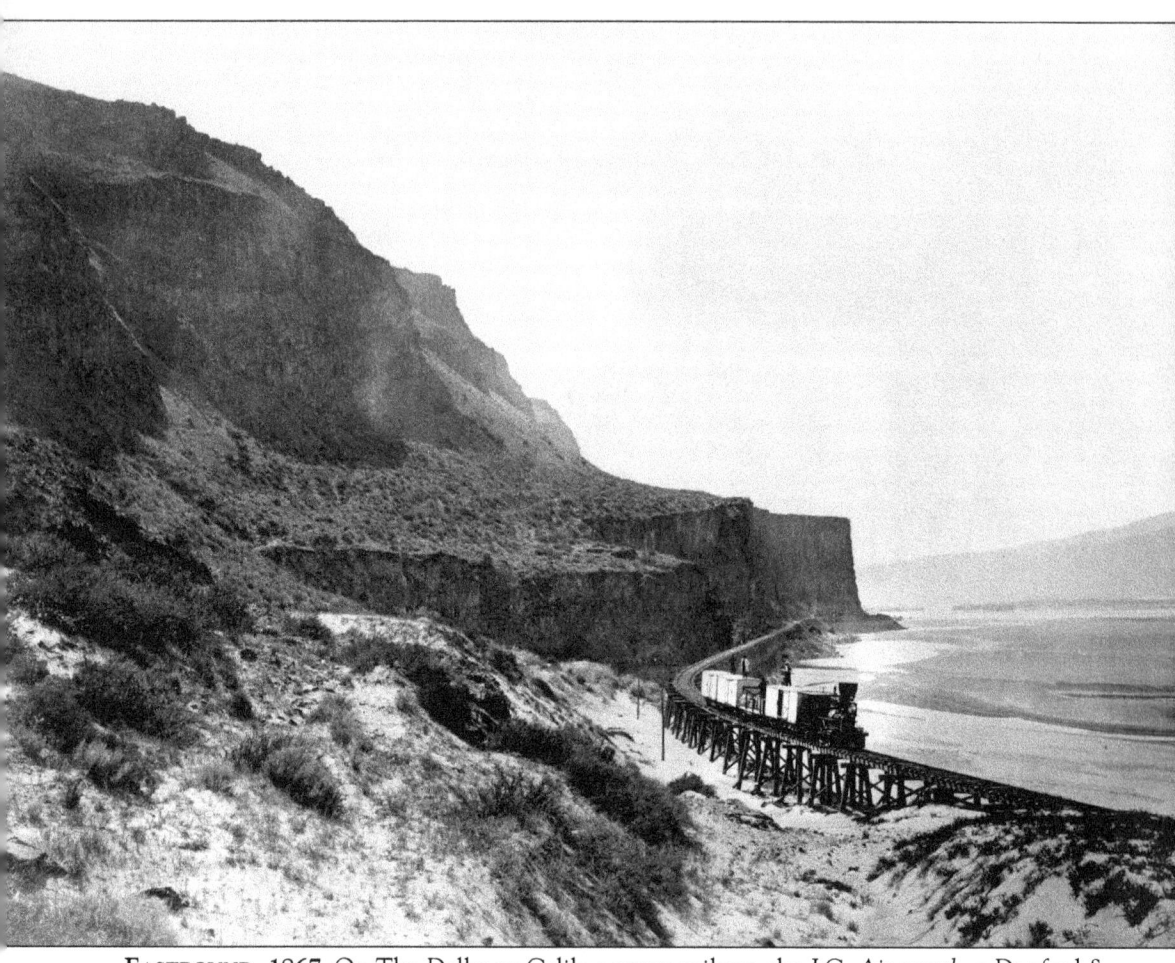

EASTBOUND, 1867. On The Dalles to Celilo portage railway, the *J.C. Ainsworth,* a Danford & Cooke locomotive named for the president of the Oregon Steam Navigation Company, passes Cape Horn as it approaches Celilo, Oregon, in this 1867 photograph by C.E. Watkins. This five-foot gauge railroad, which went into service on April 20, 1863, was employed to get people and goods around hazardous Columbia River narrows and falls, including Celilo Falls, between The Dalles and Celilo. Steamboats waited at either end of this 12-mile portage line. (Courtesy of Keith McCoy.)

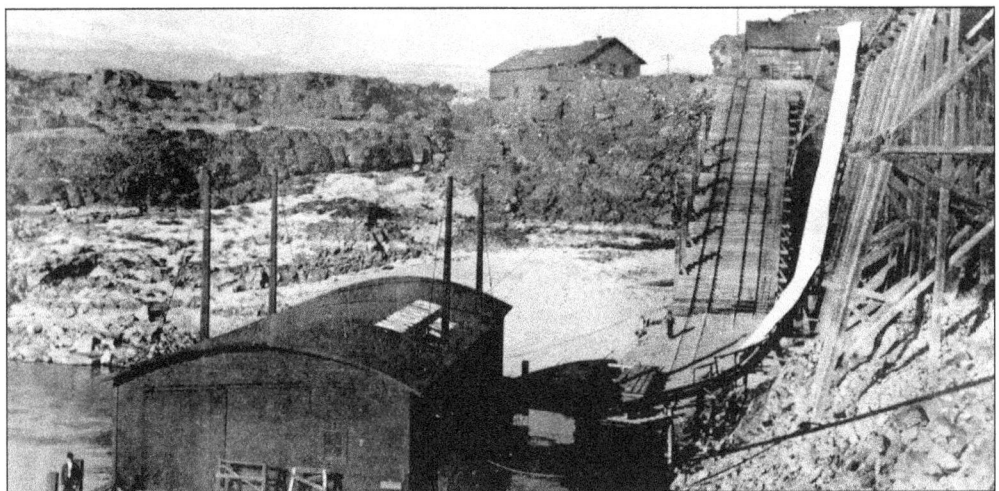

BEGINNINGS OF A NETWORK. This portage railroad to Celilo, Oregon, bypassed the Columbia River's non-navigable narrows and Celilo Falls, allowing passage for passengers and freight. The Oregon Steam Navigation Company built a 12-mile line from Big Eddy (near The Dalles) to a spot above the falls. Freight cars were pulled from barges on the river and hauled up the tracked incline to the railroad above. Upstream from Celilo, commodities and passengers were reloaded onto sternwheelers to continue to their destinations. (Courtesy of *The Dalles Chronicle.*)

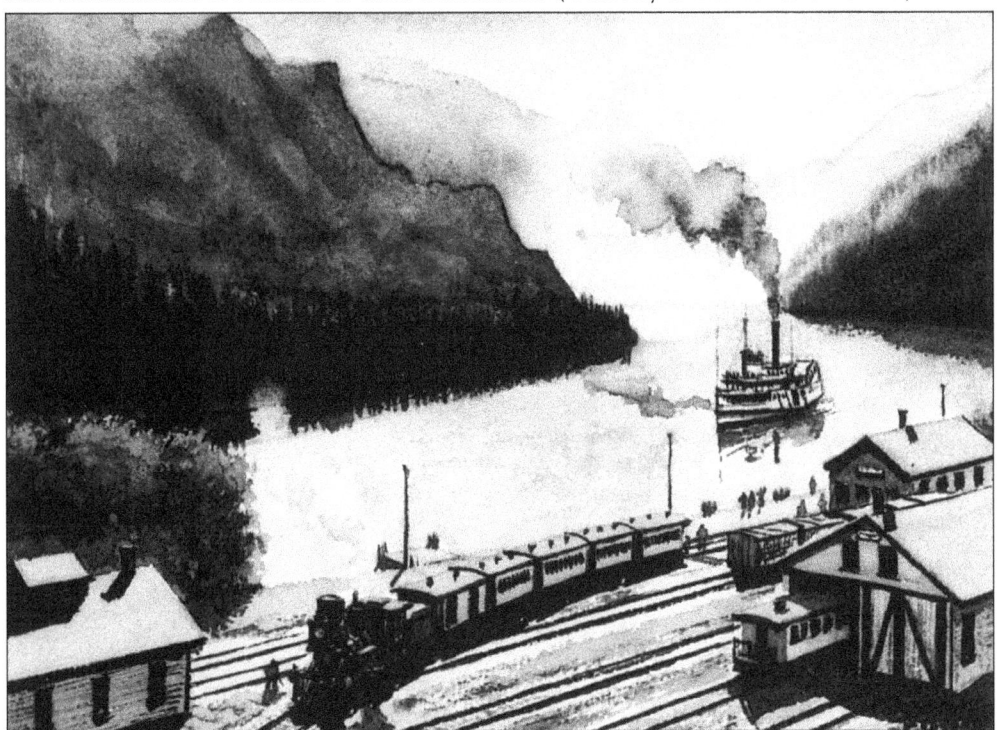

EARLY PORTAGE LINE. In this artwork from Union Pacific's 1969 promotional booklet, *The Union Pacific Story,* artist Howard Fogg depicts a Columbia River portage railroad from the spring of 1867. The steamer *T.J. Potter* is transferring passengers and cargo to a train waiting on the shoreline. "The challenge of rail transportation is a growing reality," read the caption accompanying the artwork. (Courtesy of D.C. Jesse Burkhardt.)

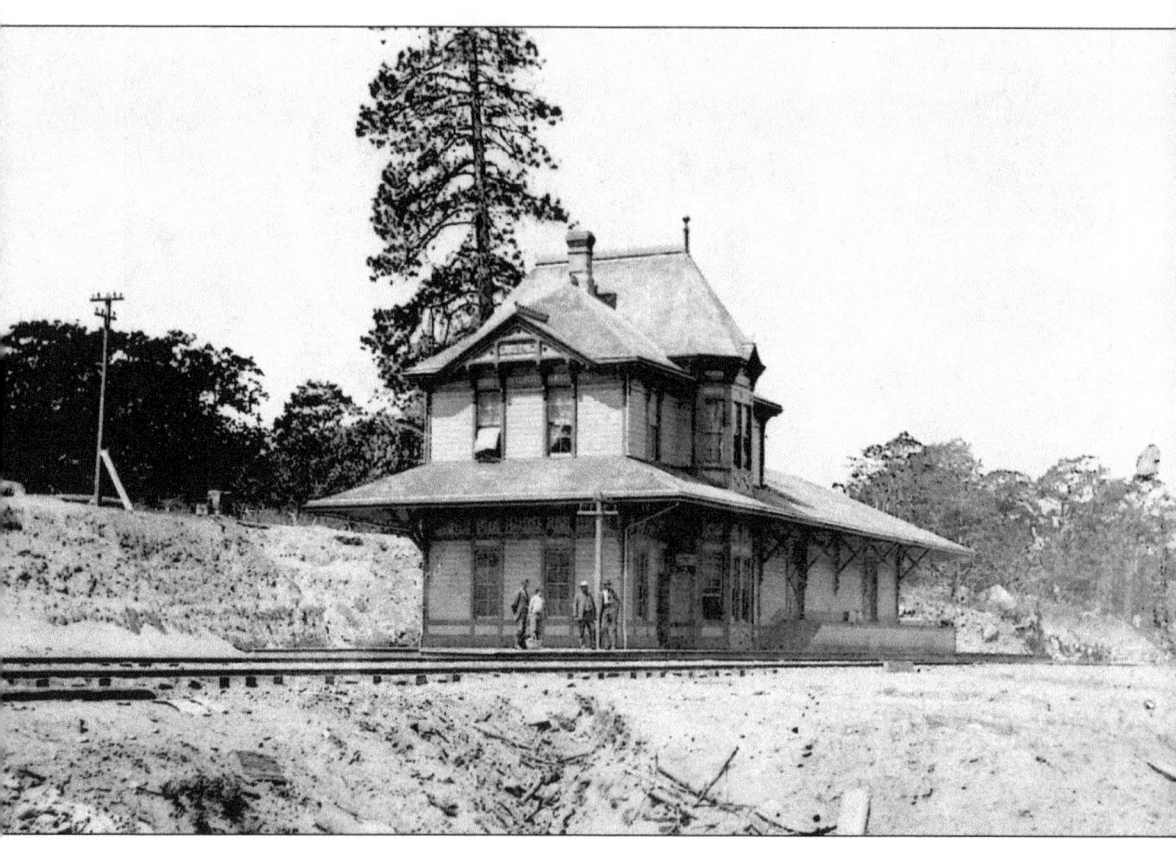

FIRST STATION. Hood River's first railroad station was built by the Oregon Railway & Navigation Company in 1882, on the south side of the mainline tracks through the Columbia River Gorge. At one time the city had three railroad depots: this one, built by the OR&N; a second one built by the Oregon Lumber Company in 1906; and a third one—still standing today—built by the Mount Hood Railroad in 1911. (Courtesy of the Gorge Heritage Museum.)

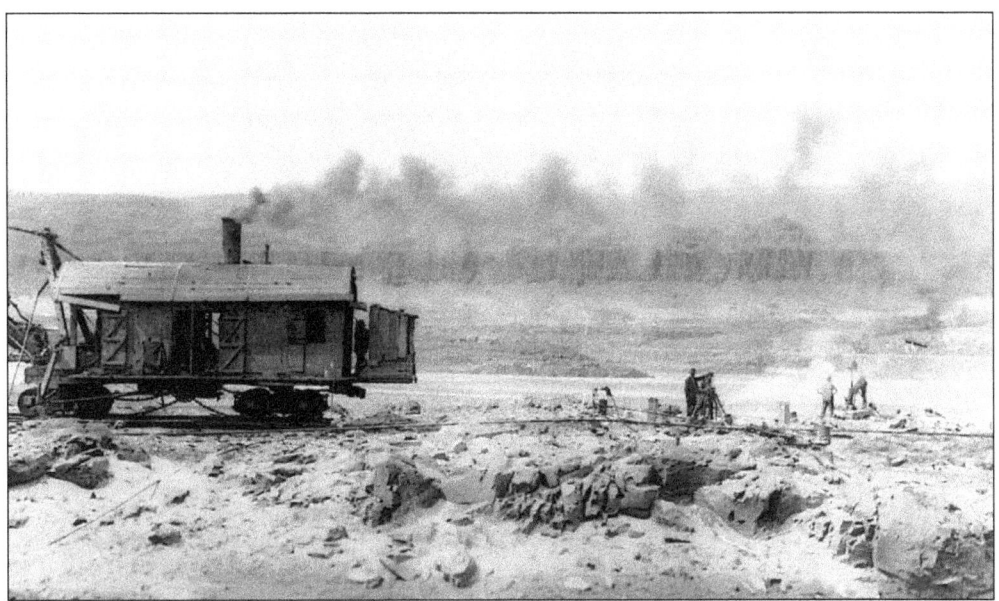

UNDER CONSTRUCTION. A section of the Oregon Railway & Navigation Company tracks is built along the Columbia River in Oregon; precise date and location unknown. Judging by the scenery on the Washington side of the river, however, the crew appears to be working east of Celilo. Union Pacific Railroad eventually absorbed the OR&N. (Courtesy of *The Dalles Chronicle*.)

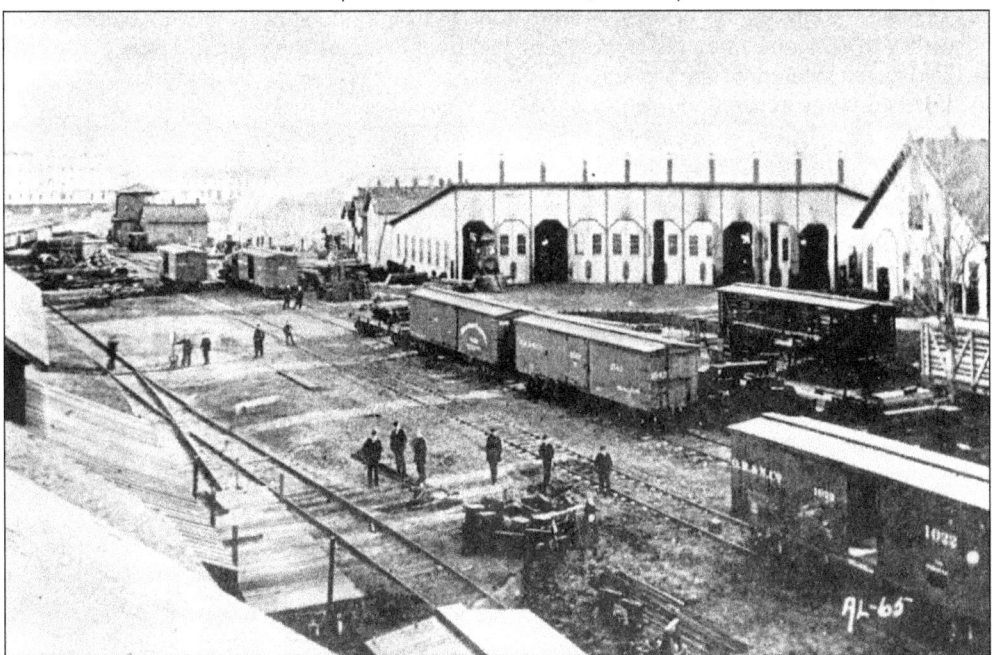

TYPICAL DAY IN THE YARD. The Oregon Steam Navigation Company established boat and railroad repair shops along West First Street in The Dalles in 1862. According to the Wasco County Historical Society, the Oregon Railway & Navigation Company acquired the shops in 1882, and at one time employed more than 500 workers here. In 1900 the OR&N became a subsidiary of Union Pacific, and UP later moved its shops to Albina Yard in Portland. (Courtesy of *The Dalles Chronicle*.)

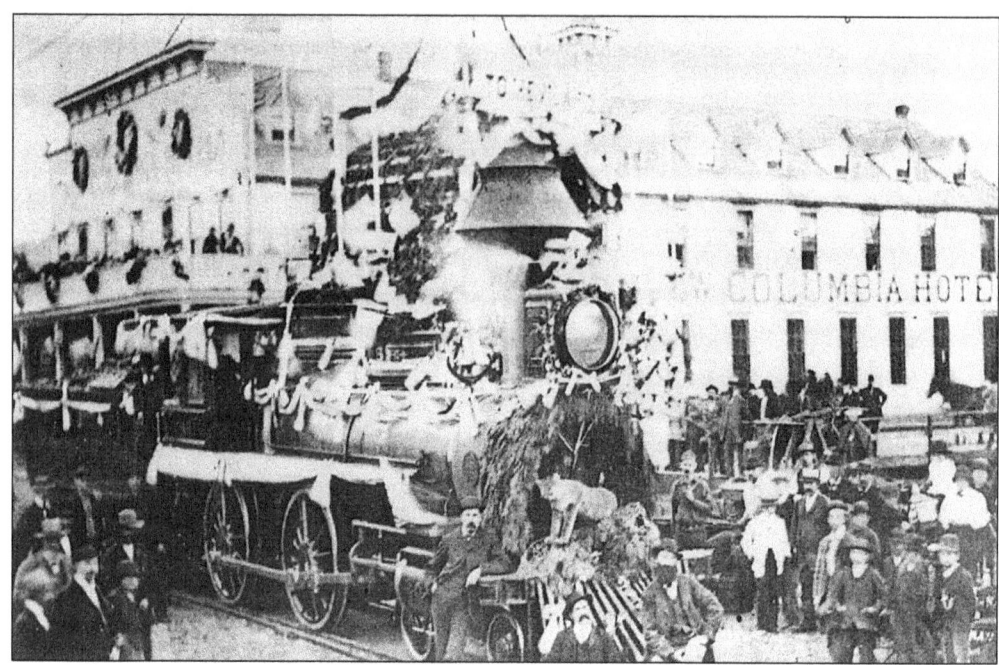

FESTIVITIES IN THE STREETS. This train, with a banner atop the smokestack that reads "To The Atlantic," was on parade in The Dalles on October 2, 1883. The ceremony was geared to celebrate the linking of Tacoma, Washington, and St. Paul, Minnesota, via completion of a Northern Pacific rail line. NP tracks being laid from east and west met and were connected at Gold Creek, Montana, on September 8, 1883. Note the cougar, presumably stuffed, on the locomotive's cow-catcher. (Courtesy of *The Dalles Chronicle.*)

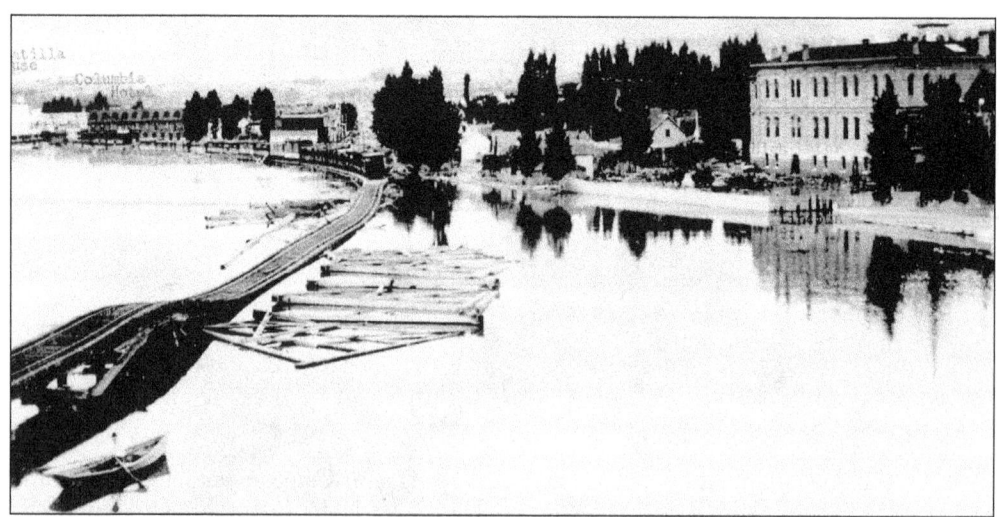

THE GREAT FLOOD. The Dalles suffered severe flooding in 1894, as this photo attests. The white marks on the St. Mary's Academy building to the right of this scene show the high water mark. The flood crested on June 6, 1894, and the Oregon Railway & Navigation's mainline was completely washed out. (Courtesy of *The Dalles Chronicle.*)

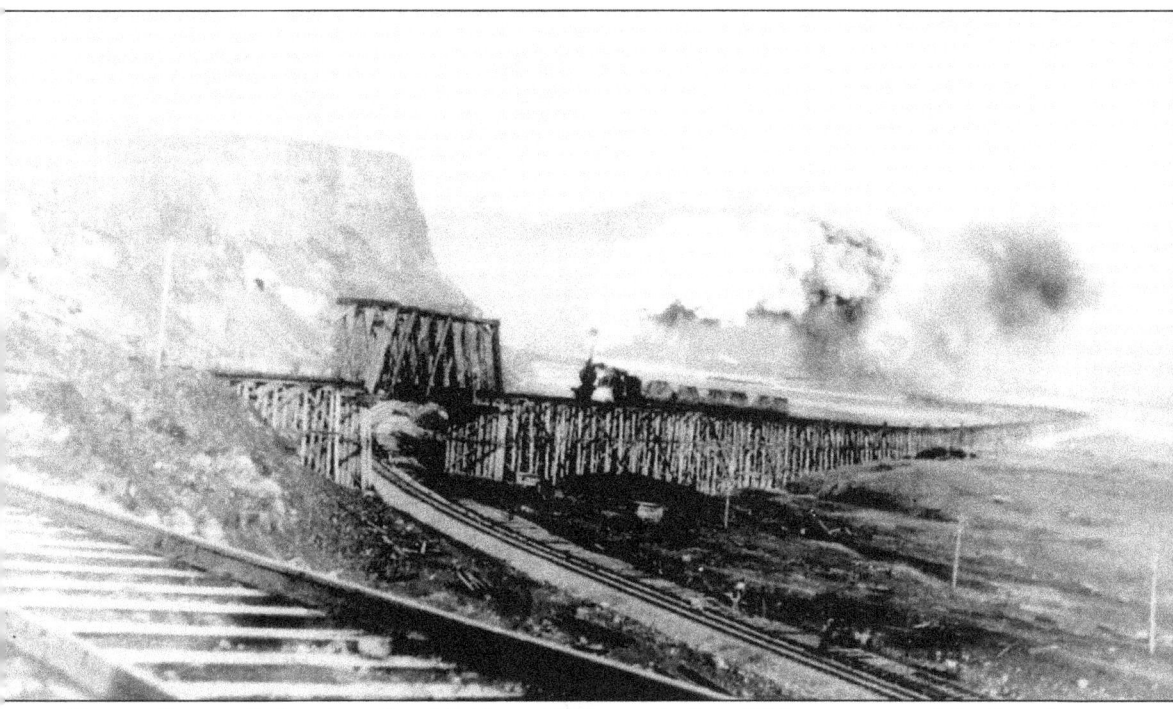

BEFORE CELILO. Before the railroad bridge at Celilo was built in 1911, a temporary 2.8-mile rail line and trestle briefly accommodated cross-river rail-barge traffic. This photo shows a train coming across the Columbia River and over the Oregon-Washington Railway & Navigation mainline near Moody, Oregon. The train is returning from a barge landing on the Spokane, Portland & Seattle Railway on the Washington side of the river. Railroad cars were transferred from barges to this railway incline, which led to the Oregon Trunk Railway on the west bank of the Deschutes River. Two double-track barges were built to shuttle cars across the river here. One was 182 feet long and carried a maximum of eight cars, while the other was 142 feet long and carried six cars. The unique operation here was in service only from September 1910 to January 1912. (Courtesy of the Columbia Gorge Discovery Center.)

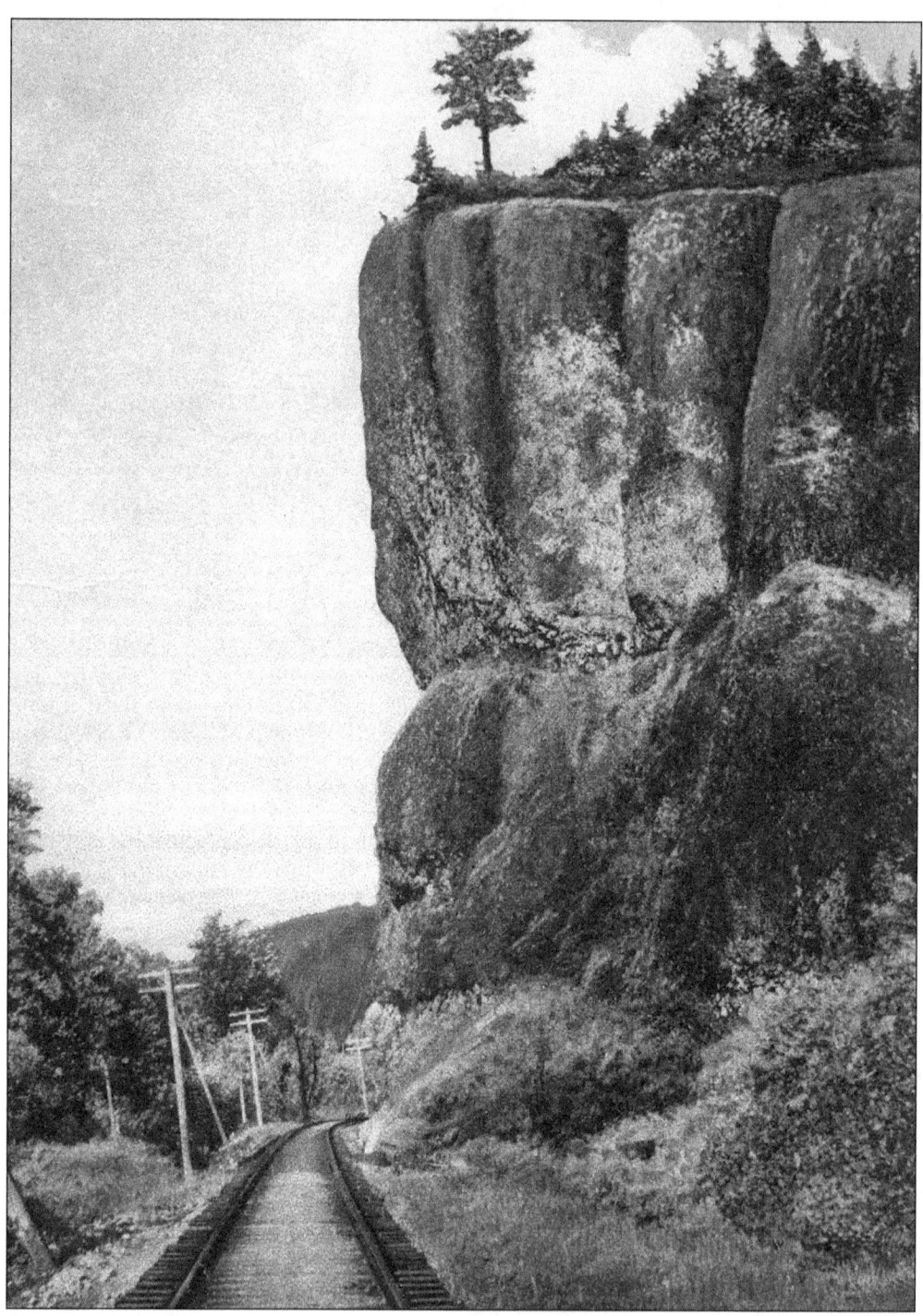

ONEONTA BLUFFS. An early colorized postcard showing a dramatic, scenic view of the Oregon Railroad & Navigation Company mainline through the Columbia River Gorge. At the time this postcard was produced, c. 1900, the domestic rate to mail the postcard was 1¢. It cost 2¢ to mail the card to a foreign address. The Oneonta Bluffs are located east of Multnomah Falls. (Courtesy of D.C. Jesse Burkhardt.)

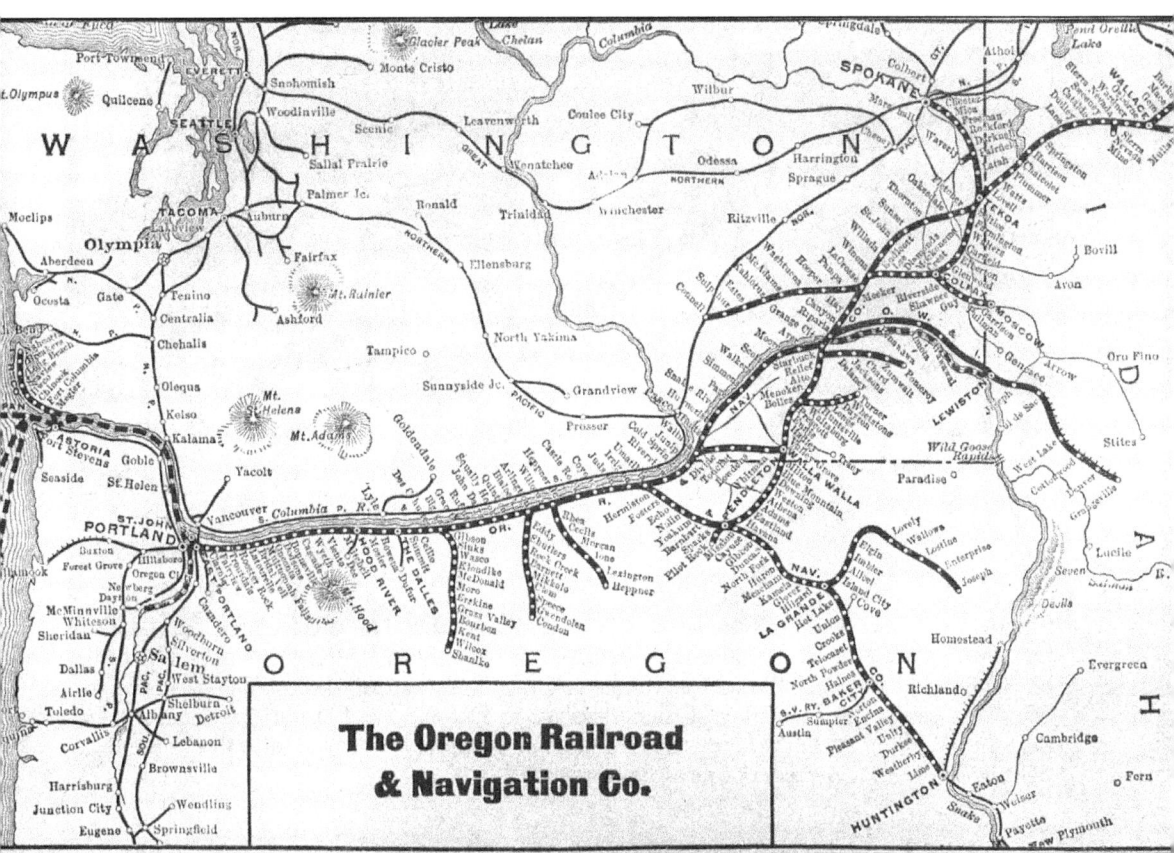

MANY BRANCHES. This route map of the Oregon Railroad & Navigation Company shows the carrier's rail lines in Oregon, Washington, and Idaho, in the early 1900s. (Courtesy of the Columbia Gorge Discovery Center.)

OPENING TO DUFUR. A special excursion train is on its way out of the east end of The Dalles on the Great Southern Railroad line to Dufur, Oregon, in the early 1900s. The excursion was planned to mark the beginning of freight service to Dufur, a rural farming community. The tall white building in the background is the Columbia Brewery. Note the turntable at the lower right in this view. (Courtesy of *The Dalles Chronicle*.)

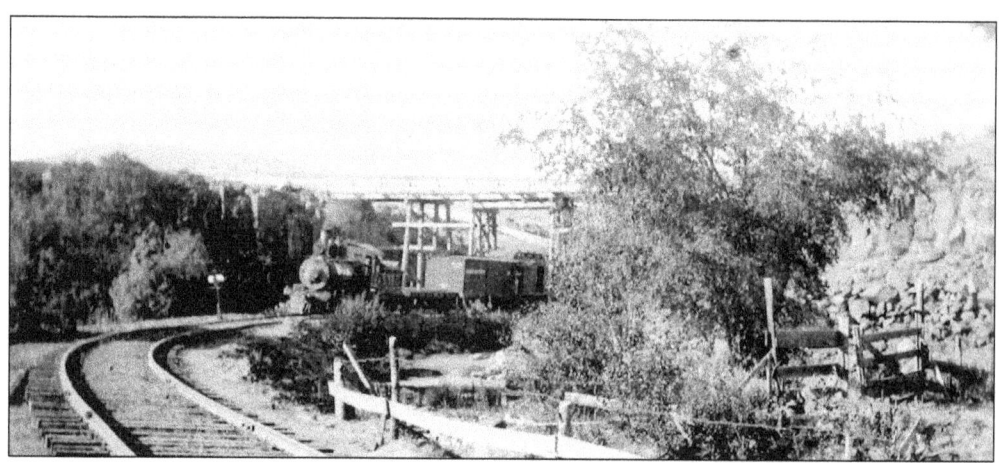

ON THE GREAT SOUTHERN. A mixed train on the Great Southern Railroad steams around a bend near Boyd, Oregon, date unknown. The Great Southern, which at its peak operated about 25 miles of track south from The Dalles, went bankrupt in 1933. Another carrier—The Dalles & Southern—took over and operated the line for several more years after the demise of the Great Southern. (Courtesy of *The Dalles Chronicle*.)

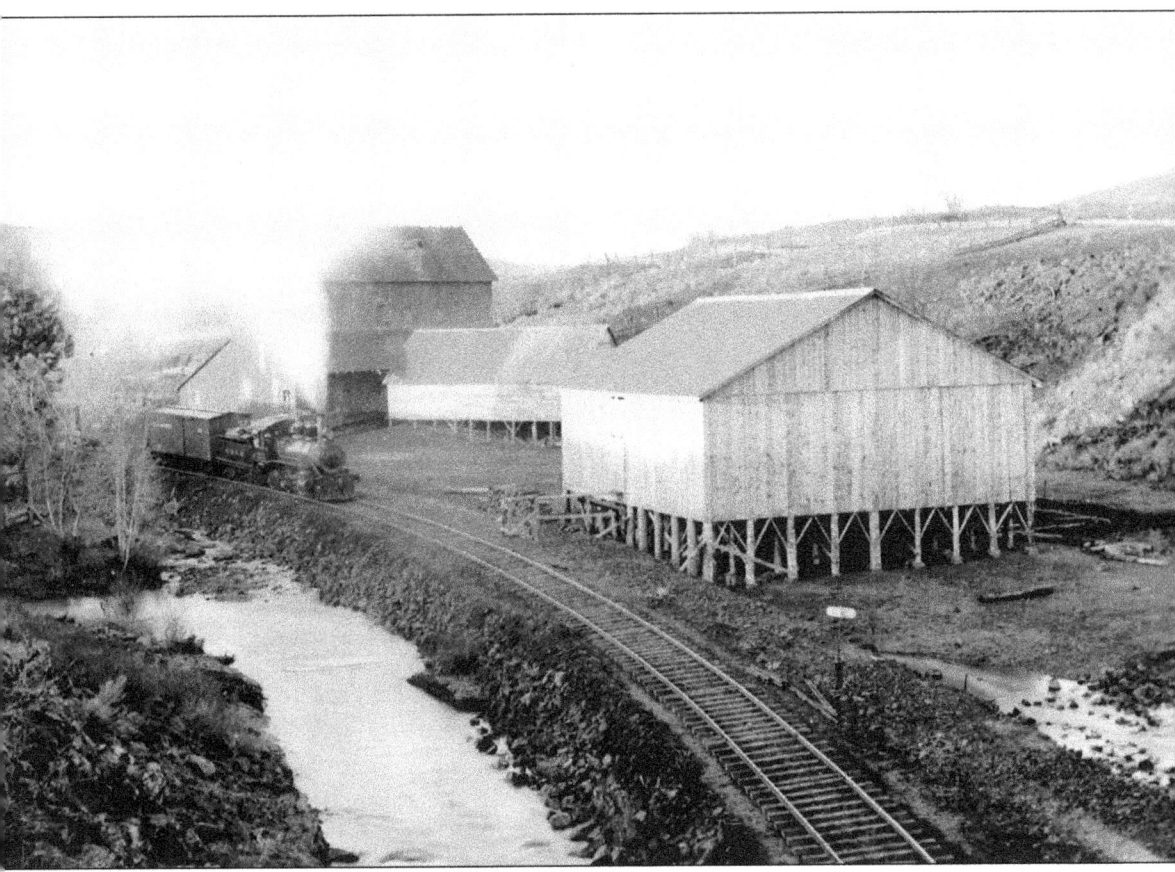

ROLLING BY THE CREEK. A Great Southern freight swings past the mill at Boyd, Oregon, as it rolls northward on its way from Dufur to The Dalles. Fifteenmile Creek is on the left in this scene. Although the Great Southern's founders had big dreams—they wanted to drive tracks all the way to San Francisco from here—the rails made it only as far as Friend, about 25 miles south from The Dalles. (Courtesy of *The Dalles Chronicle.*)

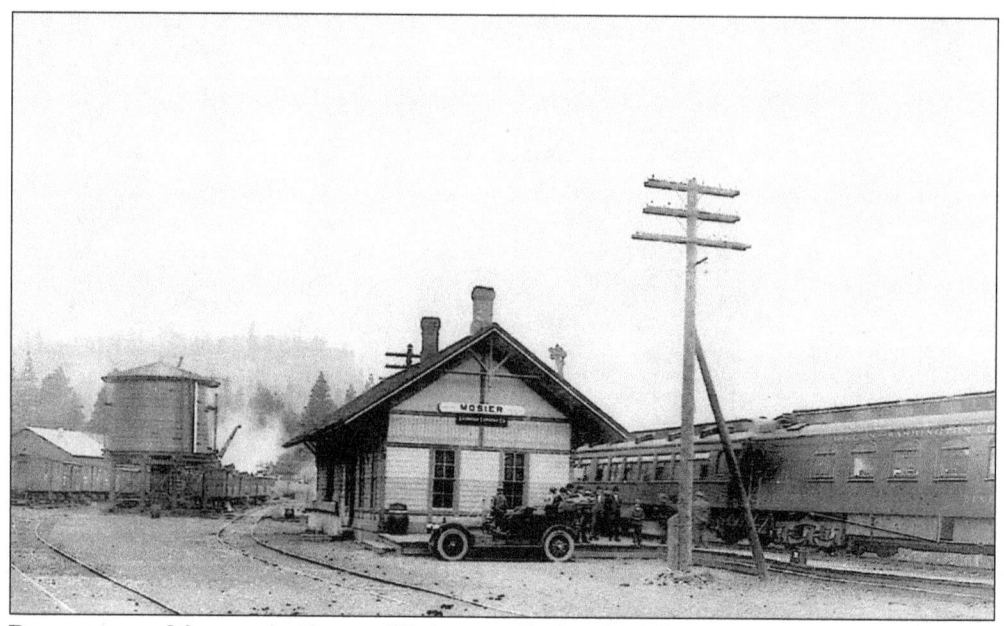

PULLING INTO MOSIER. An Oregon-Washington Railroad & Navigation Company train pauses at the depot in Mosier, Oregon, in 1915. Note the diner car in front of the station, as well as the large water tank. The Oregon Railroad & Navigation Company became known as the Oregon-Washington Railroad & Navigation Company—a Union Pacific subsidiary—in 1910. The Mosier depot, the water tank, and all the spur tracks have long since been removed from the landscape. (Courtesy of the Wildflower Café.)

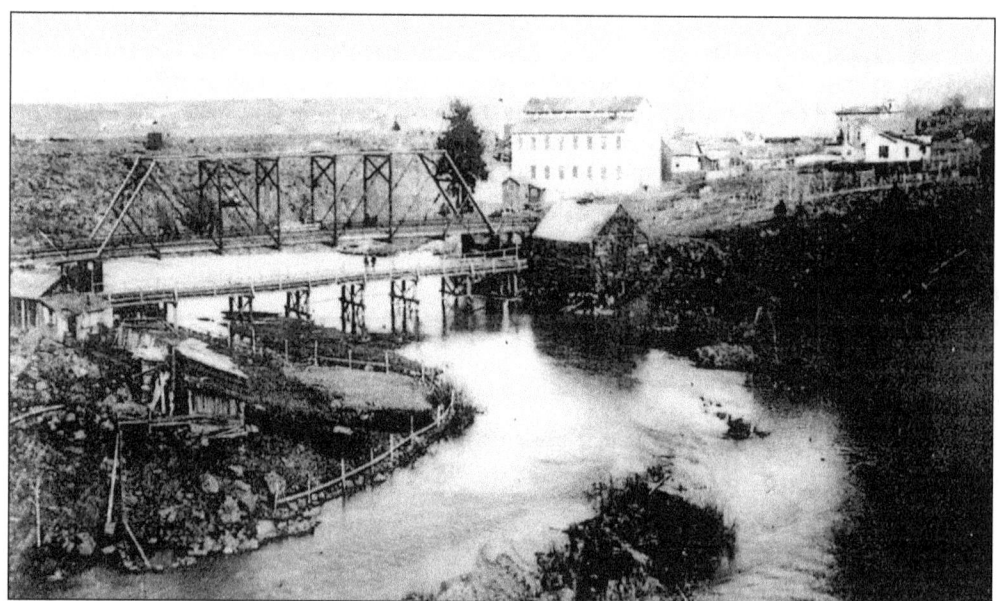

LINE TO THE WOOLEN MILL. A wagon road bridge and a railroad bridge over Mill Creek lead to the Robert Pentland woolen mill (the tall white building) in The Dalles, Oregon. This particular woolen mill started operating in the 1890s, when the wool industry was peaking. During this era, as much as 8 million pounds of wool a year was brought to The Dalles, creating the largest primary market for this commodity in the nation. (Courtesy of *The Dalles Chronicle.*)

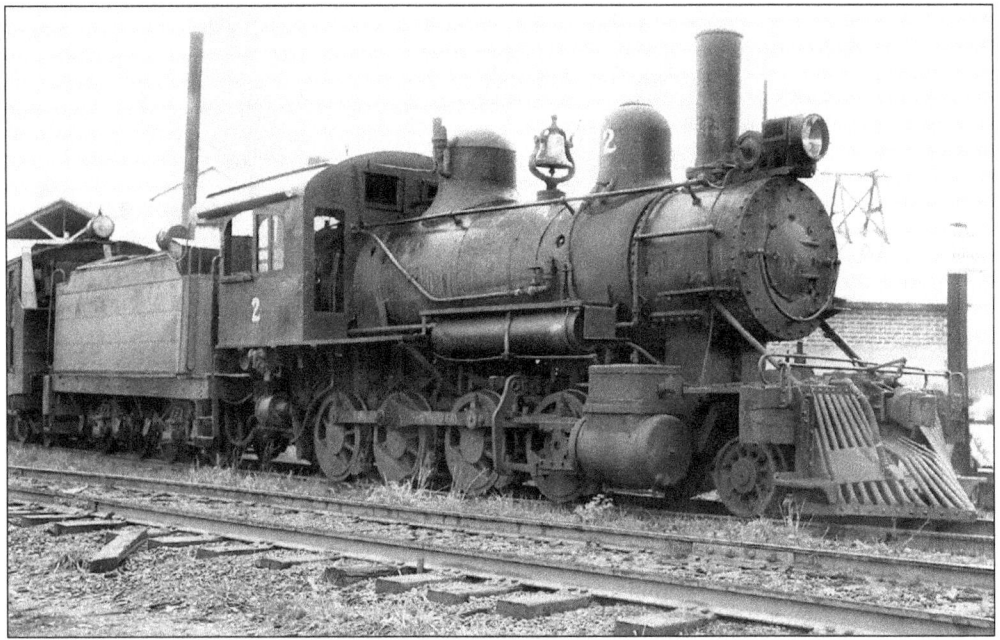

DALLES & SOUTHERN. The Great Southern Railroad was reorganized as The Dalles & Southern Railroad in 1933. It operated between The Dalles and Friend, Oregon, until the carrier went out of business in 1936. In this scene, probably taken at The Dalles, Dalles & Southern 2-8-0 locomotive No. 2 takes a break before being called to work again. (Courtesy of Warren Wing.)

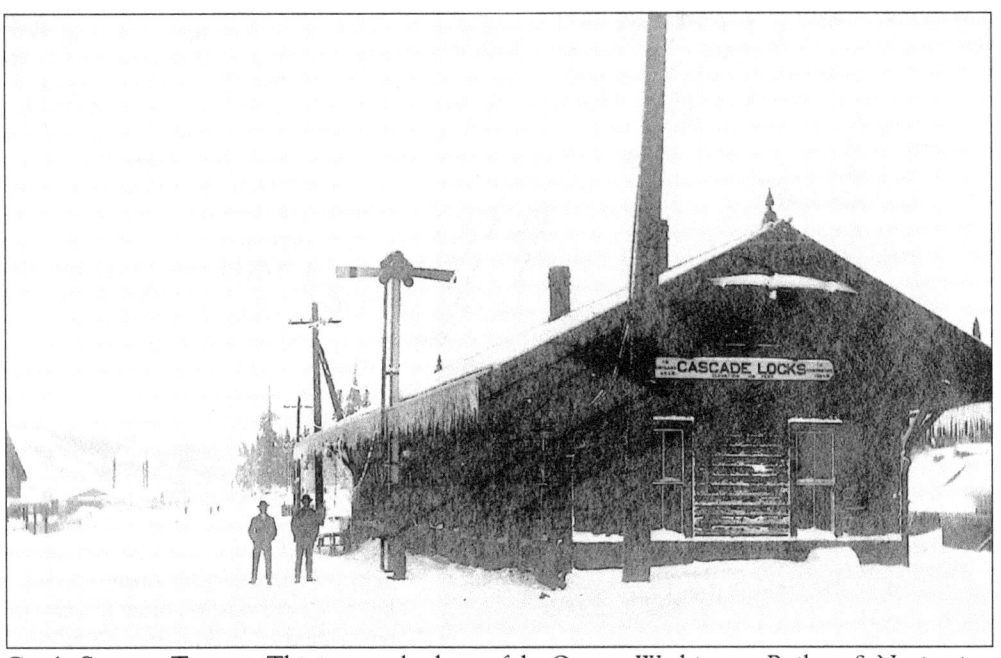

CAN'T SEE THE TRACKS. This is an early photo of the Oregon-Washington Railway & Navigation Company depot at Cascade Locks, Oregon, during a severe snow and ice storm. Note how the thick ice coating has brought down many of the wires above the station. (Courtesy of the Hood River County Historical Museum Photo Archives.)

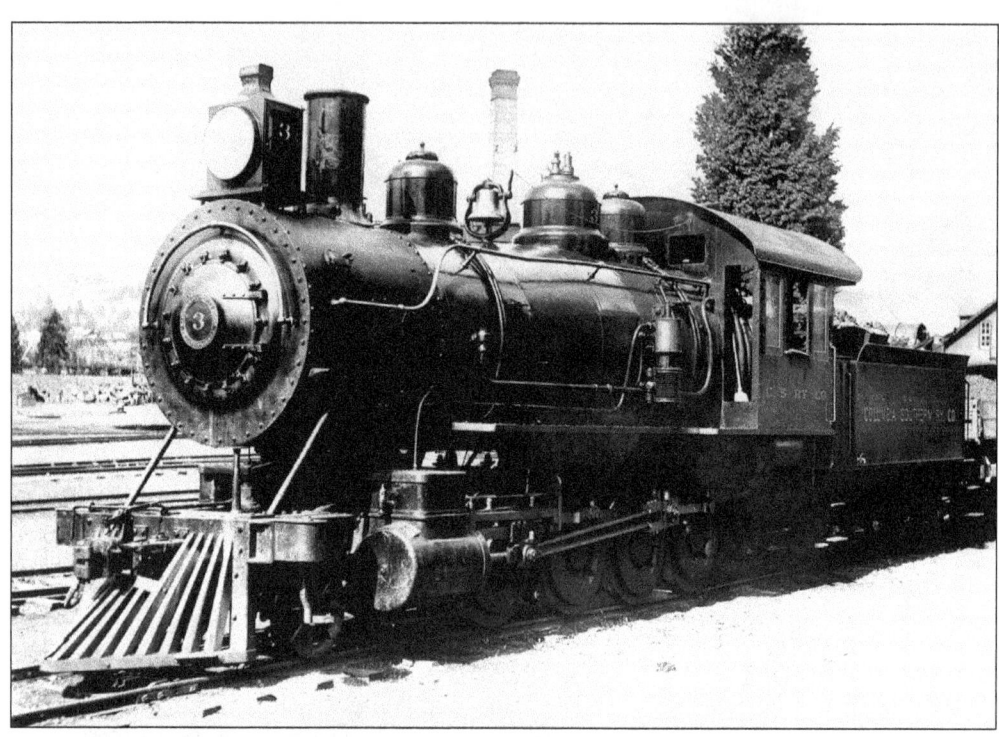

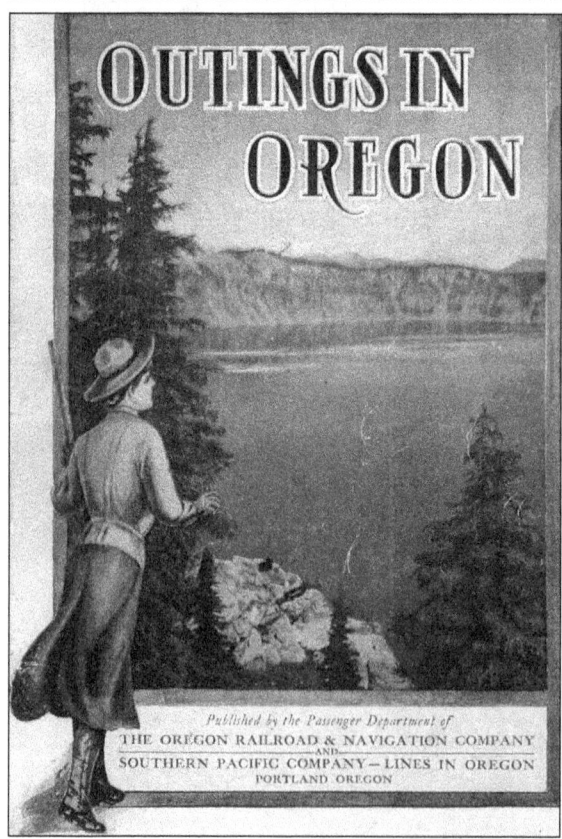

COLUMBIA SOUTHERN. Here is a view of Columbia Southern locomotive No. 3, resting outside the Oregon Railroad & Navigation roundhouse in The Dalles, Oregon, on a Sunday morning. This locomotive was built in 1901 by the Baldwin Locomotive Works, and when this photo was taken, No. 3 was on its way to its new owners. The Columbia Southern Railway operated between Biggs (on the Columbia River east of Celilo) and Shaniko, Oregon. (Courtesy of Warren Wing.)

OUTINGS IN OREGON. This is the cover of an undated brochure produced jointly by "the passenger department of the Oregon Railroad & Navigation Company and Southern Pacific Company." Obviously, the objective here was to entice tourists to come ride the OR&N and the SP to reach scenic Oregon points, including what appears to be Crater Lake. (Courtesy of the Columbia Gorge Discovery Center.)

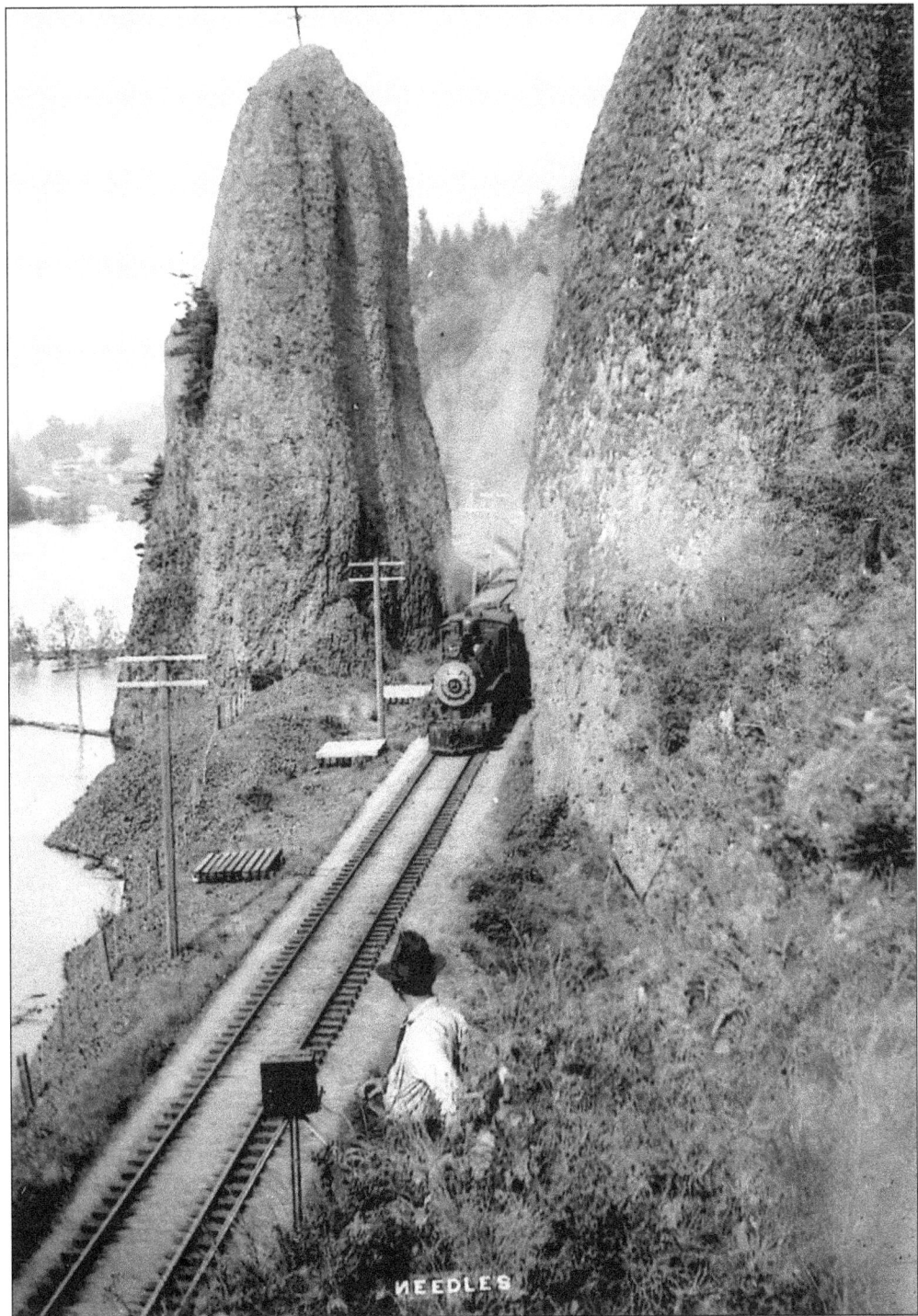

PILLARS OF HERCULES. As a photographer waits with his tripod-steadied camera for a perfect shot, a westbound train splits through the distinctive "needles" at Pillars of Hercules, near Bridal Veil, Oregon, on the Oregon Railroad & Navigation mainline between Portland and Pendleton. (Courtesy of the Hood River County Historical Museum Photo Archives.)

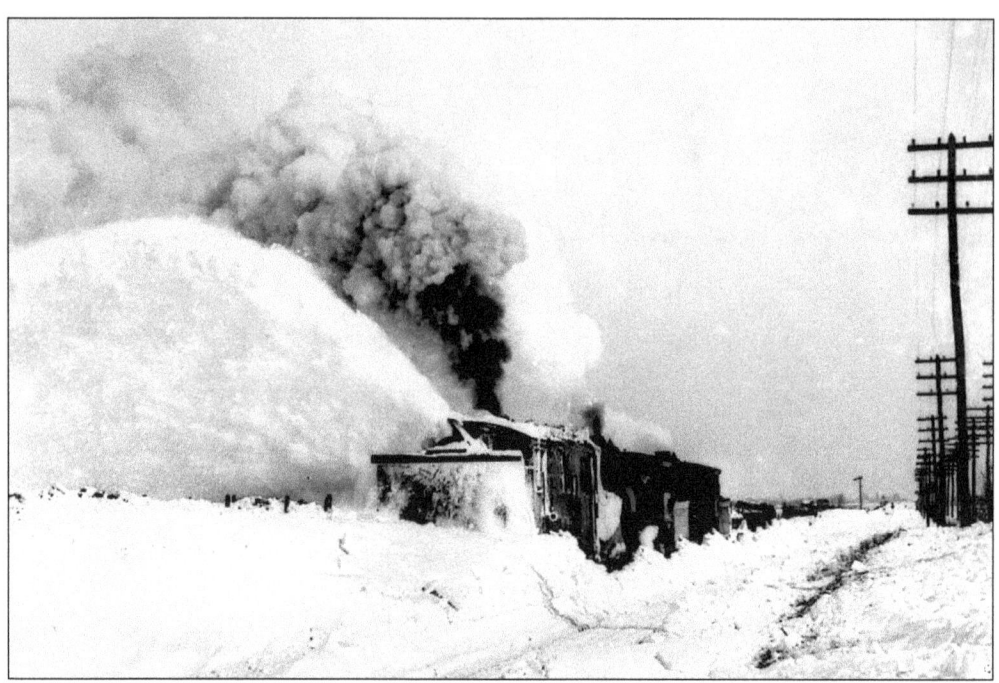

BATTLING THE ELEMENTS. Fighting the heavy snowfall in the Columbia River Gorge and elsewhere occasionally turns into a major struggle, and railroads have to employ their most efficient snow-removing equipment to clear the tracks. In this January 1899 scene from an unidentified location, a rotary, steam-powered snow blower, pushed by two steam locomotives, does its impressive work. (Courtesy of Ron Burkhardt.)

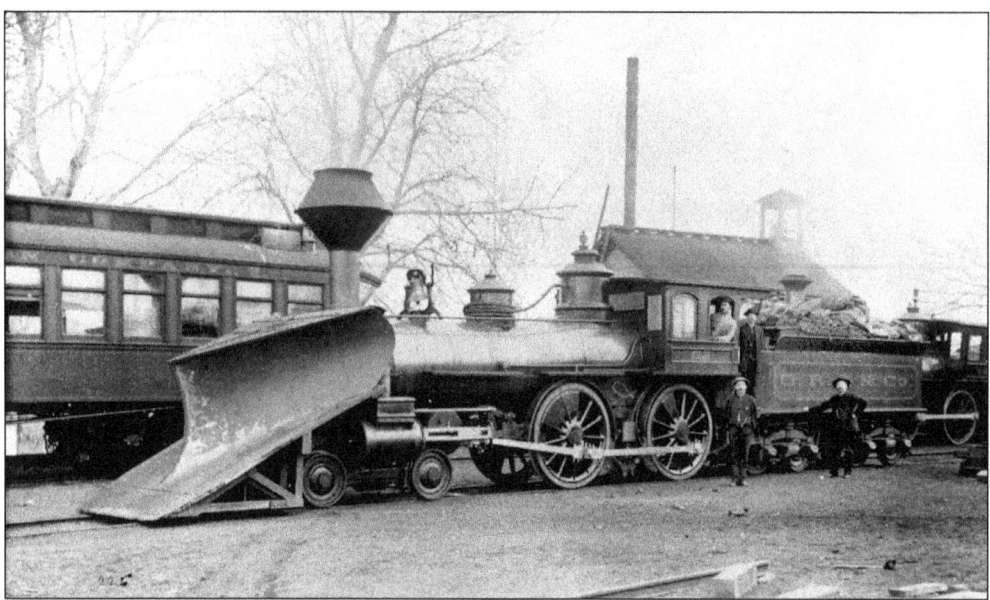

A SIMPLER APPROACH. Another way to clear snow from the tracks is demonstrated by this Oregon Railway & Navigation locomotive, OR&N No. 62, which has been mounted with a snowplow to help the railroad get through its winter operations. This photo was taken in 1887 at the OR&N yard in The Dalles, Oregon. (Courtesy of the Columbia Gorge Discovery Center.)

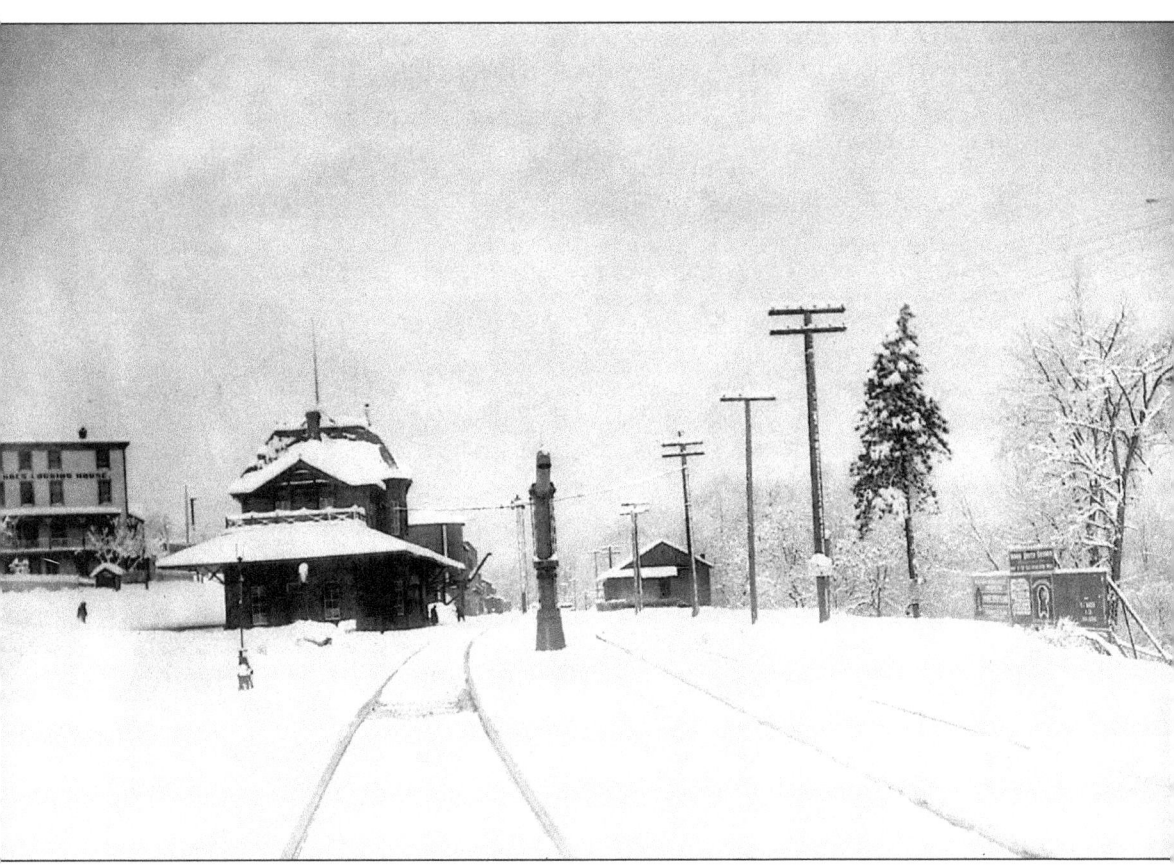

WINTER 1907. Looking west at the Oregon Railroad & Navigation Company depot in Hood River, Oregon, in 1907. Note the typical infrastructure of the era, including the water spout between the two sets of tracks and the water tank on the far side of the depot. Gerdes Lodging House is to the left of the station. (Courtesy of the Hood River County Historical Museum Photo Archives.)

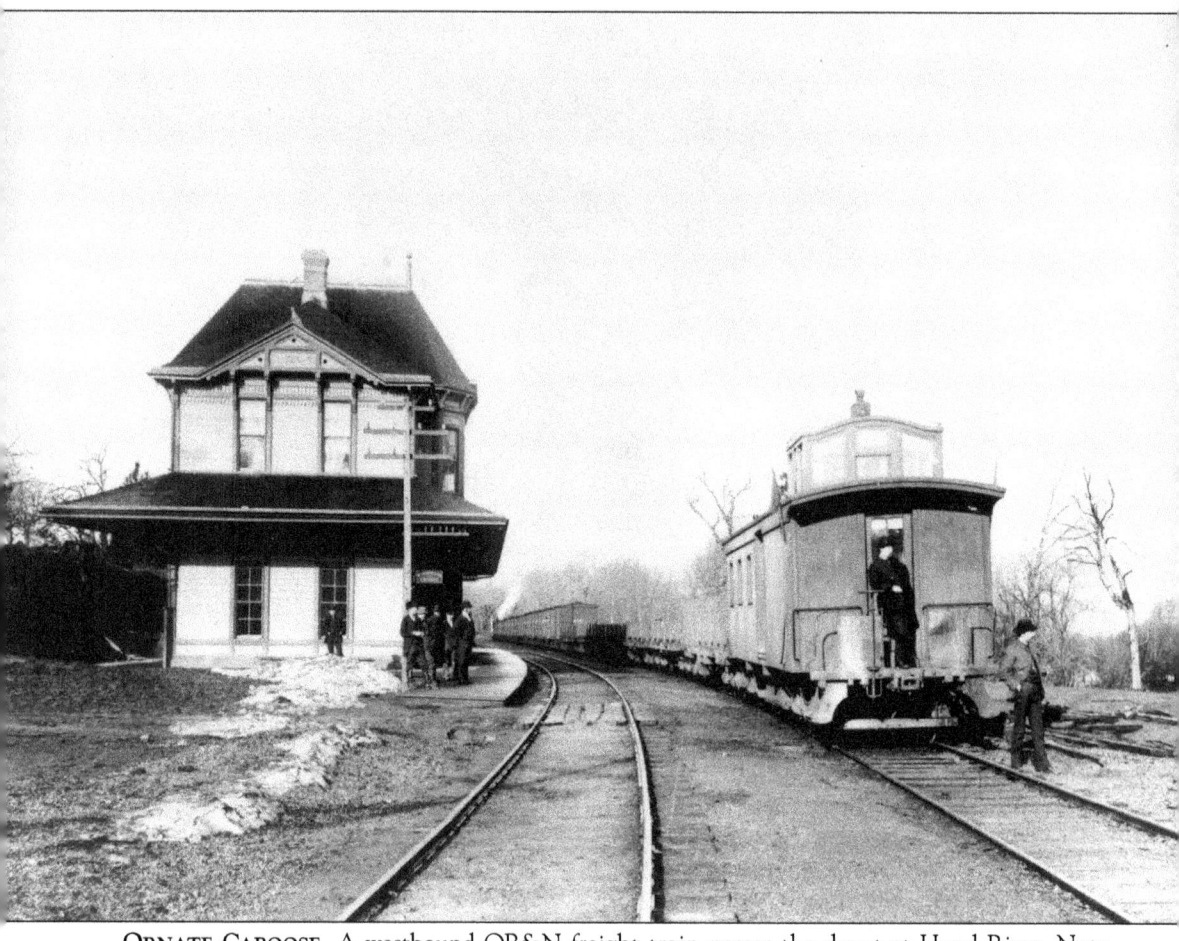

ORNATE CABOOSE. A westbound OR&N freight train passes the depot at Hood River. Note the wonderful ornate woodworking of the caboose's tall cupola. The wide windows allowed the conductor to easily keep an eye on his train, as well as the amazing scenery of the Columbia River Gorge. The depot—Hood River's first—was built in 1882. (Courtesy of the Oregon Historical Society, #OrHi56064.)

Two

UNION PACIFIC RAILROAD

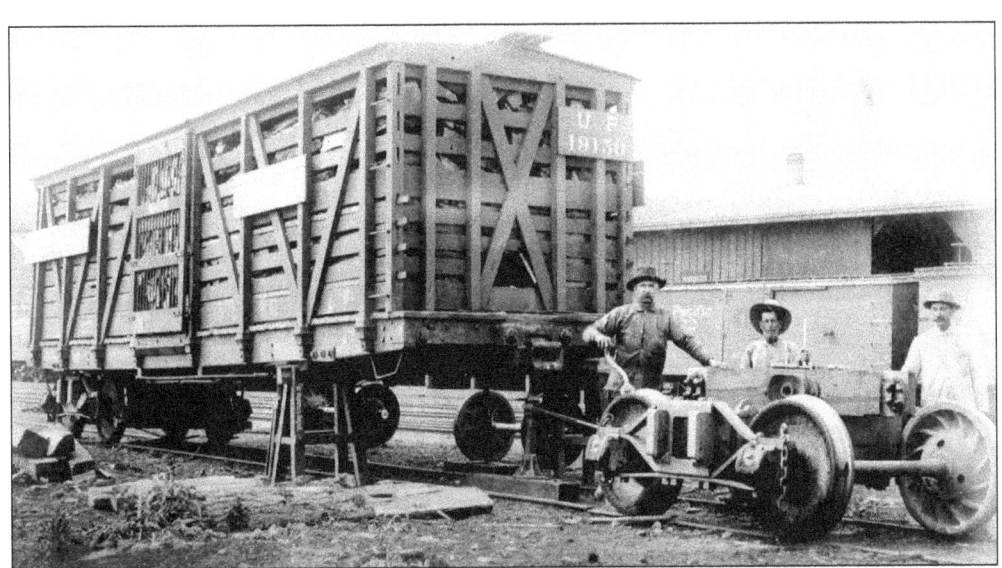

WHEEL CHANGE. A Union Pacific crew has a boxcar jacked up and appears to be changing out the wheel sets on the car, UP No. 19150, at the UP shops in The Dalles, Oregon. The boxcar is filled with what looks like cordwood, presumably to be used as fuel for wood-burning locomotives. (Courtesy of *The Dalles Chronicle*.)

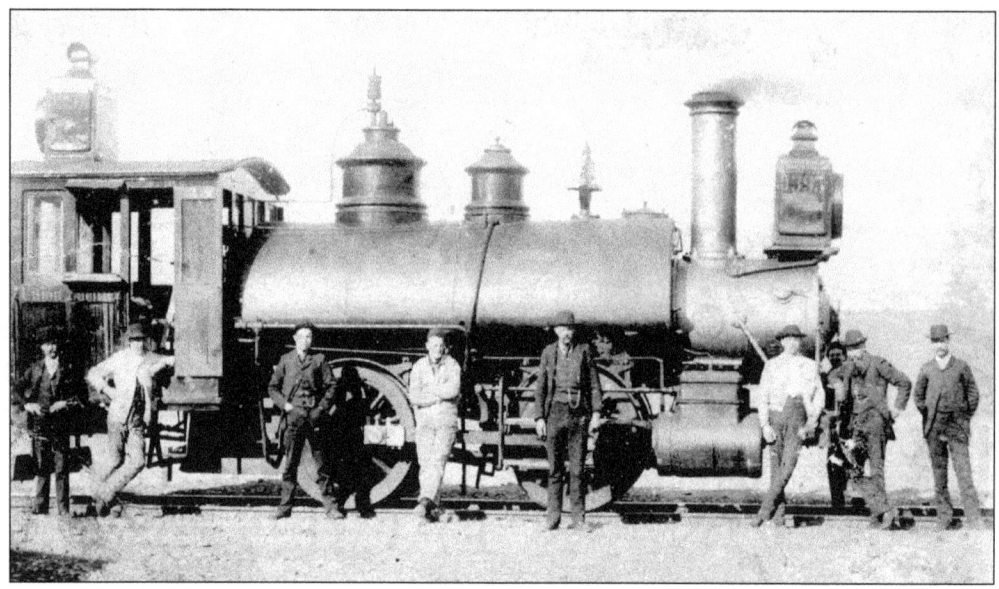

UP 1395. The Union Pacific locomotive No. 1395 is shown in an undated photograph taken near The Dalles. Judging by the design, this was one of the earliest steam locomotives in use on Union Pacific. (Courtesy of *The Dalles Chronicle*.)

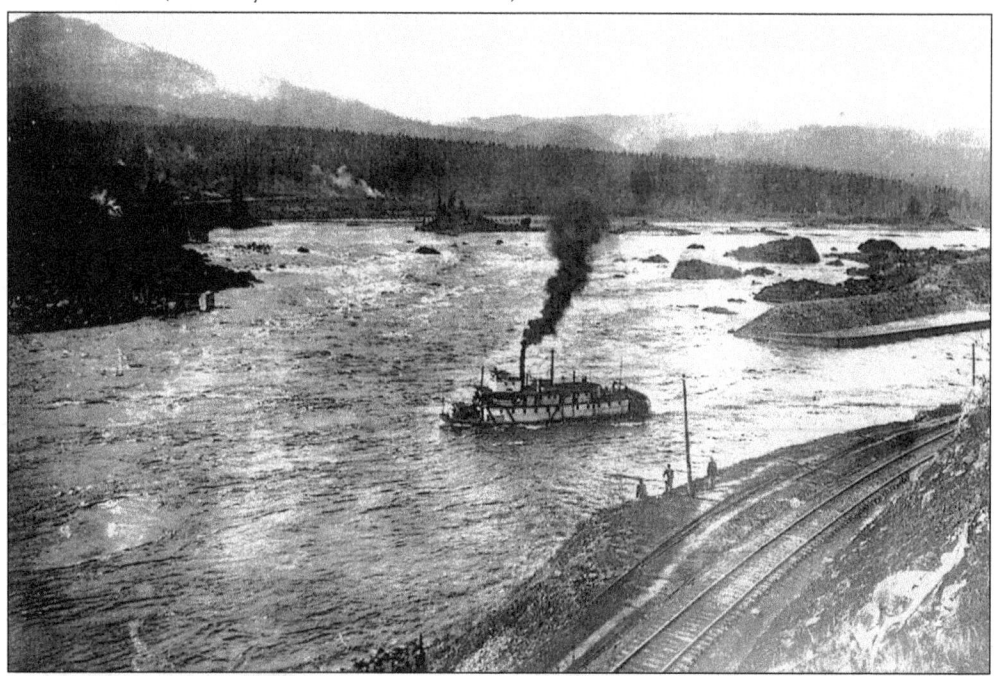

THROUGH THE LOCKS. An unidentified sternwheeler has just left the locks and is continuing west at Cascade Locks, Oregon. Locks were constructed in this location of the Columbia River in 1896 to help facilitate passage for steamboats through the dangerous Cascade Rapids. According to historian Keith McCoy, the area contained "a series of swift waters created by the constriction in the river's width, complicated by several islands, which further interrupted the free flow of the great river." The coming of the railroads would soon eliminate the need for Columbia River steamboat service. (Courtesy of the Gorge Heritage Museum.)

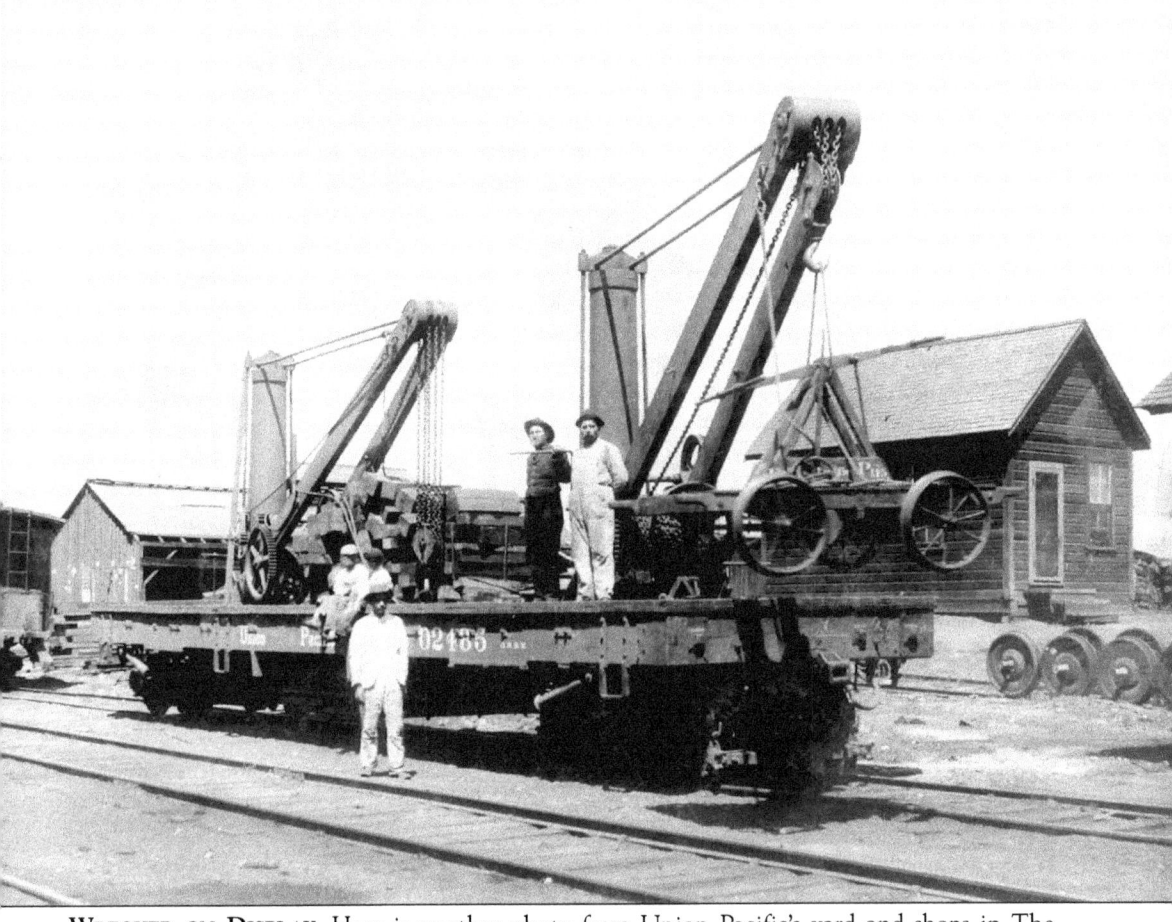

WRECKER ON DISPLAY. Here is another photo from Union Pacific's yard and shops in The Dalles. Here, a track crew poses alongside a flatcar that carries the "old UP wrecker." Note the handcar hanging from the crane in front. The flatcar, UP No. 02485, is sub-lettered for the Oregon Railroad & Navigation Company, which became a UP subsidiary in 1900. (Courtesy of *The Dalles Chronicle*.)

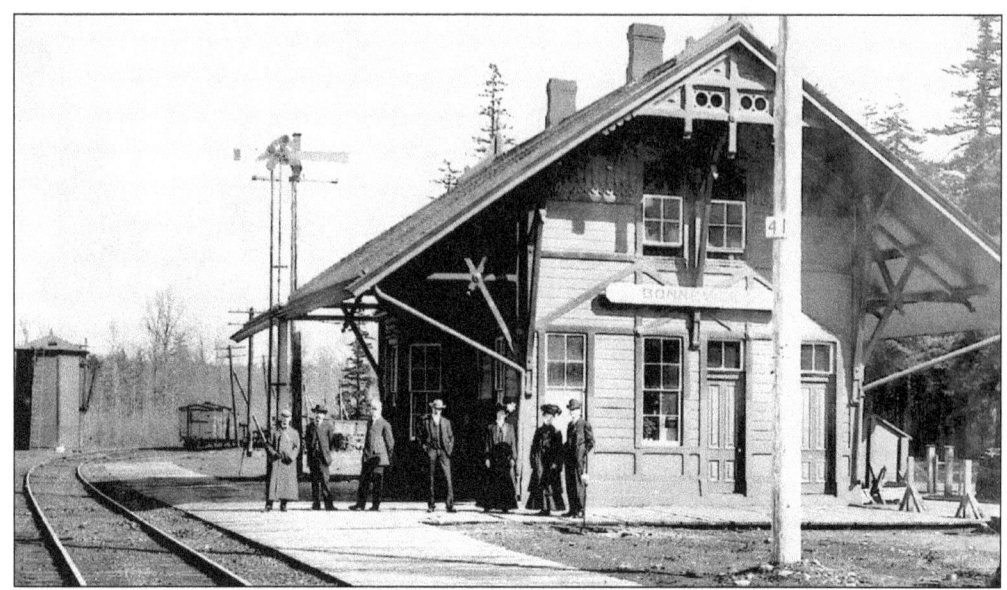

ON THE PLATFORM. Passengers wait on the wooden platform at the Union Pacific depot at Bonneville, Oregon, 41 miles east of Portland. The station features fancy detail in its woodworking, which was typical of the railroad's construction during this era. (Courtesy of the Gorge Heritage Museum.)

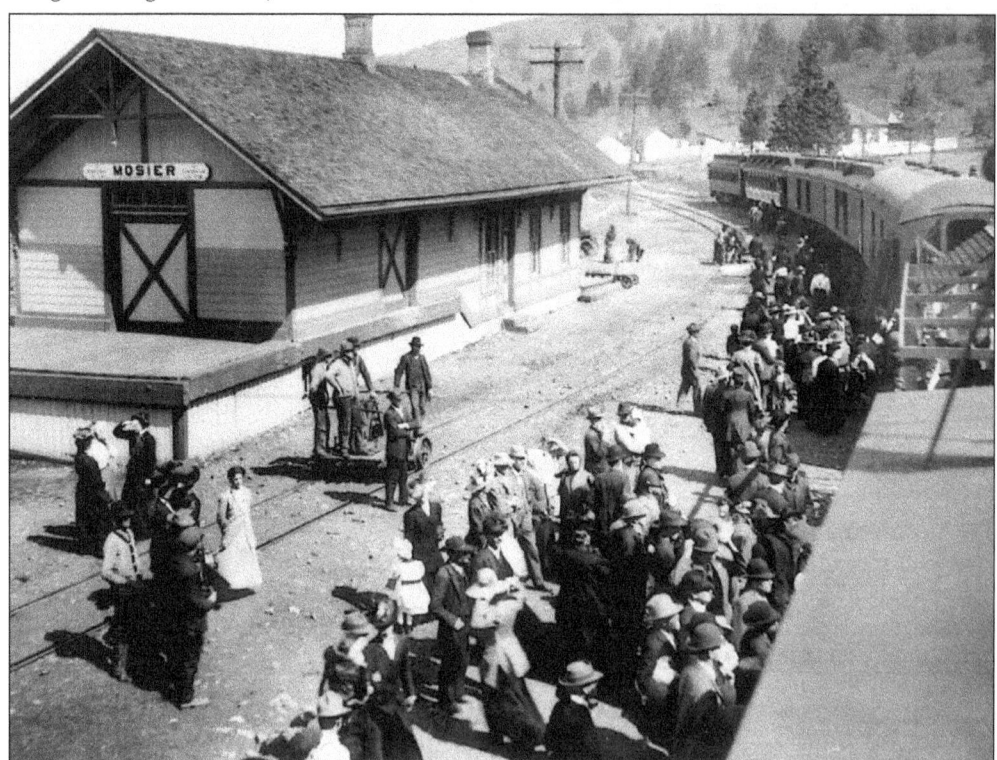

LOADING UP AT MOSIER. Passengers crowd aboard an unidentified passenger train in this car-top view from Mosier, Oregon, on Union Pacific's Columbia River Gorge mainline. Note the four men on a handcar on the siding next to the station. (Courtesy of *The Dalles Chronicle.*)

OREGON WASHINGTON
IDAHO

OFFER THE MOST PROMISING FUTURE TO HOMESTEADERS AND MINERS

UNION PACIFIC RAILROAD
OREGON SHORT LINE RAILROAD
OREGON RAILROAD & NAVIGATION CO.

The Short Line to the Northwest

Tourist Sleeping Cars, Reclining Chair Cars, SEATS FREE and Standard Sleeping Cars from Chicago and Missouri River Points to the Pacific Coast Without Change.

LOW RATES

SEND SIX CENTS IN POSTAGE STAMPS TO EITHER OF THE UNDERSIGNED FOR ILLUSTRATED BOOKLET DESCRIPTIVE OF THE GREAT NORTHWEST

E. L. LOMAX, A. L. CRAIG,
G. P. & T. A., U. P. R. R. Gen. Pass. Agt. O. R. & N. Co.
 Omaha, Neb. Portland, Ore.

A PROMISE TO HOMESTEADERS. This advertisement was designed to entice "homesteaders and miners" to the Pacific Northwest with the promise of "low rates" and "reclining chair cars." See the slogan under the Union Pacific shield logo: "World's Pictorial Line," which is very appropriate for the Columbia River Gorge. Union Pacific president Edward H. Harriman maintained a central business philosophy that featured high freight volume and low rates. Harriman made sure his railroad kept to a high standard in track, maintenance, equipment, and operations. (Courtesy of *The Dalles Chronicle.*)

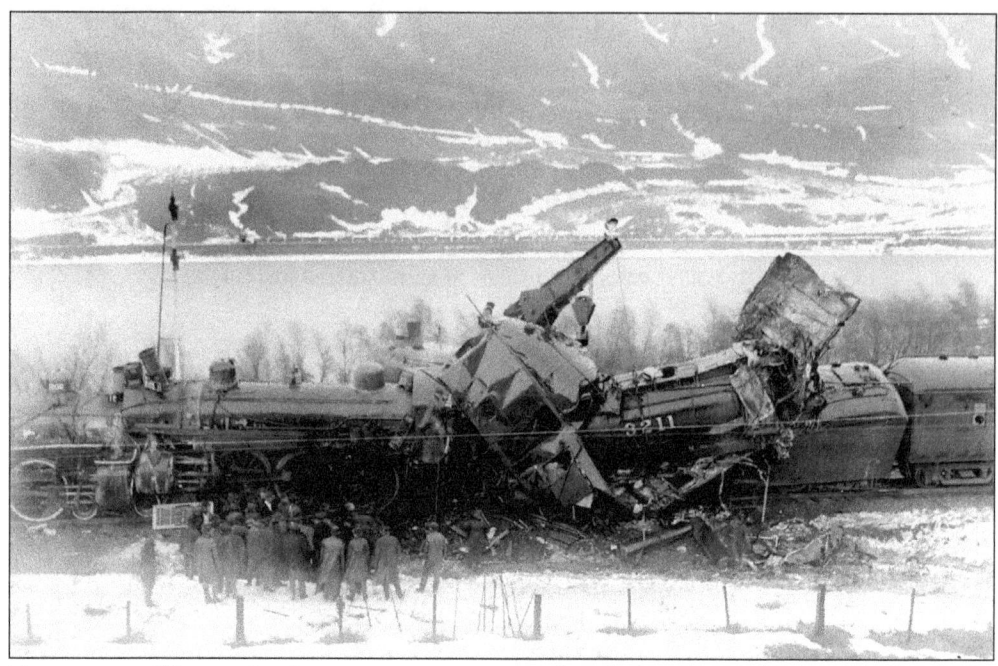

VIEWS TO A WRECK. In these two scenes, an unidentified photographer captured a deadly collision on the Union Pacific just west of Biggs, Oregon, in 1929. Agnes Hastings Adkisson, a resident of nearby Fairbanks, Oregon, at the time, wrote an identical caption on the back of each of these photographs, which otherwise provided no specific details. Her hand-written note read simply: "Awful train wreck where several people were killed. Seven people in all." The photos themselves provide a few additional clues, however: It is obvious there was a head-on collision, and the UP locomotives involved were No. 3202 (train No. 12 eastbound) and No. 3211 (extra No. 32 westbound). The No. 3211 train, which was westbound, appeared to be a passenger train. In the photo at the top, note the long SP&S freight on the Washington side of the Columbia River. (Photos courtesy of the Willard and Agnes Hastings Adkisson family.)

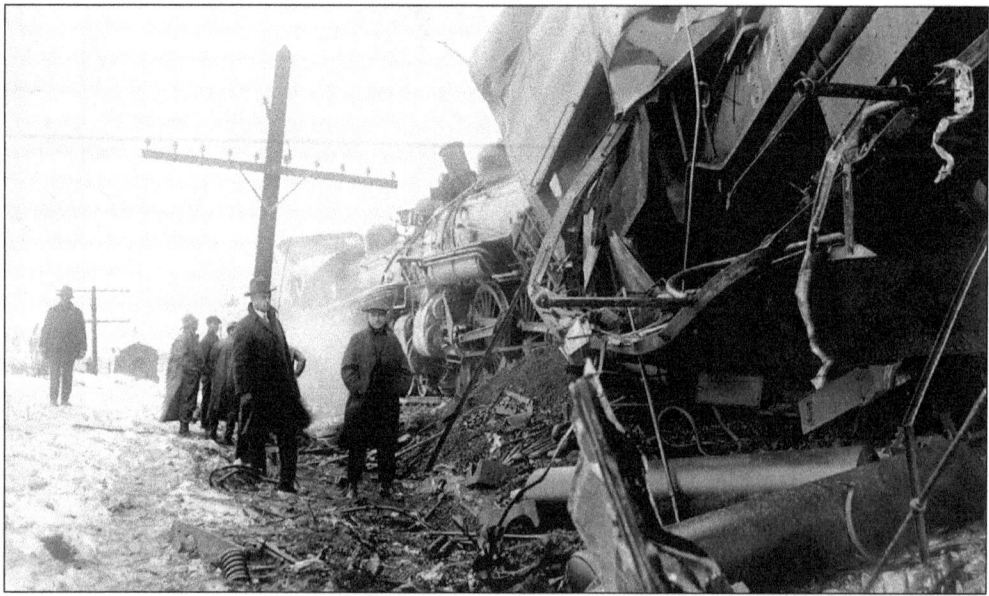

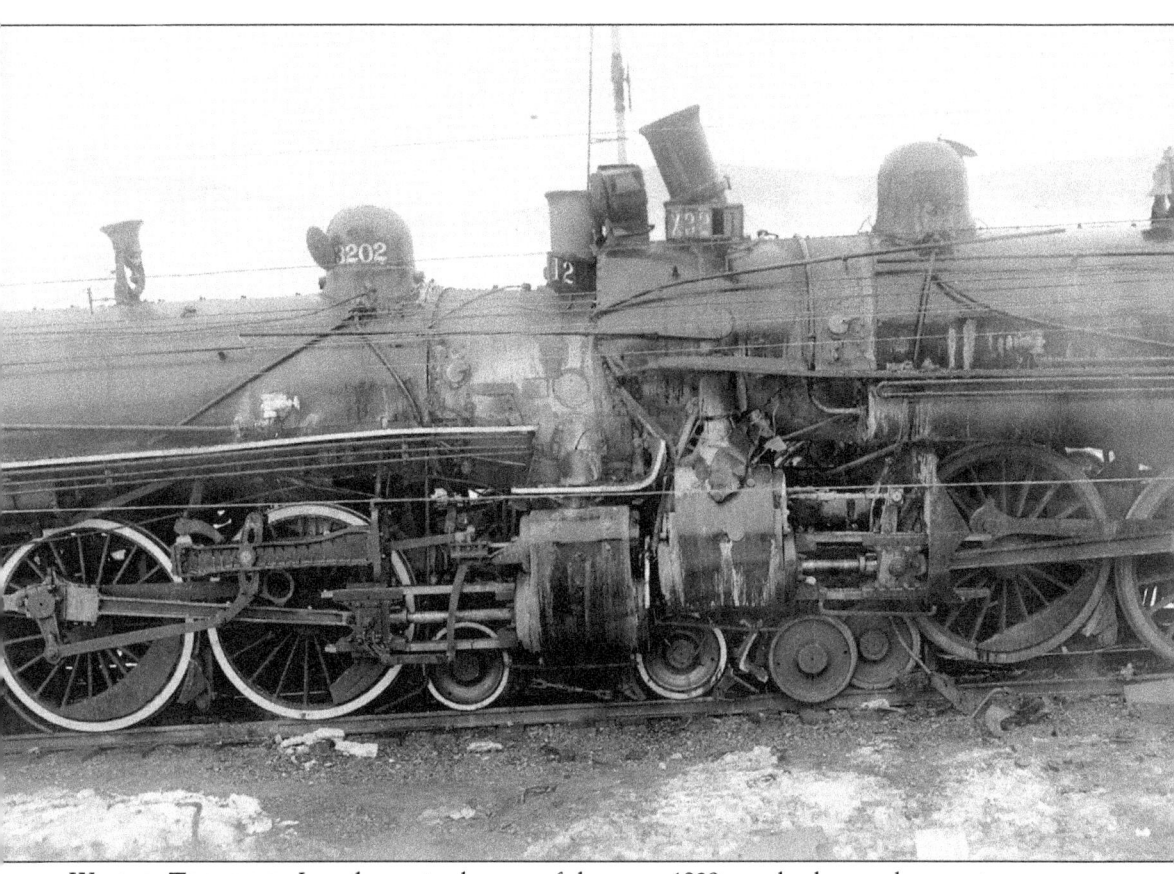

WELDED TOGETHER. In a dramatic close-up of the same 1929 wreck, the two locomotives are shown to have smashed into each other with such force that they appeared to be welded into one. The bell on No. 3202 was inverted toward the sky and frozen in place after the crash. (Courtesy of the Willard and Agnes Hastings Adkisson family.)

MOSIER, 1915. This is a view looking east at Mosier, Oregon. The date is March 1, 1915, and the town's spur tracks are crowded with gondolas. All the tracks on the right in this photograph have been removed, as have the water tower and the station. Only a single mainline on the left remains, along with a passing siding that begins about a half-mile to the east of where this photo was taken. (Courtesy of the Wildflower Café.)

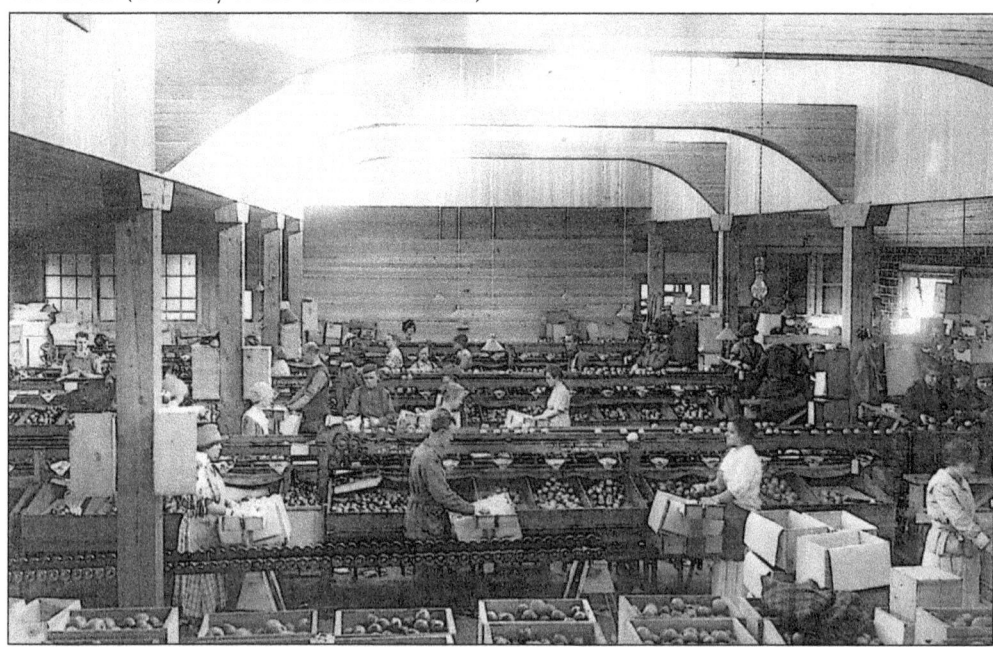

PACKING HOUSE. A large crew works the apple crop at the Fruit Growers Building in Mosier in the 1920s. Apples were loaded onto freight cars and transported east and west by rail. During the early 1900s, the Oregon Railroad & Navigation Company produced a promotional brochure designed to entice farmers and investors to the Mosier area. "Uncleared orchard land can be bought for from $25 to $40 an acre," read an excerpt from the brochure, which was titled, "How To Get To Mosier, Oregon." (Courtesy of the Wildflower Café.)

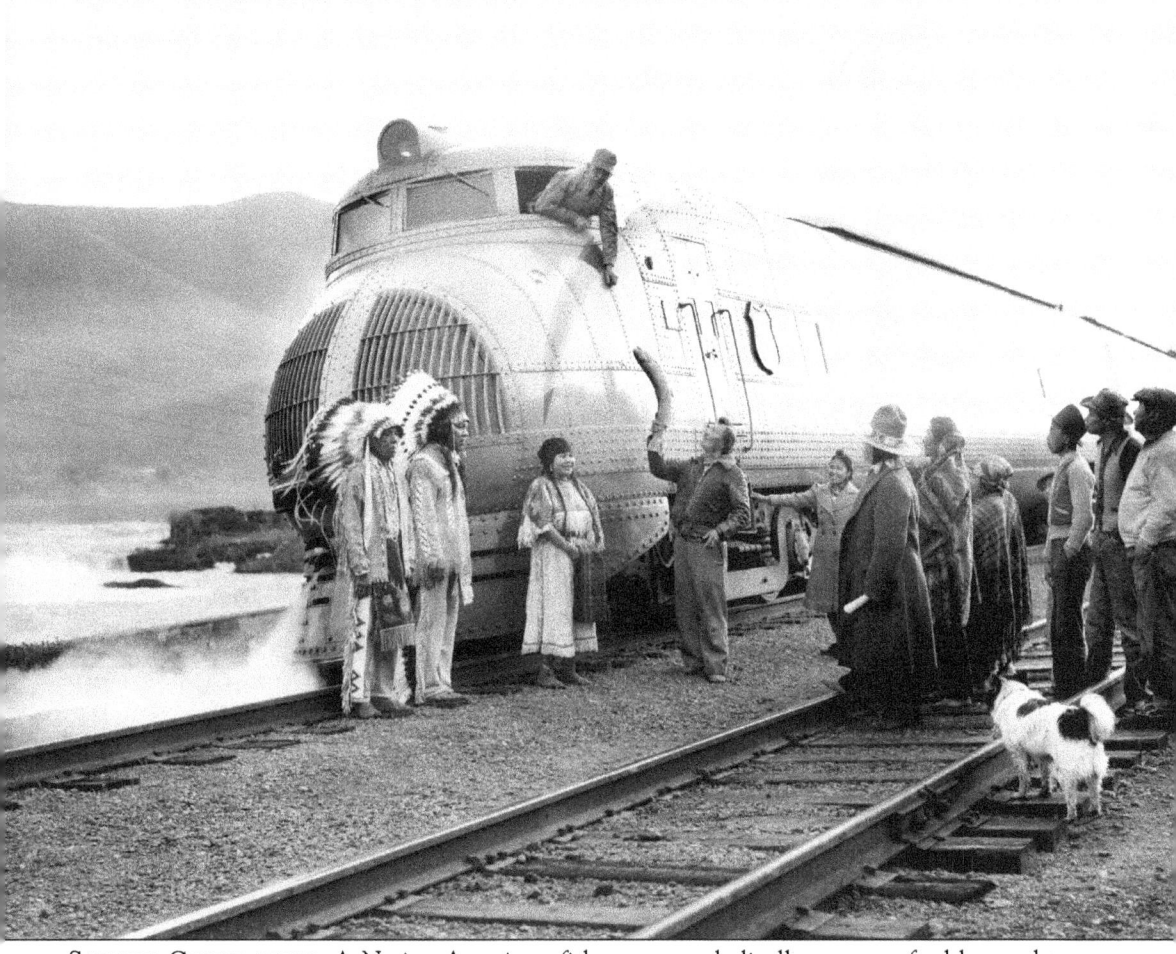

SALMON CELEBRATION. A Native American fisherman symbolically passes a freshly caught salmon to the engineer of Union Pacific's streamliner *City of Portland* at Celilo Falls, Oregon, in April 1940. This shot was staged as part of an advertising campaign. The engineer leaning out of UP No. M10002 is Tom Rumgay, who passed away in 1942. The tribal members are from the village of Celilo, and those in full dress on the left are Chief Tommy Thompson and his son, Henry Thompson. This particular streamliner, removed from service in 1939, was brought out of retirement for the photo shoot. (Photograph by Everett Olmstead, courtesy of Thomas Robinson.)

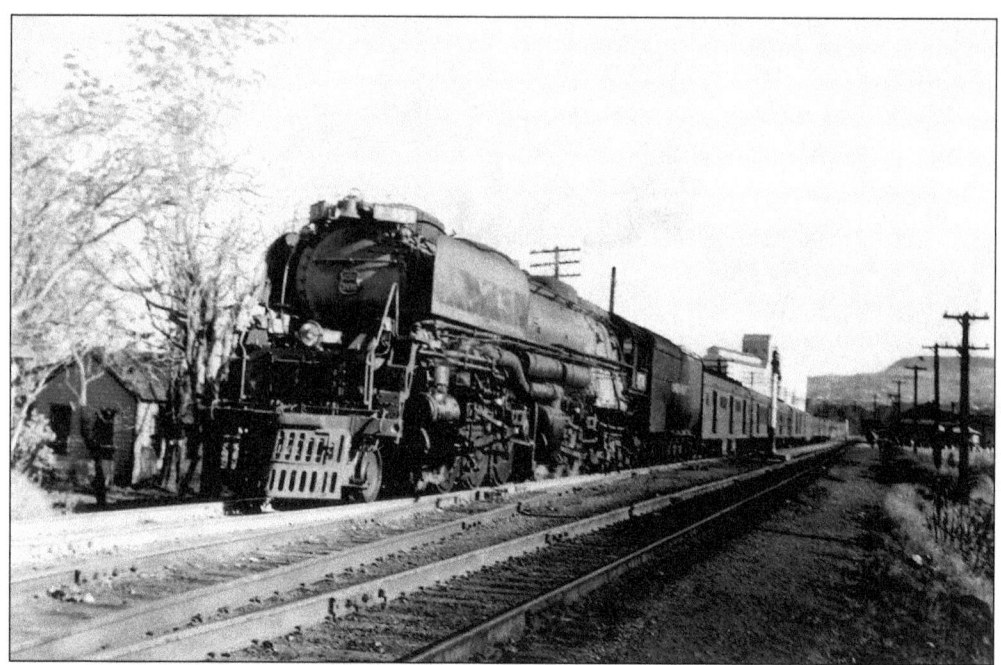

CHALLENGER WEST. Union Pacific 4-6-6-4 "Challenger" No. 3978 glides westbound on its way to Portland with a long passenger train in the early 1950s. This photo was taken near Crates, Oregon. Note the water spout a couple of cars behind the locomotive. (Courtesy of John Wood.)

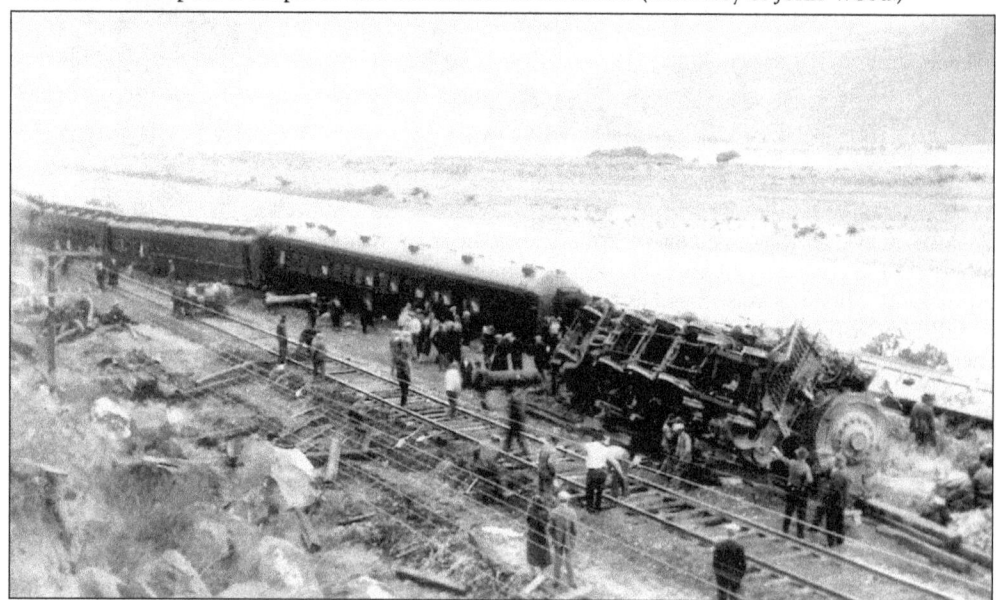

UPSIDE-DOWN TRAIN. In October 1925, Oregon-Washington Railroad & Navigation Company (Union Pacific) Train No. 26 derailed at Blalock, Oregon, about 10 miles west of Arlington. The locomotive, express car, and smoker went over the embankment and into a ditch along the Columbia River, with the locomotive coming to rest on its top. Fireman Robert H. Lee was killed in the mishap, and 20 others were injured. The wreck was reportedly caused by a boulder that fell from the bluffs onto the track, breaking a section of rail. (Courtesy of the Columbia Gorge Discovery Center.)

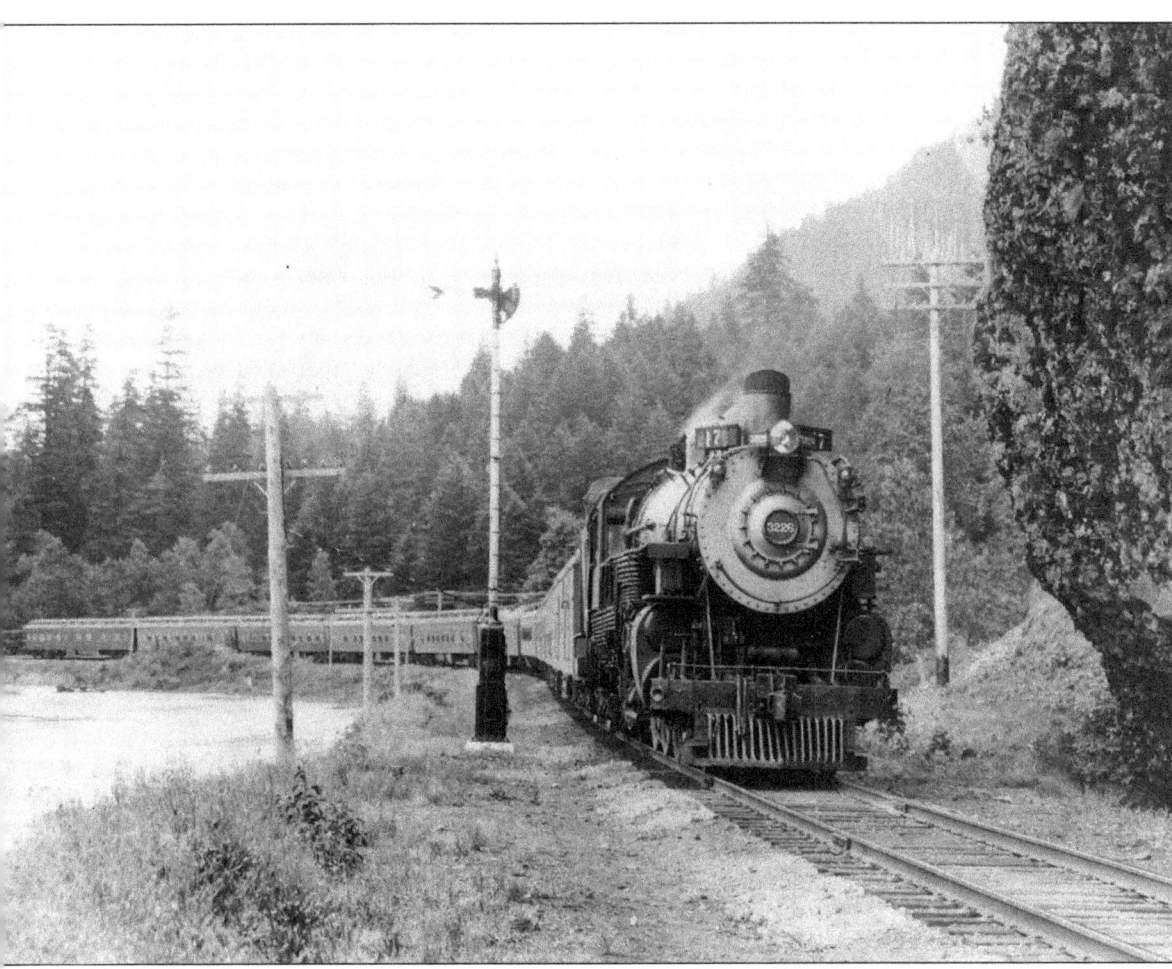

Sweet Rose. Union Pacific's Train No. 17, the *Portland Rose,* slips past a semaphore signal tower west of Multnomah Falls as it rolls toward Portland near the end of its daily route from Denver. This passenger train made its inaugural run on September 12, 1930, and ceased service on May 1, 1971. This day's train is headed by UP No. 3226, which is equipped with a smokestack spark arrestor to minimize the danger of wildfires. (Courtesy of the Oregon Historical Society, #OrHi56481.)

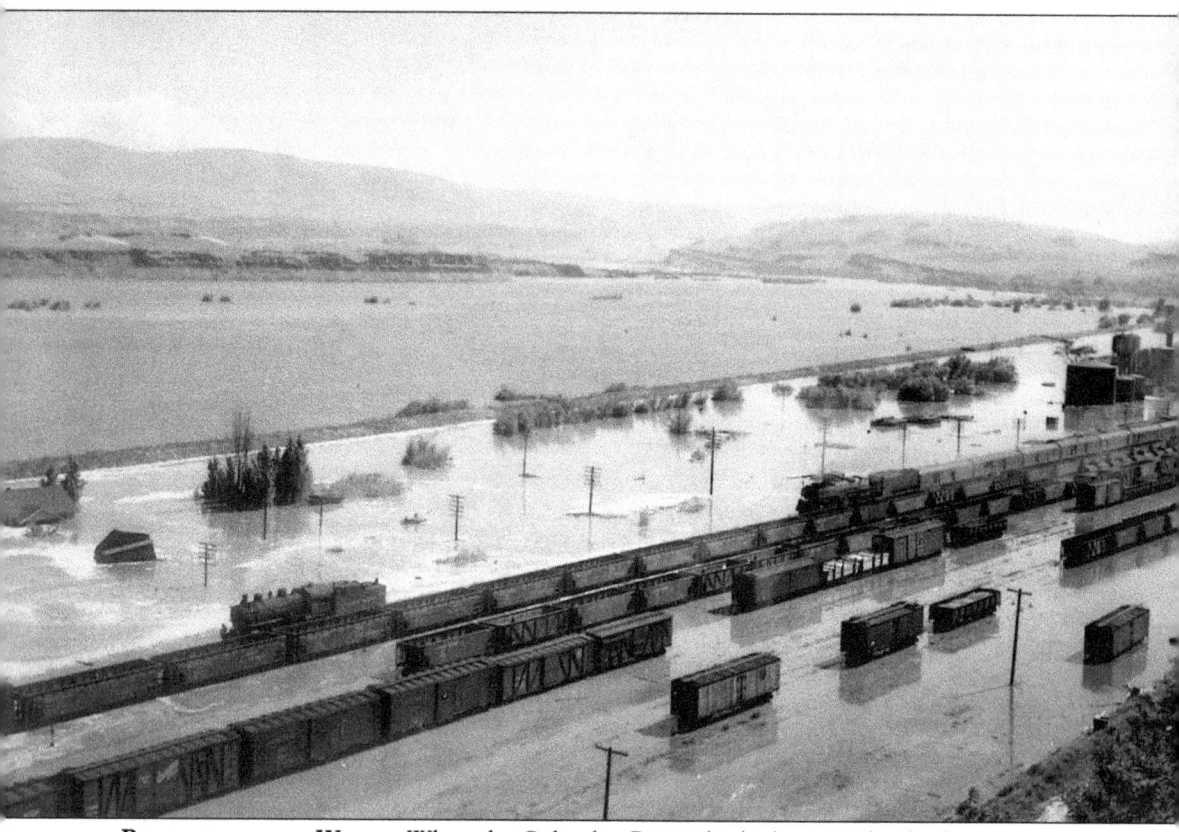

BOXCARS ON THE WATER. When the Columbia River climbed over its banks during the flood of 1948, most of the Union Pacific yard in The Dalles ended up under water. Note the UP locomotives on the northernmost track; one is gingerly pulling a passenger train over the wet rails. To see how deep the water was, take a look at the two-story house at the far left of this photo: only a bit of the second floor remains visible. (Courtesy of the Columbia Gorge Discovery Center.)

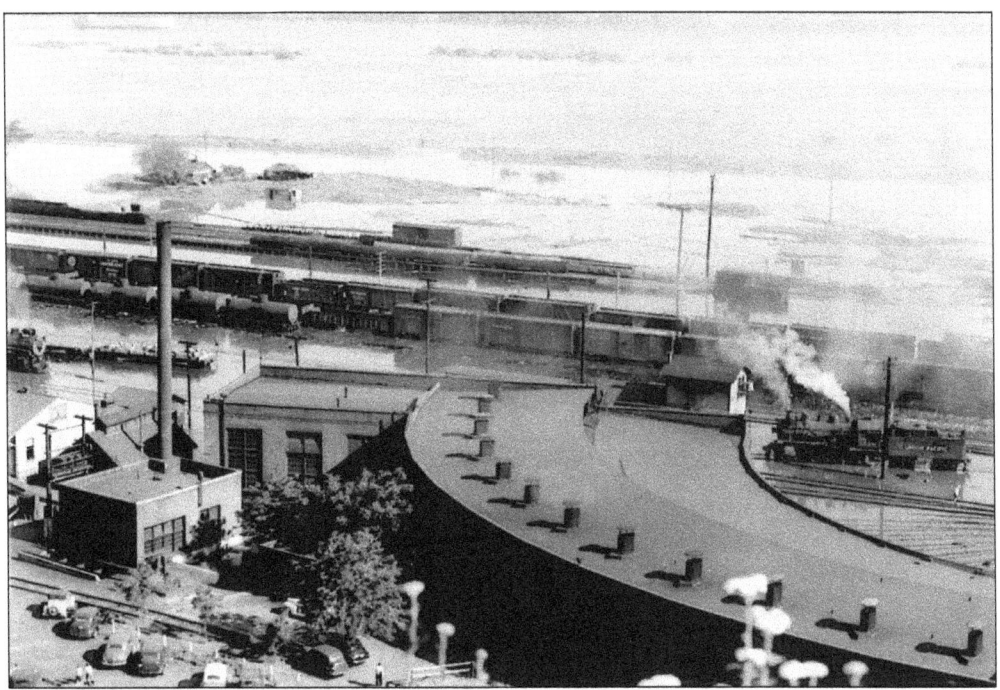

ROUNDHOUSE REFLECTIONS. Another photo taken during the 1948 flood shows the impressive, once essential Union Pacific roundhouse in The Dalles, with a couple of locomotives idling outside. Water is still standing in the yard, creating reflections of the locomotives on this sunny day. (Courtesy of Alex Chisholm.)

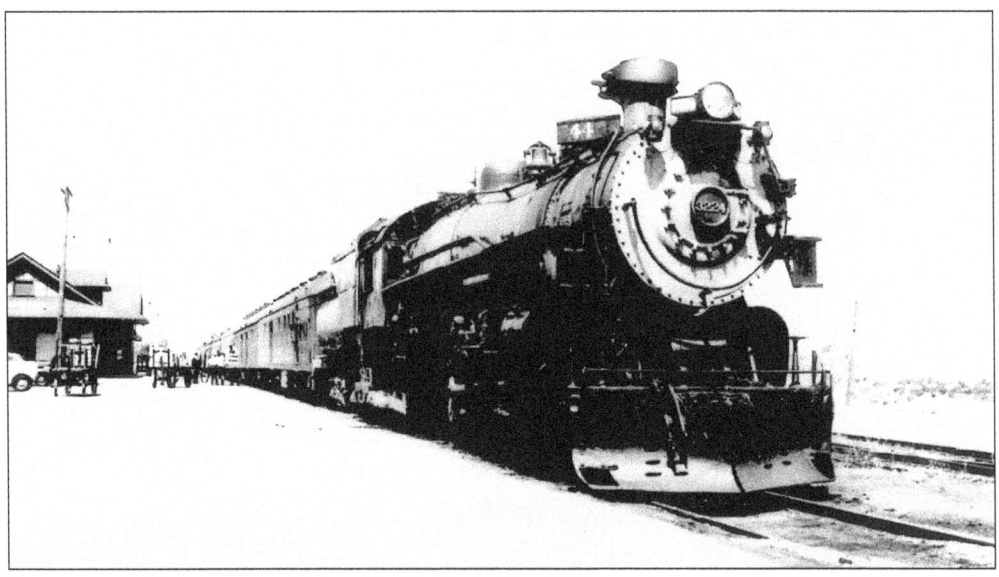

EASTBOUND PASSENGERS. Union Pacific Train No. 44 East waits at The Dalles while passengers board and luggage is loaded in this typical scene from the early 1950s. UP locomotive No. 3224 handled the assignment on this day. (Courtesy of the Columbia Gorge Discovery Center.)

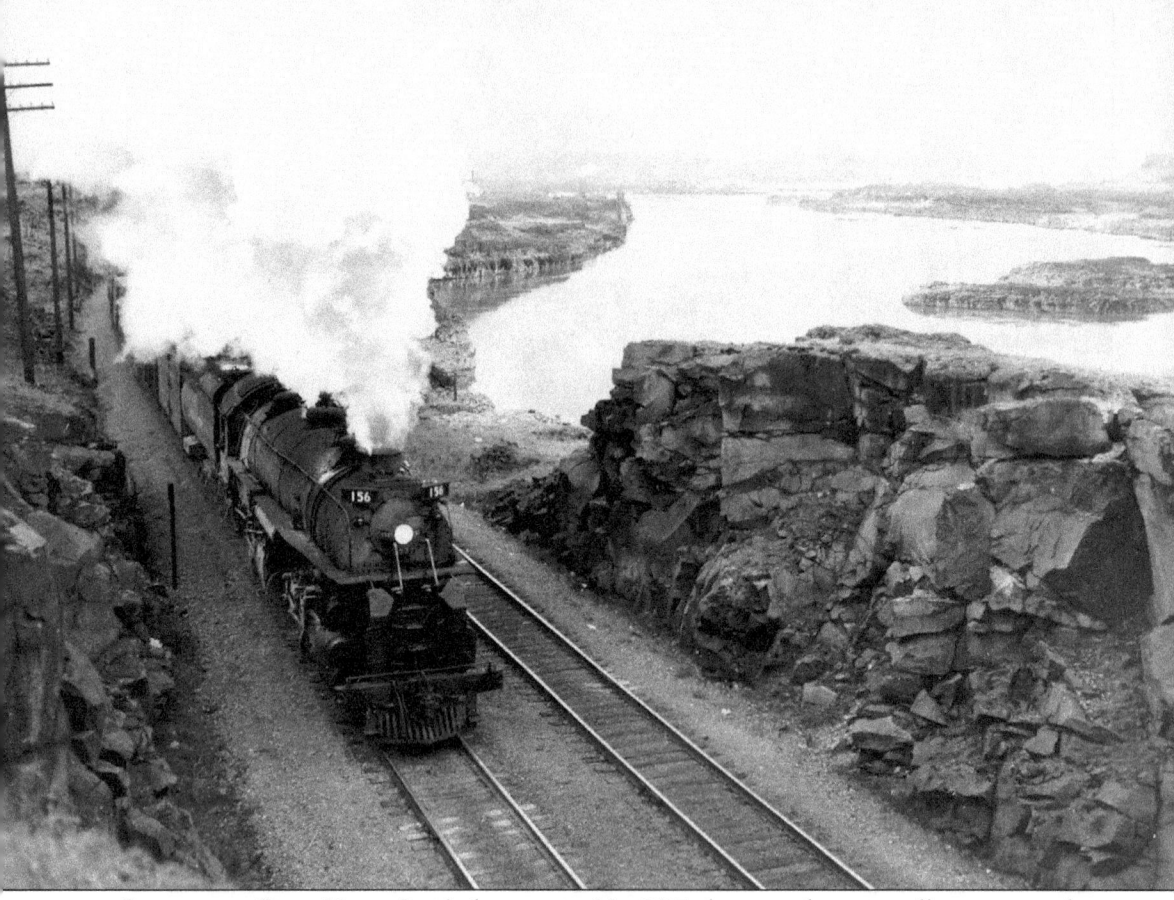

BEFORE THE DAM. Union Pacific locomotive No. 3537 obscures what it is pulling in gray-white clouds of steam as it powers train No. 156, an eastbound mixed manifest freight, through Seufert, Oregon. The Columbia River and the area's signature rock formations form a poetic backdrop to the continual passage of the trains. This location is not far from where The Dalles dam would later be built. Construction of the dam started in 1952. (Courtesy of John Wood.)

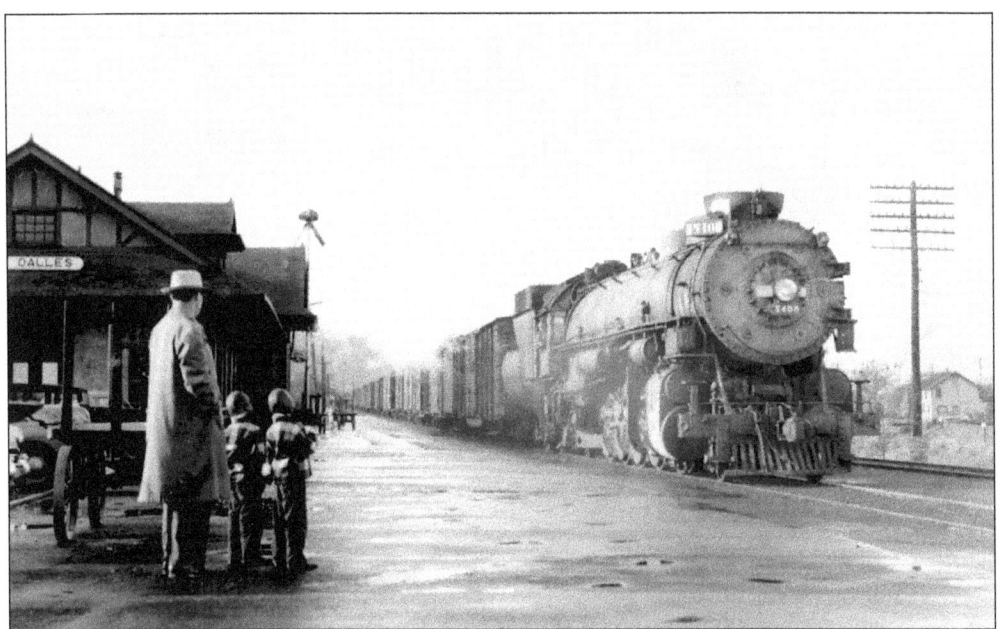

Long Freight Running. A father and his two sons stand on a rainy platform at The Dalles, Oregon, watching Union Pacific No. 5408 bring a long, eastbound freight through town. This was an archetypal scene from the 1950s on the UP's Columbia River Gorge mainline. The Dalles served as a crew change point for UP train crews operating between Portland and Hinkle, Oregon, until April 1973. (Courtesy of *The Dalles Chronicle.*)

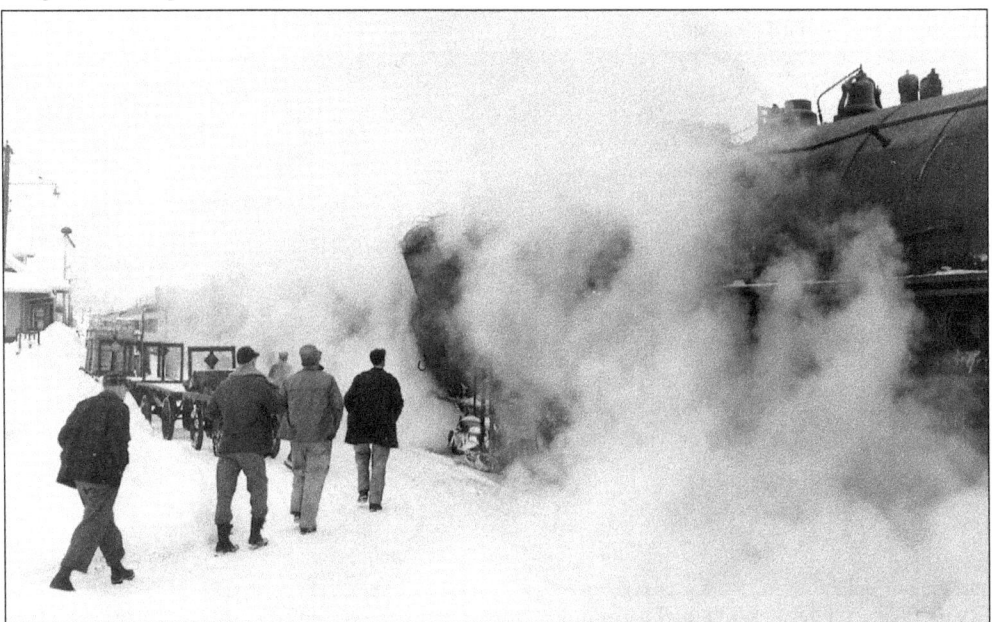

The Idahoan. With its locomotive enveloped in steam in the cold temperature and its passengers disappearing into the swirling clouds, Union Pacific's eastbound *Idahoan* wades through the snow during a station stop in The Dalles in 1950. *The Idahoan* ran daily between Cheyenne, Wyoming, and Portland, Oregon, via Pocatello and Boise, Idaho. (Courtesy of John Wood.)

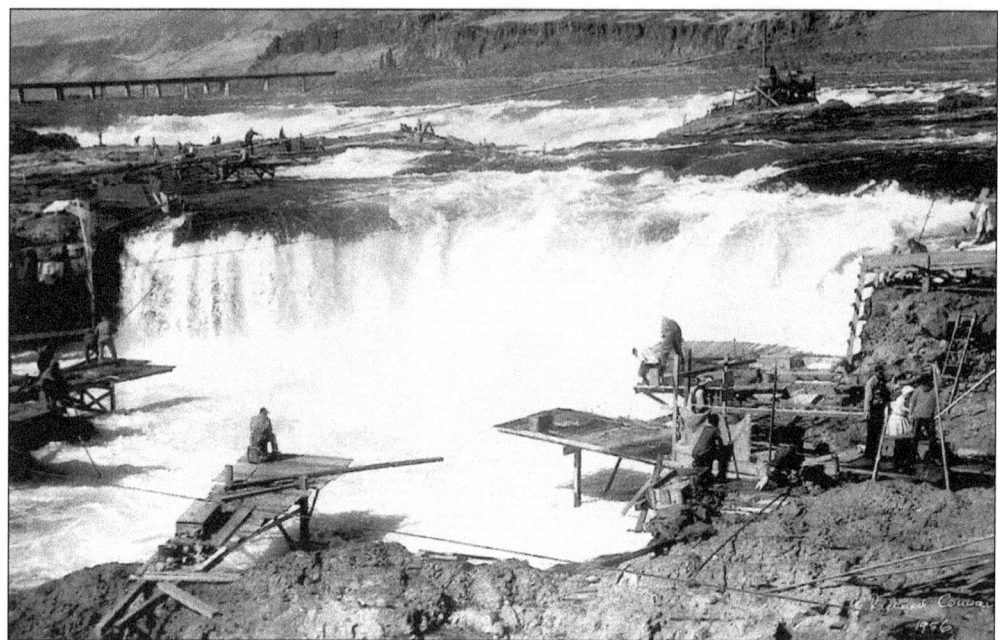

A Tradition Lost. Tribal fishers practice their generations-old tradition of fishing for Columbia River salmon using dip nets in this wonderful scene from Celilo Falls in September 1956. Sadly, this year represented the final fish run at Celilo Falls before the unique area was flooded following completion of The Dalles dam, a few river miles from this spot, in spring 1957. The bridge in the background carries the tracks of the Oregon Trunk line to Bend, Oregon. (Photo by Fr. Richard Conway.)

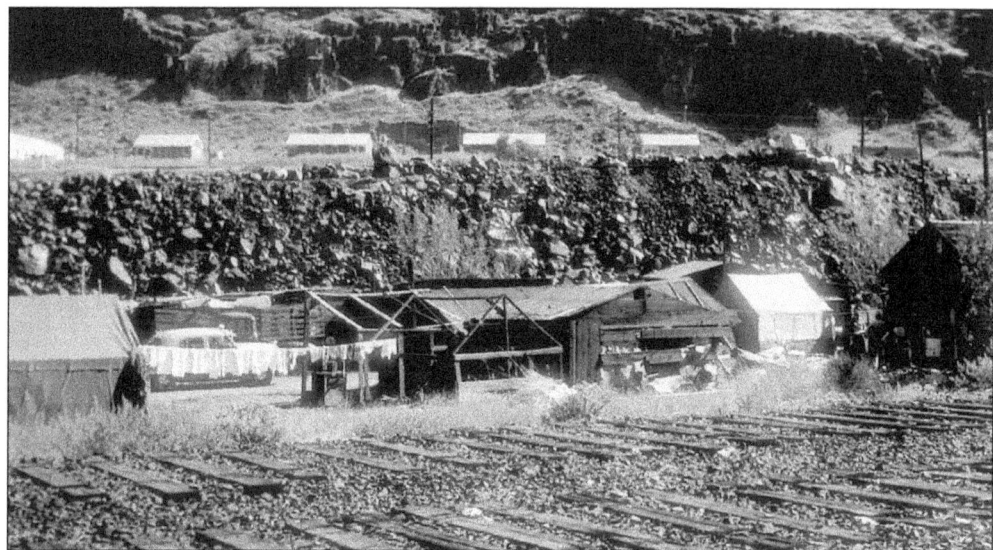

Soon Going Underwater. Ties remain from an otherwise empty right of way at Celilo, Oregon—all that's left of the Union Pacific mainline here in 1956. The tracks had to be relocated, as the coming of The Dalles dam would soon flood the area. The rail line was shifted to higher ground to the south. The structures behind the tracks were part of a fishing camp where tribal members stayed while at Celilo Falls. The buildings in the background were part of the village of Celilo. (Photo by Fr. Richard Conway.)

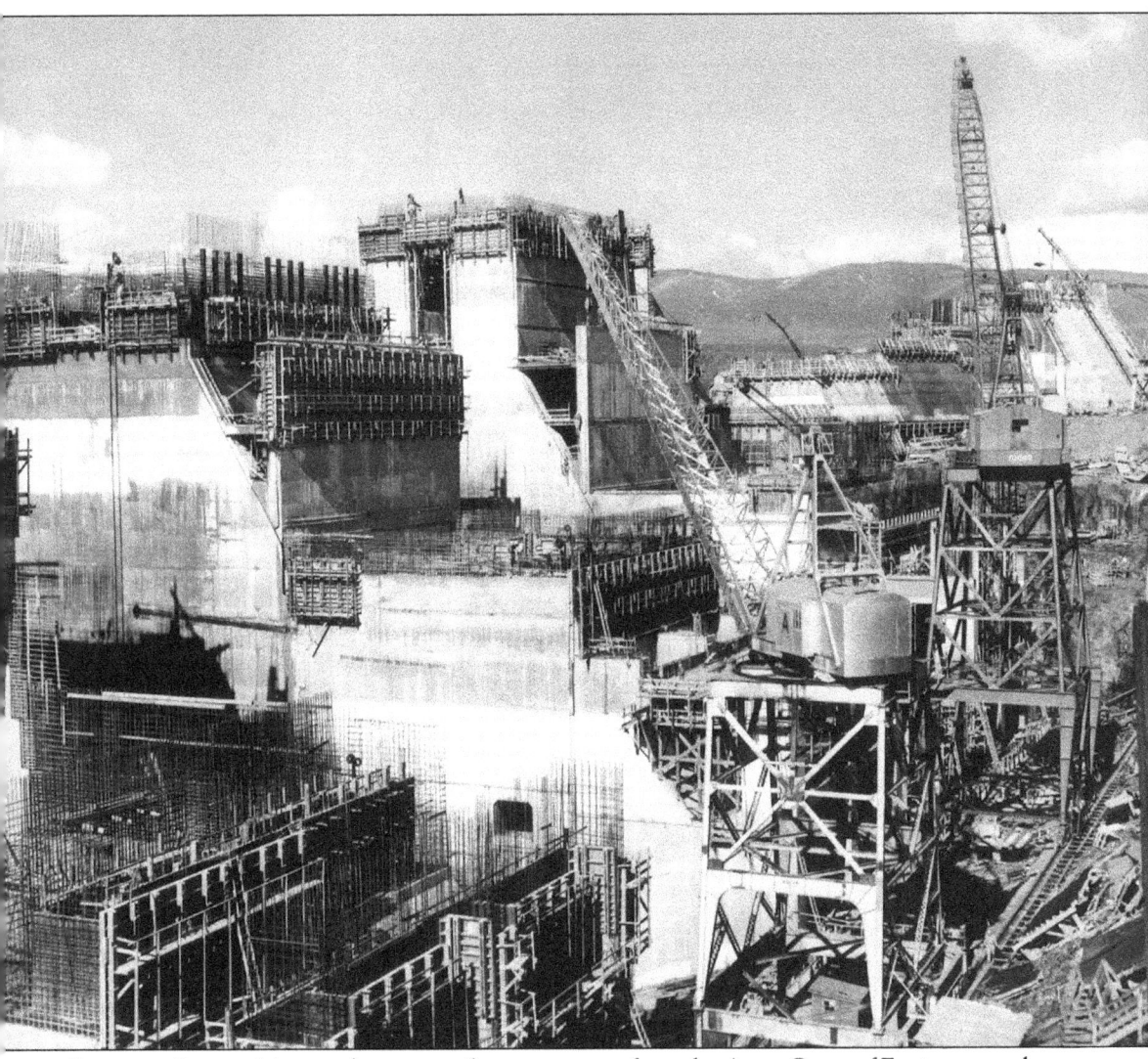

RIVER OF REBAR. Mammoth cranes toil away as teams from the Army Corps of Engineers work on The Dalles dam during its construction between 1952 and 1957. Once the dam went up, the Columbia River was forever changed, with the migrating patterns of wild salmon disrupted and roads, railroads, and towns forced to relocate to make way for the rising water. (Courtesy of John Wood.)

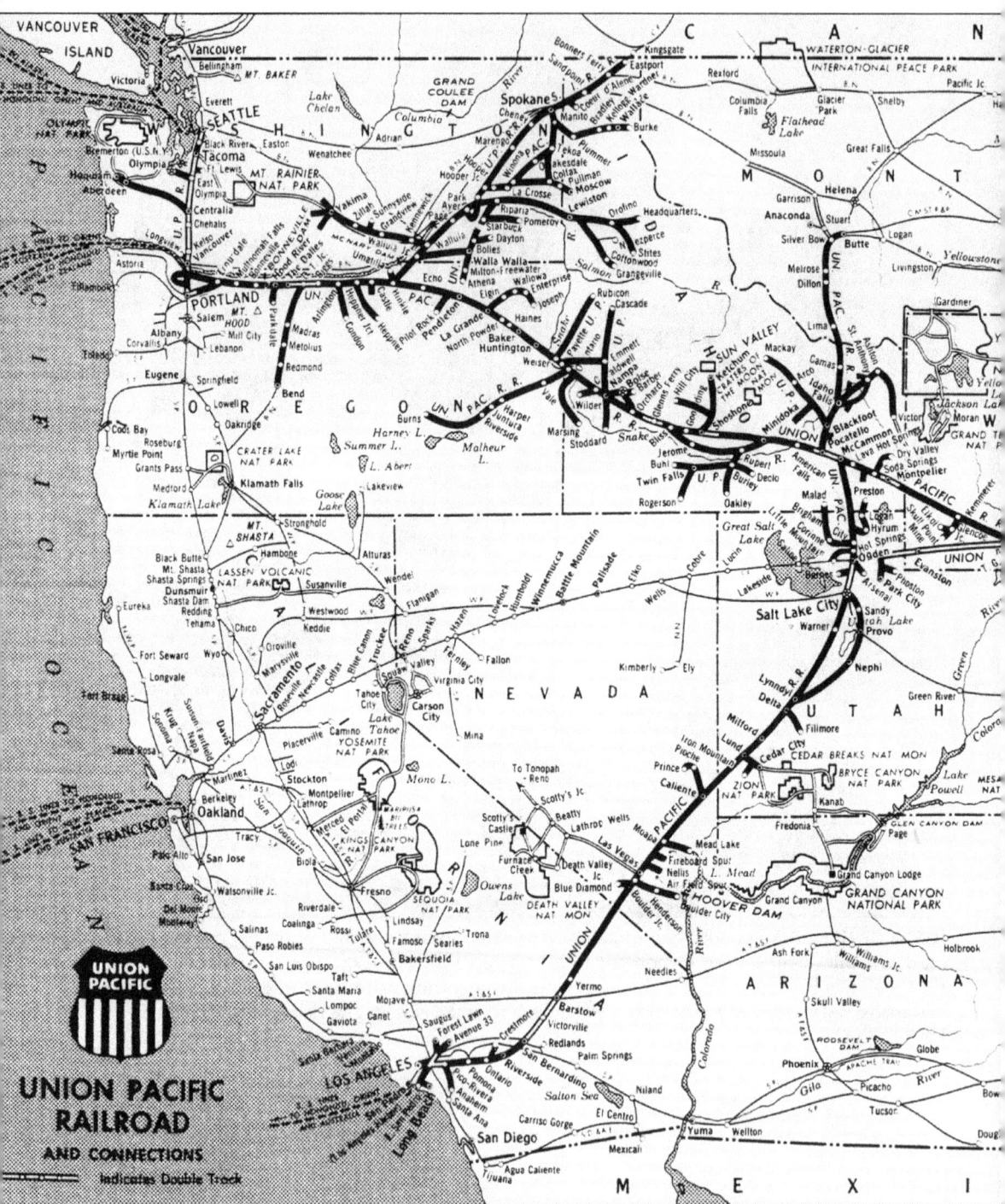

UNION PACIFIC LINES. This route map, produced in 1981, shows Union Pacific's trackage in the Pacific Northwest, including the Columbia River Gorge lines in Oregon. The UP stretched from Omaha and Kansas City in the east to Portland and Los Angeles in the west, but

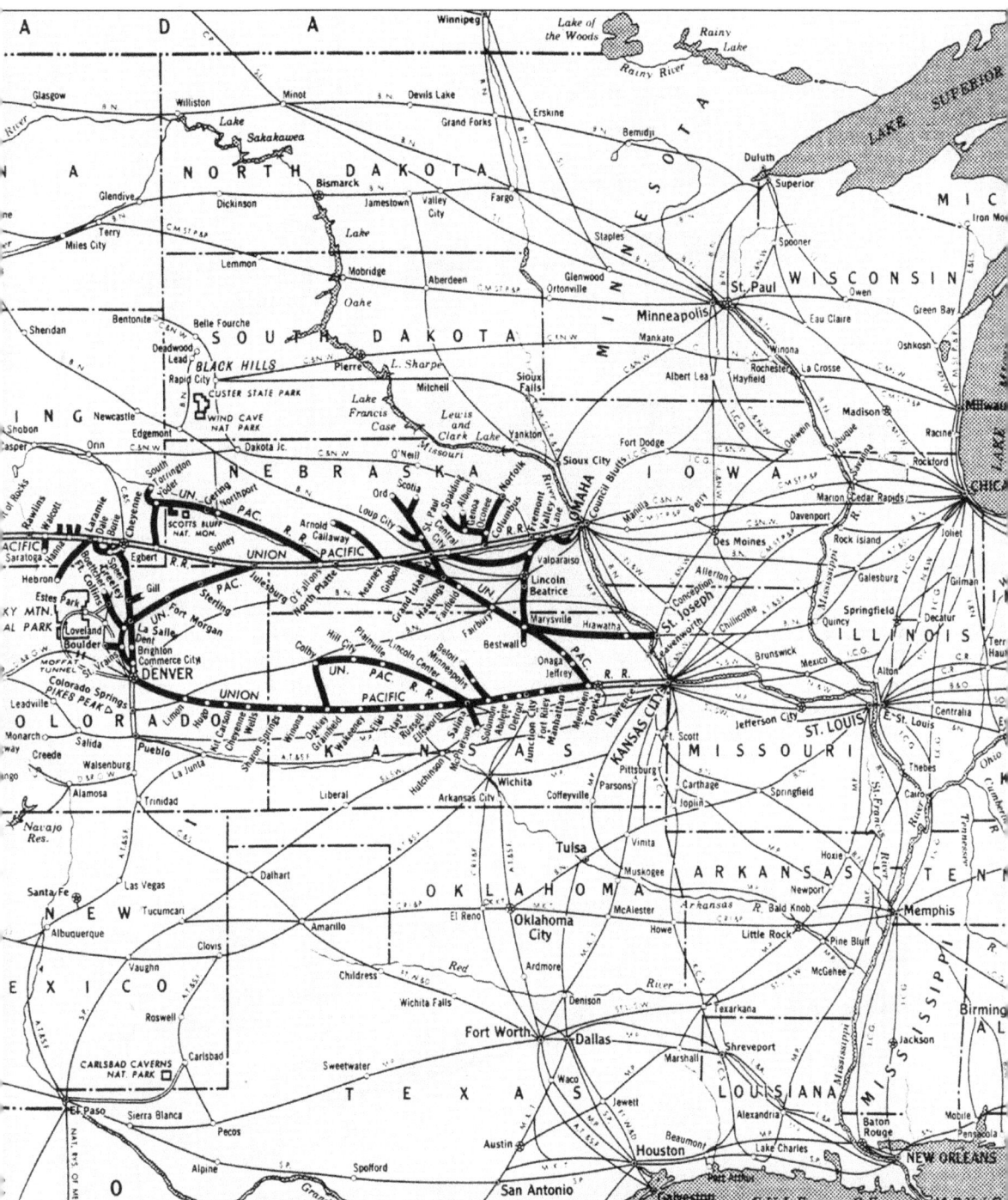

the railroad company did not gain its own direct access to the nation's primary rail hub of Chicago until it absorbed the Missouri Pacific Railroad in December 1982. (Courtesy of D.C. Jesse Burkhardt.)

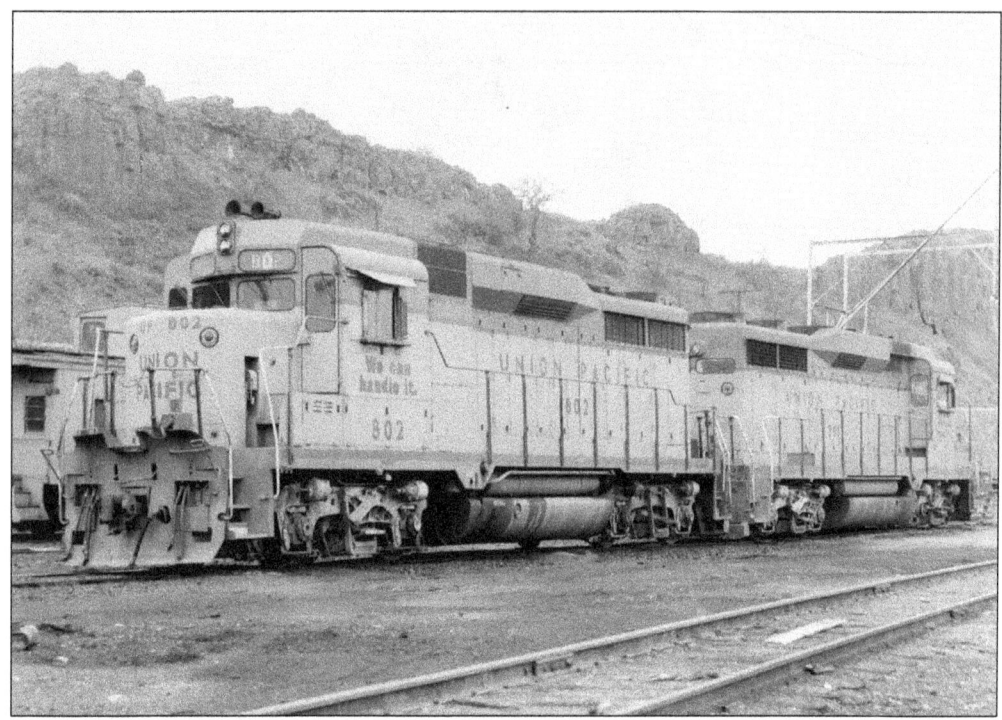

WE CAN HANDLE IT. With basalt rock formations towering in the background, two Union Pacific GP30s—No. 802 and No. 801—idle in the locomotive servicing area in The Dalles in March 1981. The sanding and refueling facility is on the right in this scene. Much of the yard infrastructure here, including the sanding towers and the turntable, was removed in 1985. (Photo by Robert W. Johnston, courtesy of Walter Ainsworth.)

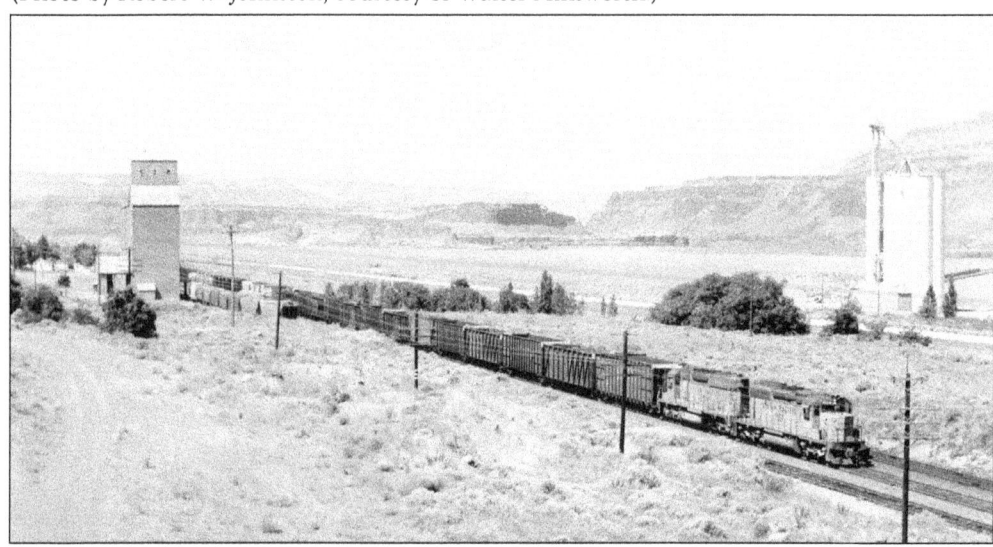

EASTBOUND AT BIGGS. In July 1981, a drag freight, behind two SD40-2 locomotives, rolls eastward through Biggs, Oregon, at Milepost 103 on UP's Portland Subdivision. The tall bluffs on the far side of the Columbia River are in the state of Washington. Biggs is an important grain shipping station, as the long string of hoppers at the elevators to the left of the train attests. (Photo by Robert W. Johnston, courtesy of Walter Ainsworth.)

46

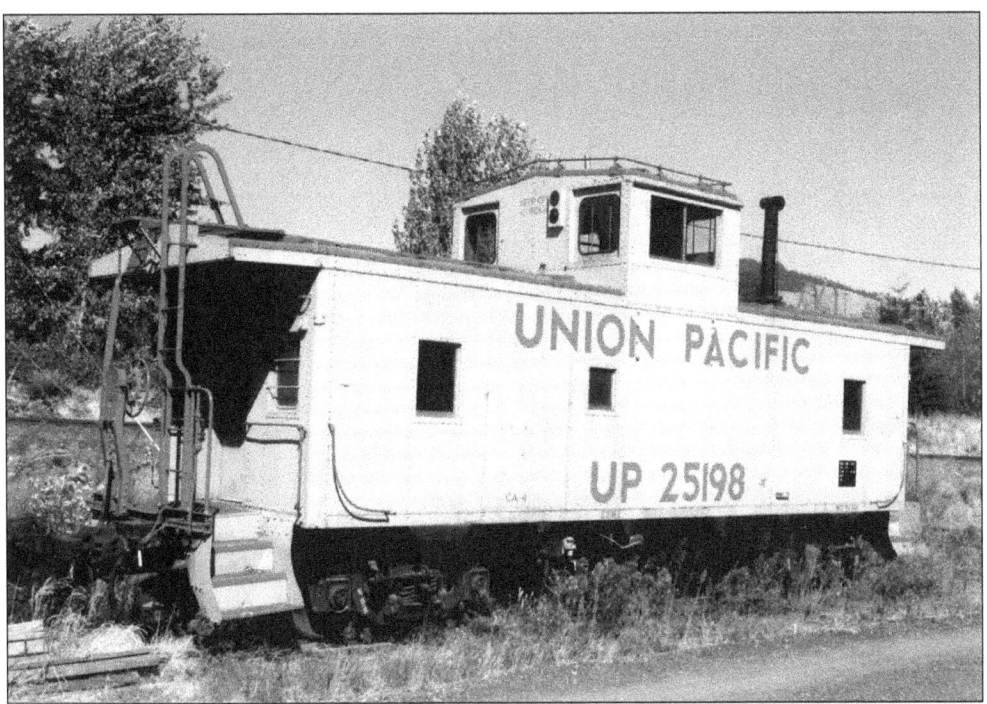

BUILT IN '44. Union Pacific caboose No. 25198 rests in the yard next to the mainline at Hood River, Oregon. This caboose was built in October 1944 and featured something new: The small symbol just to the right of the cab's road number—a capital "R" with a lightning bolt through it—meant the cab was "Radio Equipped." From 1968 to 1987, the branchline south from Hood River to Parkdale was owned and operated by Union Pacific. (Photo by D.C. Jesse Burkhardt.)

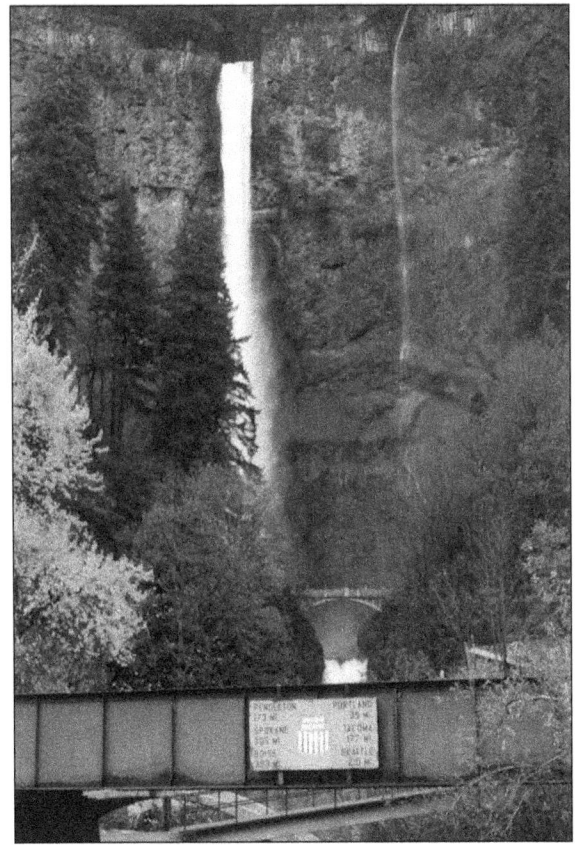

MULTNOMAH FALLS. At Multnomah Falls, Oregon, one of the Columbia River Gorge's natural wonders sprays over the cliffs close to the Union Pacific mainline. In the foreground, a fading Union Pacific signboard on a bridge near the falls details how many miles it is from this point to Boise (393 miles), Spokane (305), Seattle (210), Tacoma (177), Pendleton (173), and Portland (35). (Photo by D.C. Jesse Burkhardt.)

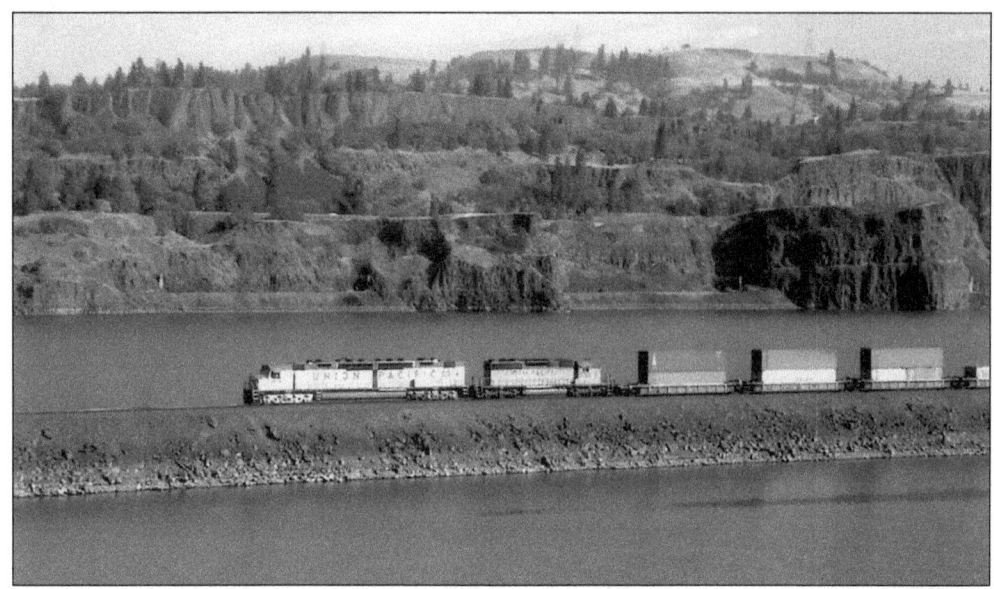

LAST ONE RUNNING. Union Pacific's 6,600-horsepower DDA40X No. 6936, built by EMD in 1971, was brought out of storage following UP's 1996 merger with Southern Pacific when there didn't seem to be enough locomotive power to move all the trains. On October 25, 1997, No. 6936 pulled a westbound stack train through the Columbia River Gorge near Rowena, Oregon, with an assist from SD40-2 No. 3766. Although once commonly seen in the gorge, No. 6936 was the last active one of its type on the UP system. (Photo by D.C. Jesse Burkhardt.)

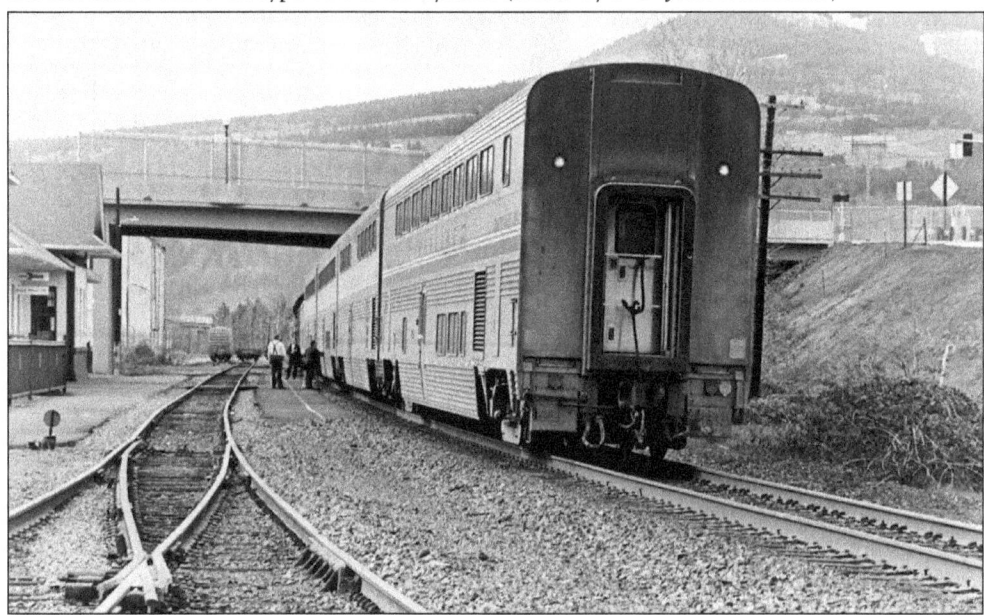

ENDANGERED TRAIN. Amtrak's westbound *Pioneer*, with four Superliner cars, prepares to leave the Hood River, Oregon, passenger depot on March 22, 1997. The *Pioneer*, which ran between Seattle and Chicago via Portland and UP's Columbia River Gorge route, was targeted for termination because it was not considered viable. Originally, service was planned to come to an end in November 1996, but Oregon Senator Mark Hatfield won funding for a six-month extension of the service, which ended on May 10, 1997. (Photo by D.C. Jesse Burkhardt.)

Three

SPOKANE, PORTLAND & SEATTLE RAILWAY

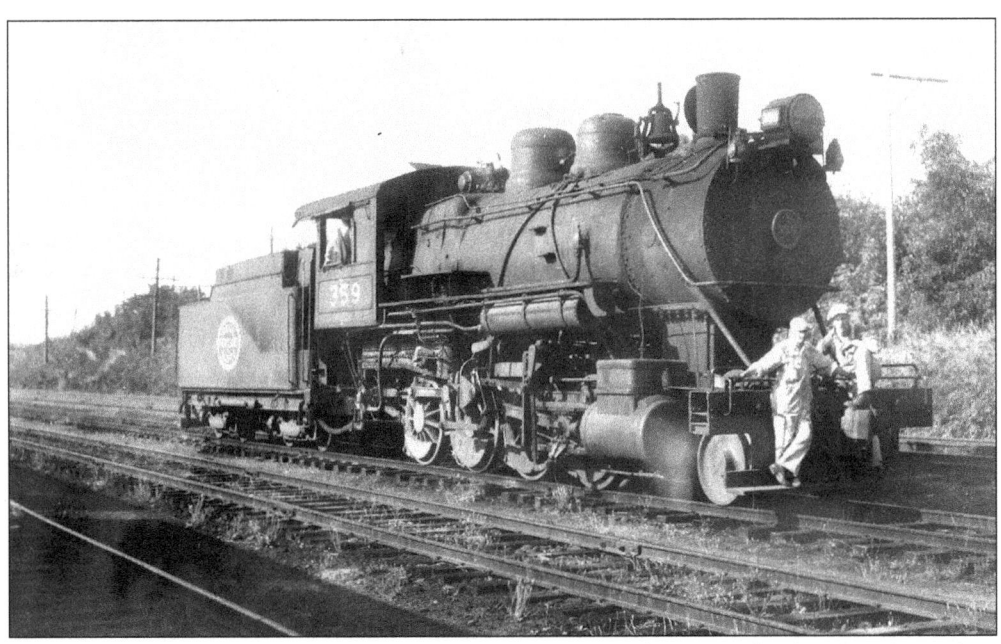

CATCHING A RIDE. In an image captured in 1940, two Spokane, Portland & Seattle workers ride the front running board of SP&S locomotive No. 359 as it rolls along in the Vancouver, Washington, freight yard on the way to the next switching chore. The Vancouver yard was vital to SP&S operations in the Columbia River Gorge. (Courtesy of Warren Wing.)

HORSE POWER. Two men working with horse teams are almost lost in the magnificent basalt rock formations of the Columbia River Gorge during construction of the right of way for the SP&S. These teams, working near Underwood, Washington, were clearing rock and dumping it over the side to prepare for the laying of track. The SP&S was built between Portland, Oregon, and Spokane, Washington, in 1907–1908. (Courtesy of the Gorge Heritage Museum.)

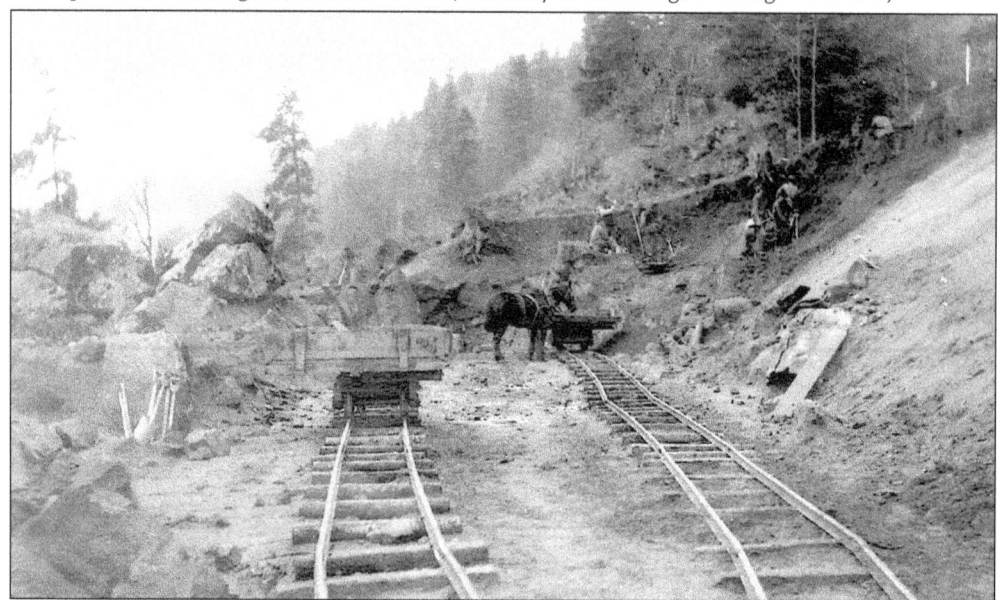

THE OLD-FASHIONED WAY. Using picks and shovels, along with strong hands, strong backs, and a helpful mule, a construction crew works on the Spokane, Portland & Seattle roadbed at Underwood in 1907. The line would officially open on March 11, 1908. The SP&S route was the dream of James J. Hill, who also controlled the Great Northern and the Northern Pacific railroads. Hill built the SP&S line to protect his business interests in the Pacific Northwest. The Northern Pacific and the Great Northern shared construction costs and ownership of the SP&S line. (Courtesy of the Gorge Heritage Museum.)

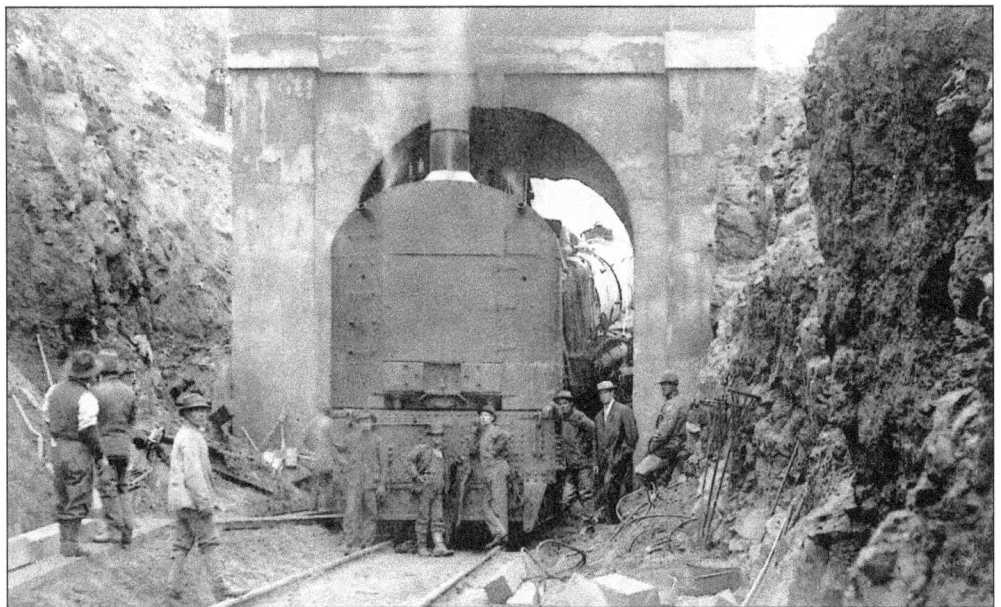

TUNNEL BUILDERS. Construction crews work to complete one of the tunnels on the SP&S mainline. This crew is boring through rock west of Underwood, one of 11 tunnels on the SP&S line between North Dalles (Milepost 93.3) and Washougal (Milepost 28.9). The longest (2,382 feet) was the Cape Horn tunnel at Milepost 34.7 near Prindle; the shortest was the Drano Tunnel (122 feet) at Milepost 67.6 near Cooks. (Courtesy of the Gorge Heritage Museum.)

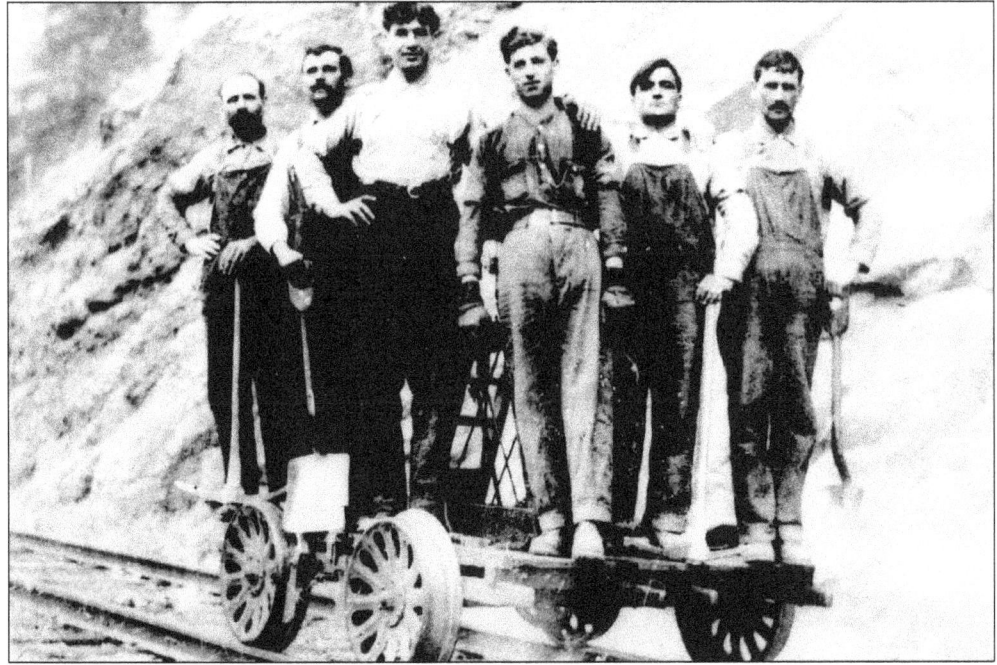

IN THE BEGINNING. Track foreman Gust Melonas, third from left, poses with an all-Greek section crew at Stevenson, Washington, in 1908. This crew was involved in the building of the Spokane, Portland & Seattle Railway through the Columbia River Gorge. James J. Hill was reported to have partaken of Greek food with Melonas's crews on several occasions. (Courtesy of Gus Melonas.)

51

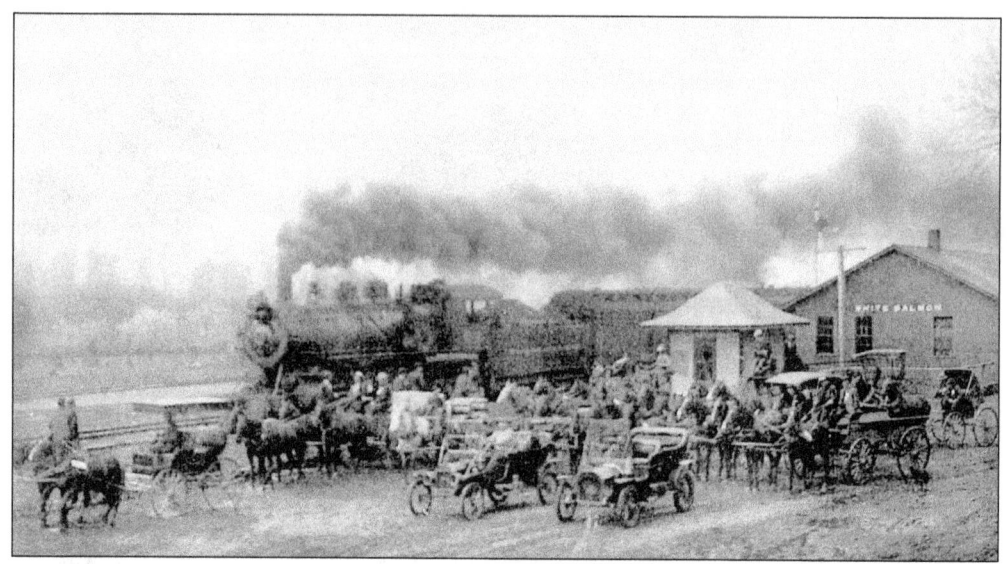

FIRST TRAIN TO WHITE SALMON. Putting out heavy smoke, a passenger train arrives at the Spokane, Portland & Seattle Railway station in White Salmon (Bingen), Washington, on the line's inaugural run in March 1908. The train was greeted by many local residents, some in horse-drawn wagons and others traveling in that era's innovative new carriage known as the automobile. (Courtesy of the Gorge Heritage Museum.)

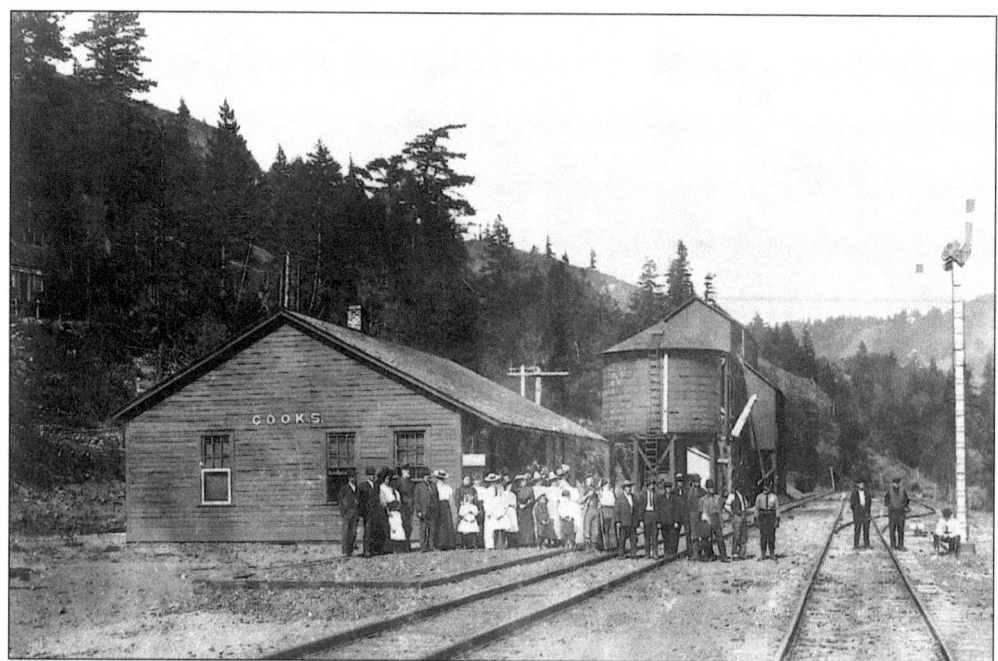

A CROWD AT COOKS. Citizens gather on the platform and along the tracks at Cooks, Washington, an SP&S station near Milepost 65. There are no longer any significant railroad structures at Cooks, but a passing siding remains in heavy use here. (Courtesy of the Gorge Heritage Museum.)

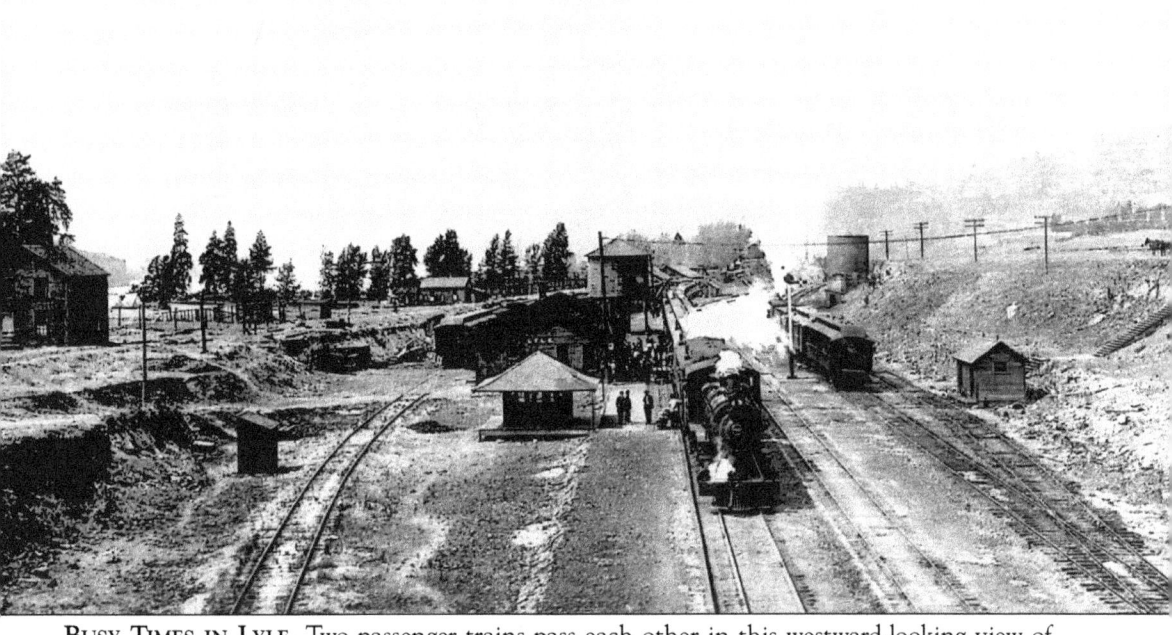

BUSY TIMES IN LYLE. Two passenger trains pass each other in this westward-looking view of Lyle, Washington, on the SP&S mainline. Note the depot on the left and the signal tower on the right, both long gone, as is the water tank in the middle of this photograph. The Columbia River & Northern Railroad completed a feeder line from Lyle to Goldendale in April 1903—and then had to wait five years until the SP&S came through to provide it with an outlet. With the arrival of the SP&S, Lyle was to become a vital shipping point for sheep and wheat. (Courtesy of the Gorge Heritage Museum.)

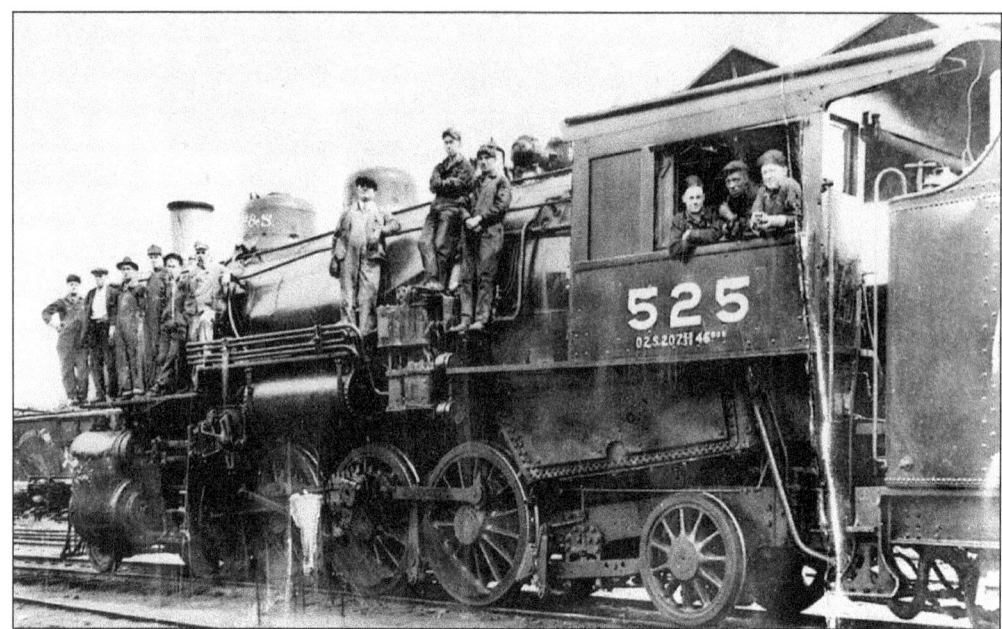

ON THE GOLDENDALE LINE. Train crew members and yard workers pose on Spokane, Portland & Seattle No. 525, a 2-8-2 locomotive built by the Schenectady Locomotive Works in 1910, in this undated scene from Goldendale, Washington, at the end of the Goldendale Branch. The SP&S purchased the 42-mile Columbia River & Northern Railroad line that ran from Lyle to Goldendale in March 1908, after the SP&S mainline through the gorge was completed. SP&S roster information shows that locomotive No. 525 was purchased from the Northern Pacific; it was scrapped in 1947. (Courtesy of Alex Chisholm.)

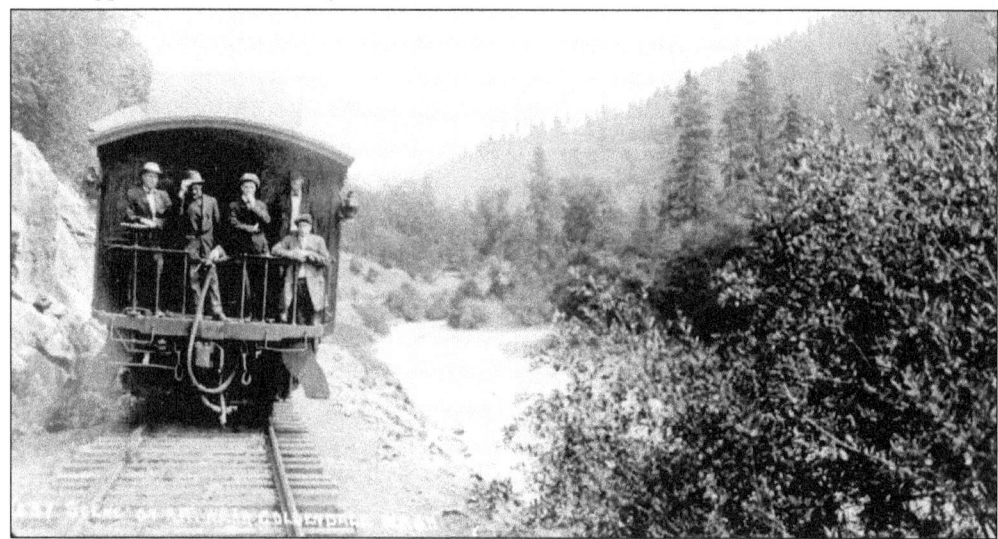

SLOW RIDE. Passengers relax on the rear platform of an SP&S passenger train rocking north to Goldendale on the Goldendale Branch in a scene from the 1920s. In that era, SP&S operated a daily passenger train from Portland to Goldendale and back. This schedule continued for several years, until the highway opened between Klickitat and Lyle and automobile travel became a more attractive option. To the right of the tracks is the scenic Klickitat River. (Courtesy of Ken Marvel.)

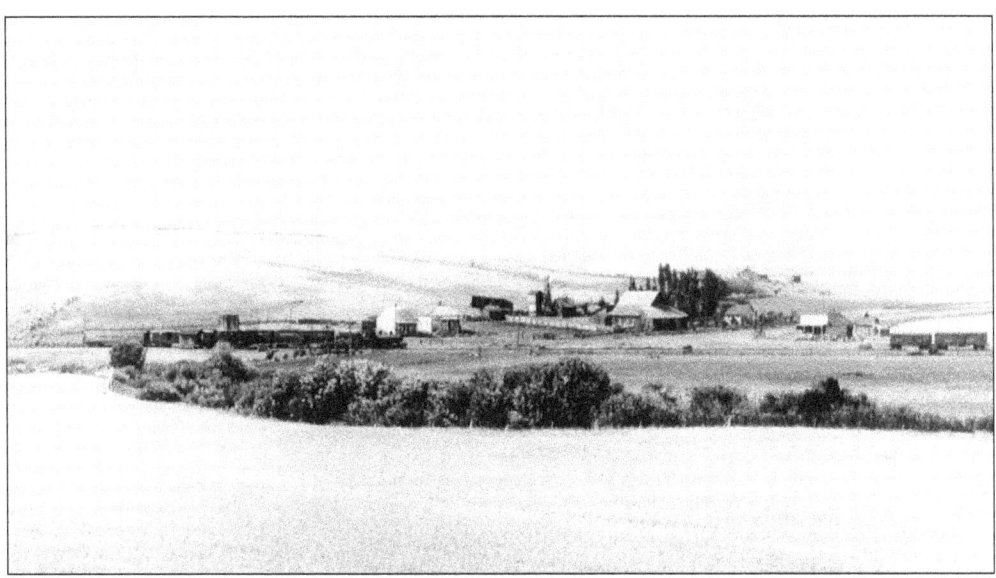

PASTURES OF PLENTY. This view looks toward Centerville, Washington, on the SP&S branch from Lyle to Goldendale. Note the pair of boxcars on a siding at the right, while a mixed train that includes passenger cars as well as freight cars cuts across the landscape to the left. This town is approximately six miles west from the end of the branchline in Goldendale. The Goldendale Branch was the only SP&S branchline in Washington. (Courtesy of Ken Marvel.)

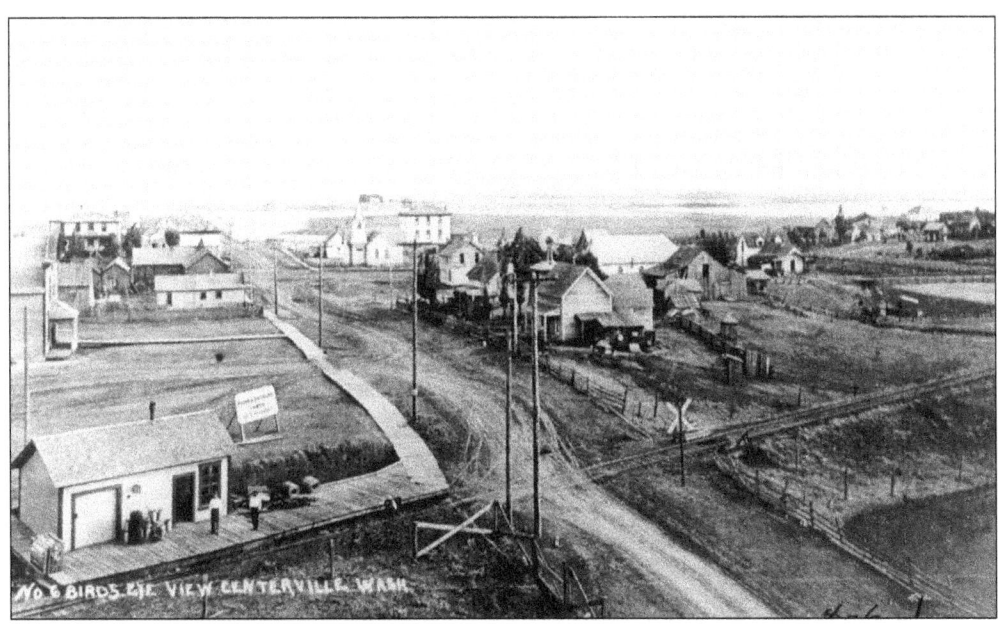

BUSINESS DISTRICT, CENTERVILLE. Here is a "bird's-eye view" of the heart of the community of Centerville, with the railroad tracks cutting through town. Note the wooden sidewalk, which parallels the muddy wagon road and turns into a platform for the small depot/freight station at the lower left. Centerville, at Milepost 35.9, was an important wheat growing region, especially in this era, which appears to be c. 1910. (Courtesy of Ken Marvel.)

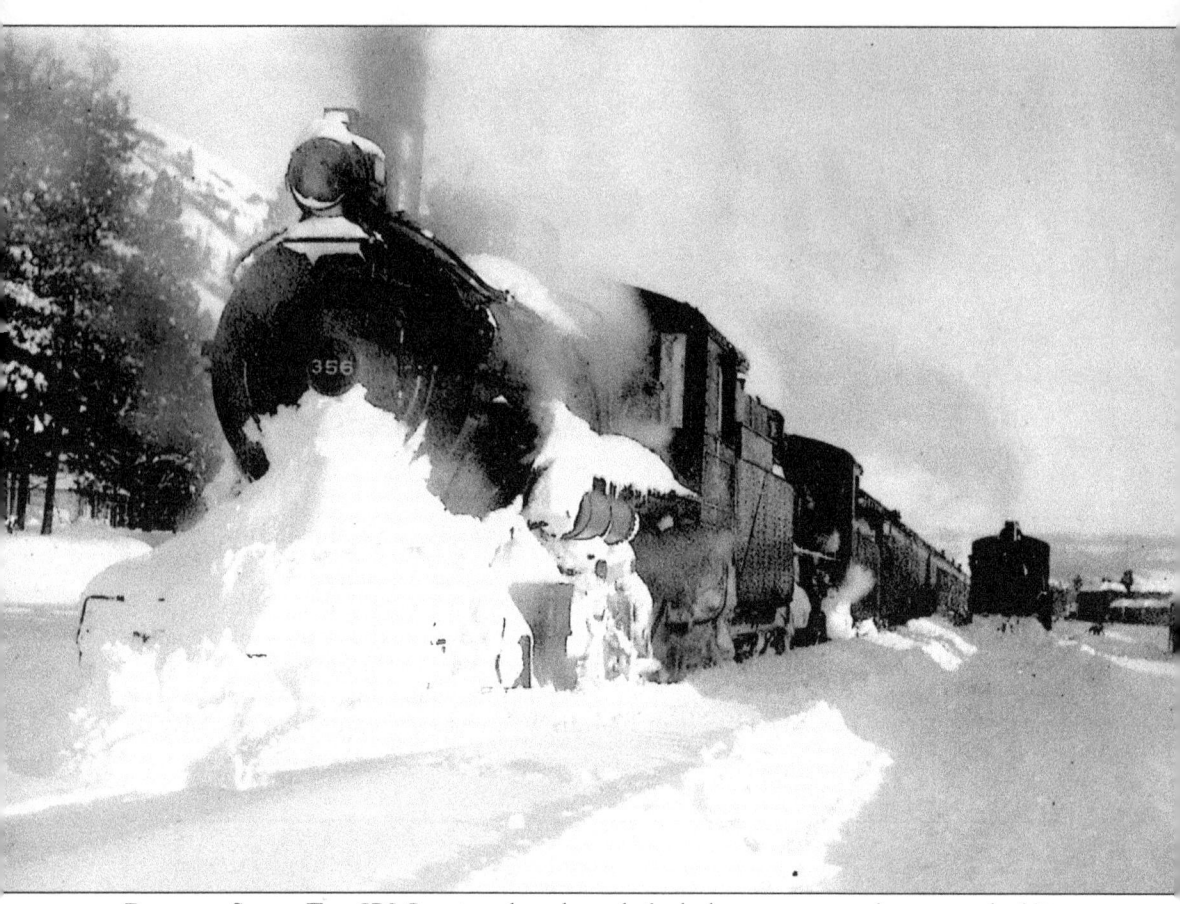

PUSHING SNOW. Two SP&S trains plow through fresh, heavy snow at the east end of Bingen, Washington, *c.* 1915. The locomotive leading the passenger train on the left is SP&S No. 356, an ex-Great Northern (GN No. 1260) 2-8-0 Baldwin built in 1907. SP&S No. 356 was scrapped in March 1954. Today Bingen remains an active station on Burlington Northern Santa Fe's Fallbridge Subdivision, with a small Amtrak depot still serving travelers and a long passing siding at the east end of town in frequent use. (Courtesy of the Gorge Heritage Museum.)

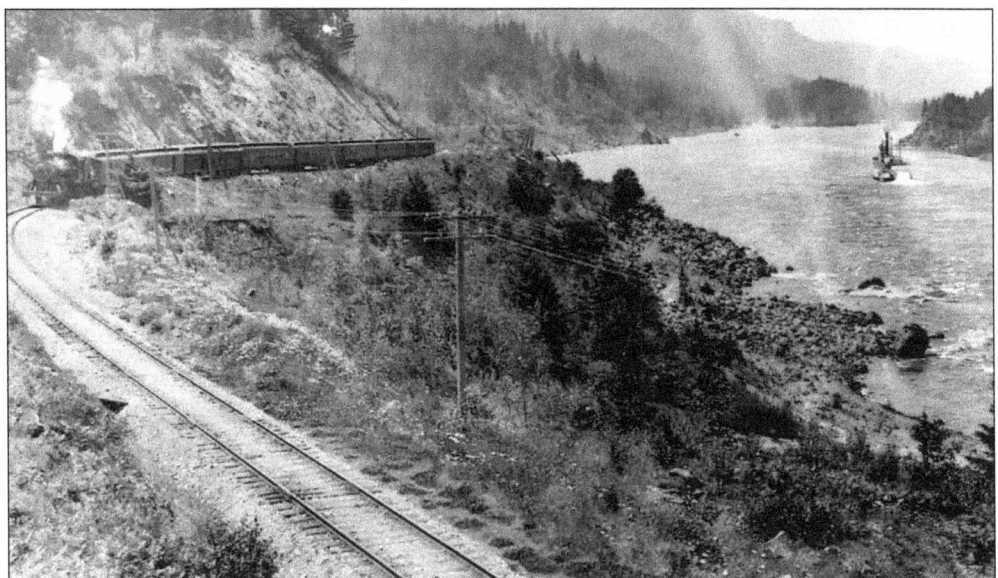

TWO WAYS TO TRAVEL. An SP&S passenger train moves west a few miles out of Stevenson, while a sternwheeler churns up the water as it heads east along the Columbia River. With the arrival of the railroads on both sides of the river, the importance of the sternwheelers for moving passengers and freight diminished, and most of the riverboats had ended service by 1917. (Courtesy of the Gorge Heritage Museum.)

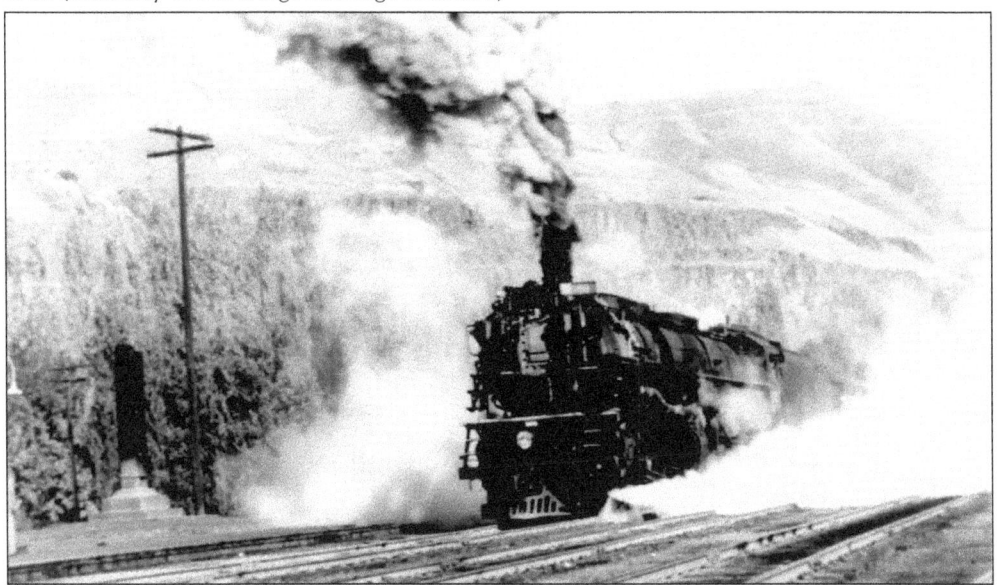

LEAVING WISHRAM. Creating its own clouds as it goes, SP&S No. 900, a Z-6 Challenger locomotive, built in 1937, pulls a westbound out of the yard at Wishram. As Keith McCoy explained in his book *Mid-Columbia North Shore*: "When the Northern Pacific and the Great Northern joined to bring the SP&S down the north side of the Columbia River in 1908, they needed a junction point which would serve the Oregon Trunk Line." A flat area that had served the Native Americans as a campsite at Celilo Falls was chosen as the place. The station was called Fallbridge until 1926, when it was renamed Wishram "in honor of the Indians who had lived there for generations." (Courtesy of D.C. Jesse Burkhardt.)

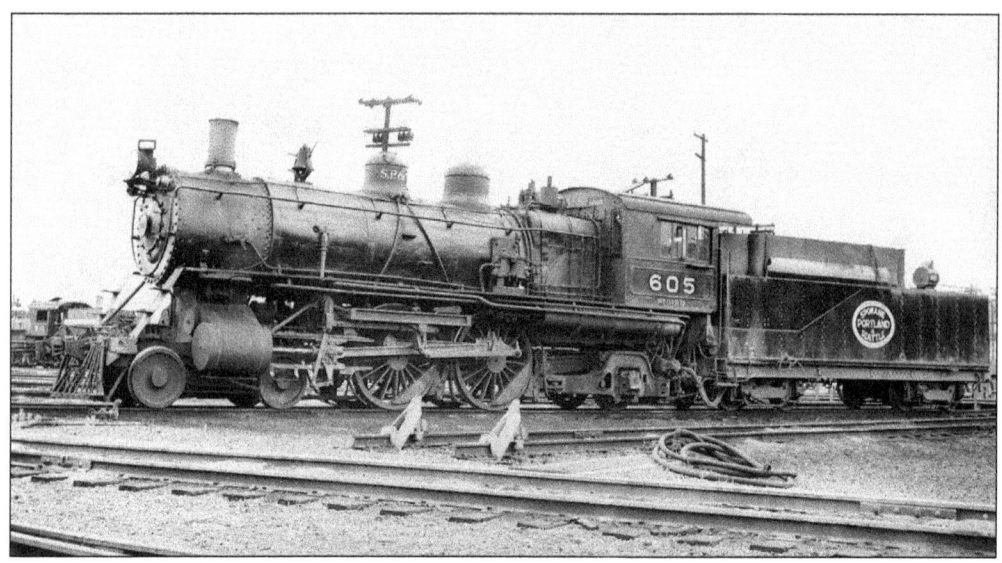

RESTING IN THE YARD. SP&S Atlantic-type locomotive No. 605, built by Baldwin in 1909, waits for its next assignment in Portland, Oregon, on June 5, 1947. According to SP&S records, No. 605 was scrapped in February 1949, less than two years after this shot was taken. (Courtesy of Warren Wing.)

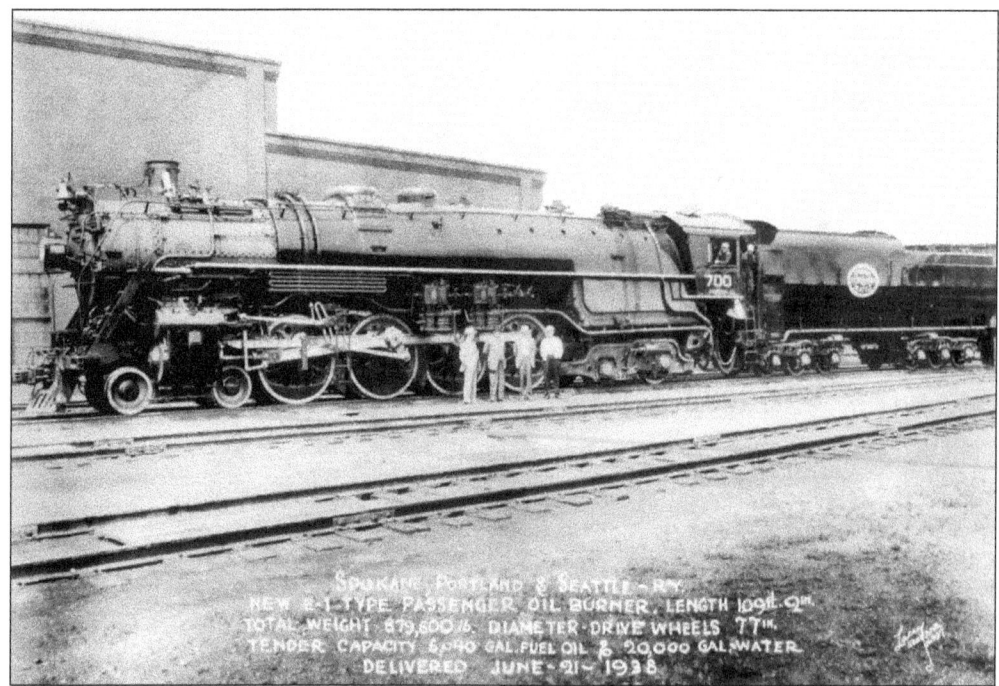

BIRTHDAY PICTURE. SP&S No. 700, an oil-burning locomotive designed to haul passenger trains, was fresh from the builder's shop as it posed for its "birthday" photo in 1938. According to the builder, Baldwin Locomotive Works, No. 700 was delivered to the SP&S on June 21, 1938, and was placed into fast passenger train service between Portland/Vancouver and Spokane. It was officially retired from service in 1956. The locomotive's driving wheels were as tall as a man. (Courtesy of D.C. Jesse Burkhardt.)

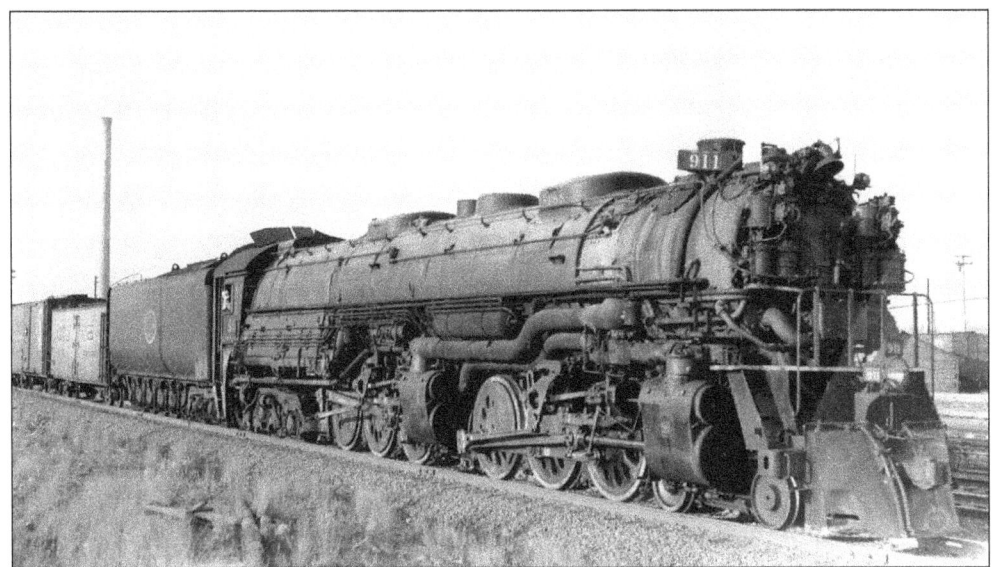

MOVING OUT. Long SP&S locomotive No. 911 (a 4-6-6-4 Alco built in 1944) leaves Spokane, Washington, en route to Portland via the Columbia River Gorge on August 19, 1949. The engineer, peering out the window at the driving wheels, is dwarfed by the massive machinery he is piloting out of the yard. Note the many wheels on the water tender, giving it the appearance of a caterpillar. (Photo by Warren Wing.)

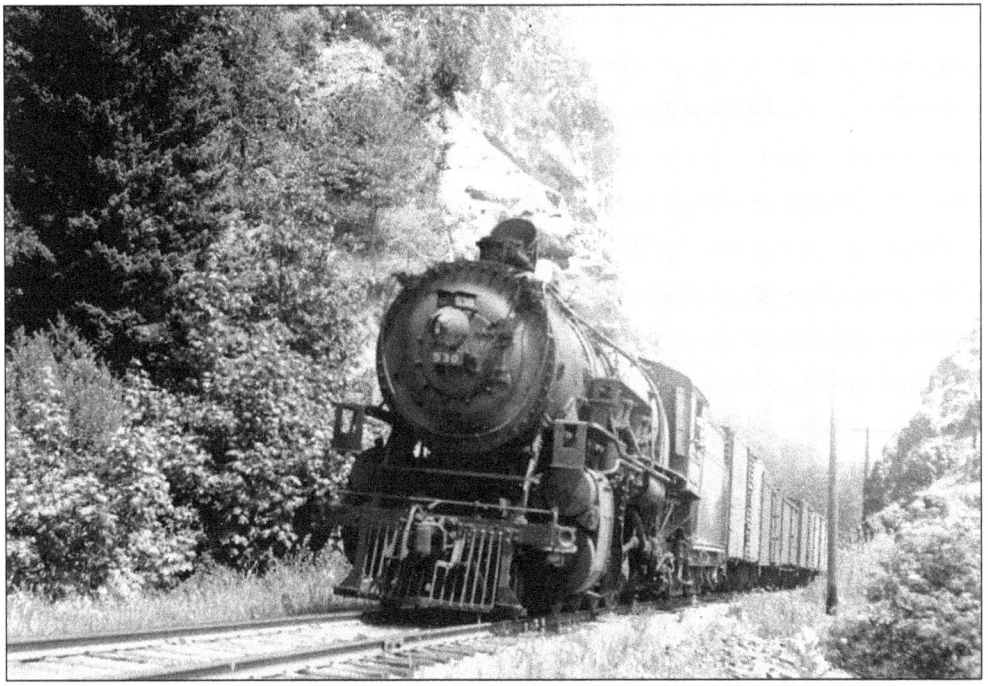

EASTBOUND DRAG. SP&S No. 530 cuts through the landscape east of Stevenson, Washington, on a dry, hot July 3, 1942. This mixed manifest freight train is headed by a 2-8-2 type locomotive, built by the Brooks Locomotive Company in 1917. The Brooks Company was based in Dunkirk, New York. In 1901, Brooks merged its operations with another locomotive builder to become part of the famed American Locomotive Company. (Courtesy of Warren Wing.)

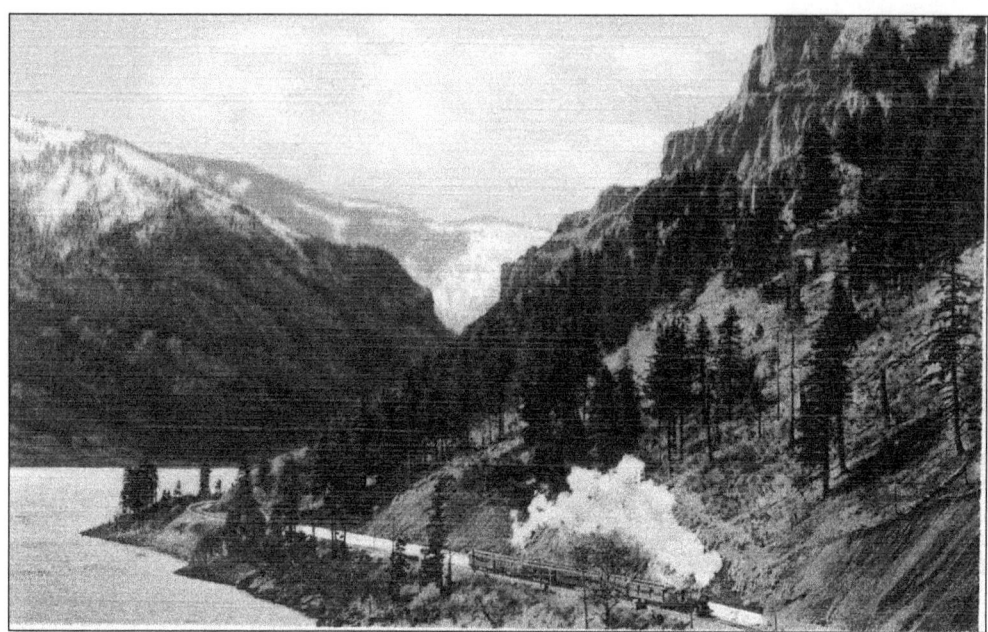

PROMOTIONAL LOOK. One of a series of SP&S promotional postcards touting the scenic values of the Columbia River Gorge. The caption on the reverse read simply: *"Between Spokane and Portland, along the Columbia River, through the Cascade Range."* The card was printed by Curt Teich & Company Inc., of Chicago. A 1¢ stamp was all that was required to mail the card within the United States. (Courtesy of D.C. Jesse Burkhardt.)

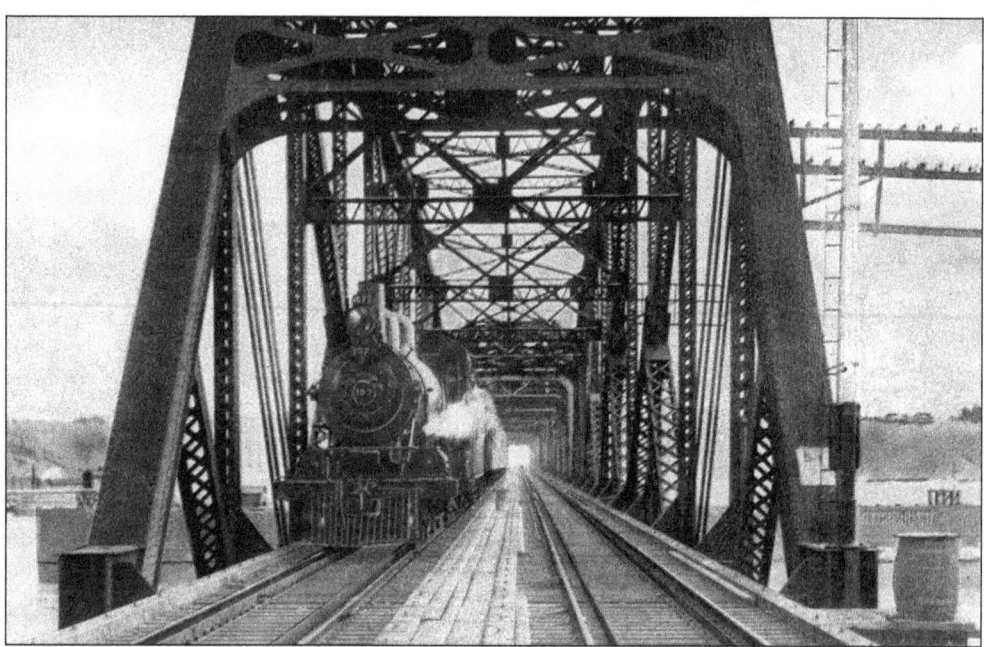

COLUMBIA RIVER SCENIC ROUTE. An SP&S passenger train crosses the double-tracked mainline bridge over the Columbia River into the freight yard at Vancouver, Washington, in this antique, colorized postcard. The train is coming north out of Portland, and will turn east for the run through the Columbia River Gorge from here. (Courtesy of D.C. Jesse Burkhardt.)

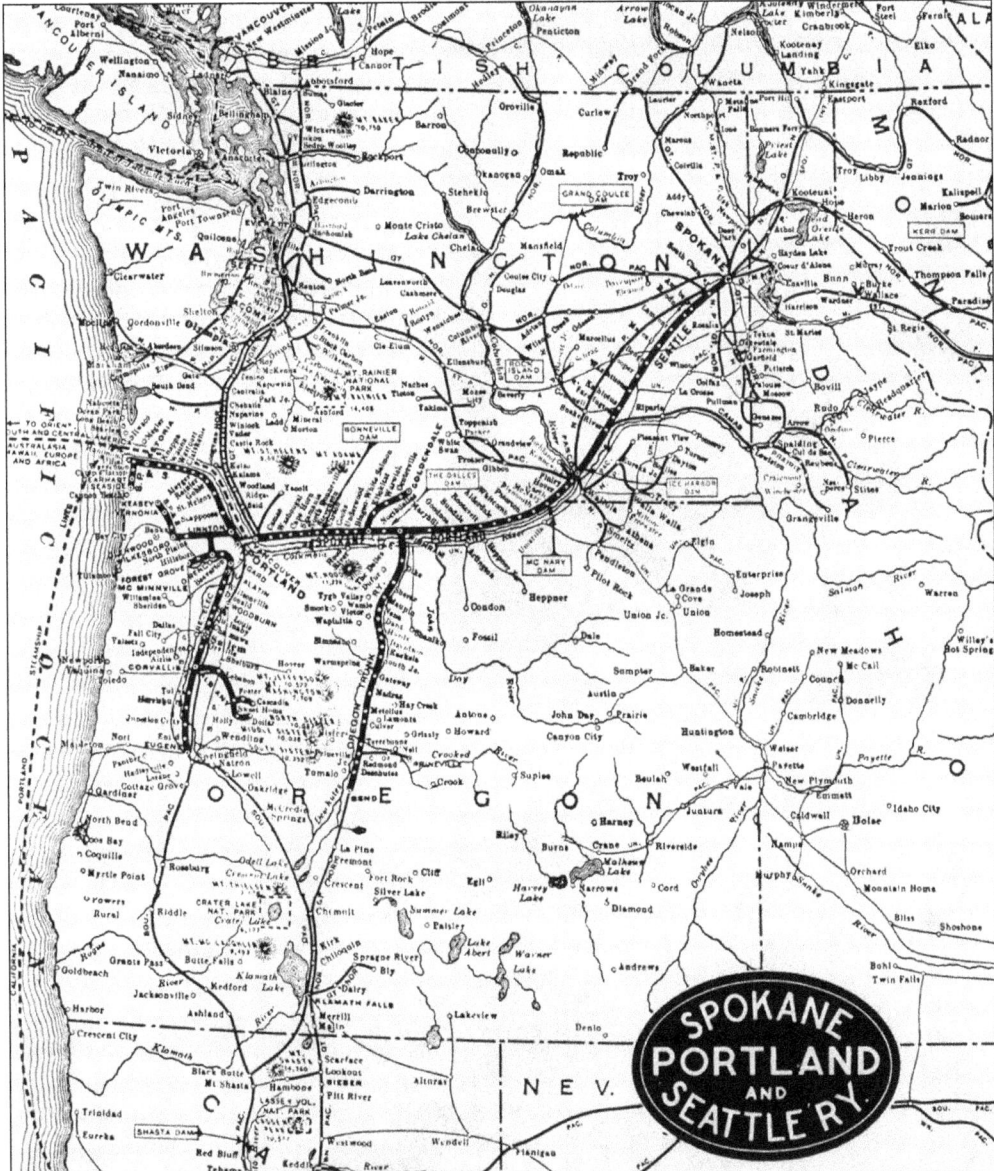

NORTHWEST SCENIC ROUTE. A map showing the lines of the Spokane, Portland & Seattle Railway in 1957. The Oregon Electric Railway in Oregon's Willamette Valley and the Oregon Trunk Branch between Wishram and Bend were part of the overall SP&S system. Despite the railroad's name, SP&S rails never reached into Seattle. The core of the railroad's mainline— from Portland to Spokane—stretched for about 375 miles. (Courtesy of Bill Manly.)

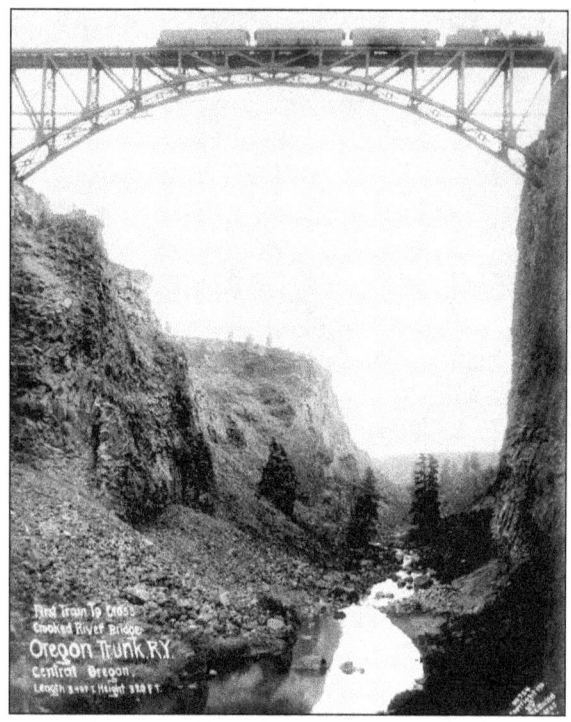

TRAIN IN THE SKY. James Hill craved rail access to California, and to get there he set his sights on a route south from Wishram, Washington, and along Oregon's Deschutes River. The Oregon Trunk Railway, an SP&S subsidiary, opened a 152-mile line from Wishram to Bend, Oregon, where it connected with a Great Northern line. This photo shows the first train to cross the 320-foot-high bridge over the Crooked River, north of Bend. A ceremony marking the opening of the route took place in Bend on October 5, 1911, with Hill driving in a golden spike. (Photo by O. Hedlund.)

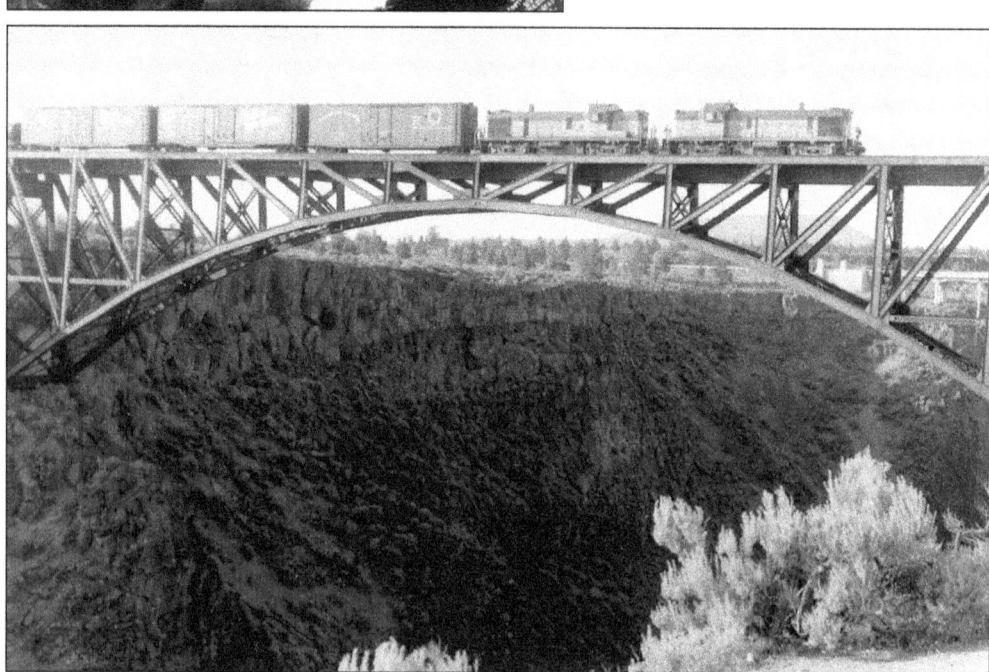

BOUND FOR KLAMATH FALLS. Running on the same bridge and in the same direction 56 years later, two SP&S Alcos pull a mixed manifest south in June 1967. During construction of the line to Bend, the Oregon Trunk and the Deschutes Railroad (a Union Pacific subsidiary) competed—sometimes violently—for the best rail route through the Deschutes River Canyon. The two railroads eventually agreed to share the track from Bend to Celilo, an agreement that continues to this day. (Courtesy of the National Railway Historical Society, Oregon Chapter.)

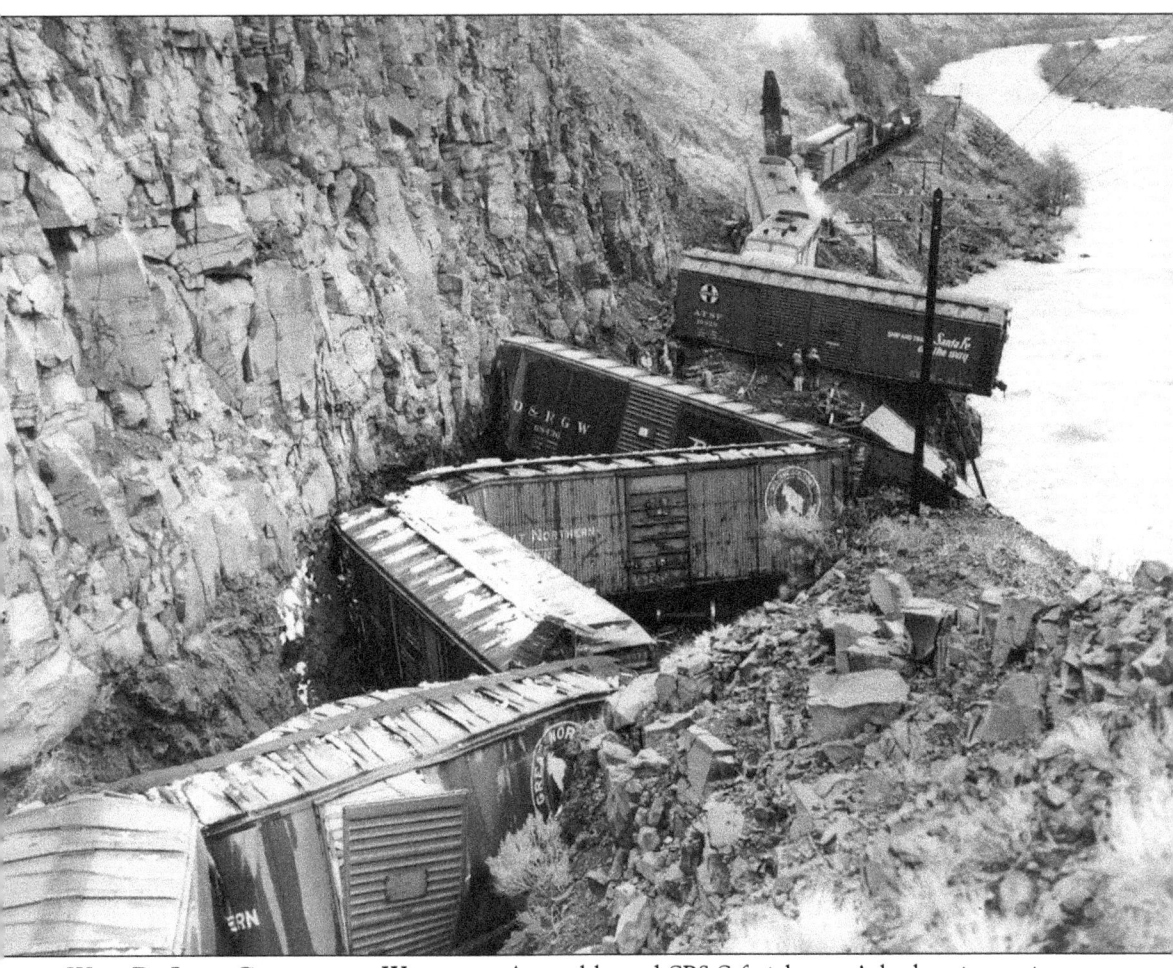

WILL BE LATE GETTING TO WISHRAM. A northbound SP&S freight won't be keeping to its schedule on this late 1950s day. This train, on its way from Klamath Falls, Oregon, to Wishram, Washington, went off the tracks near Oakbrook (Milepost 39) on the Oregon Trunk line. Because of the narrowness of the rock cut the train was passing through, the boxcars did not tip over, but rather wedged between the rocks, side to side in zigzag fashion. Note the finished lumber bursting from the sides of the torn boxcars. A diesel switcher has brought a crane down from the SP&S yard in Wishram to begin clearing the mess. (Courtesy of John Wood.)

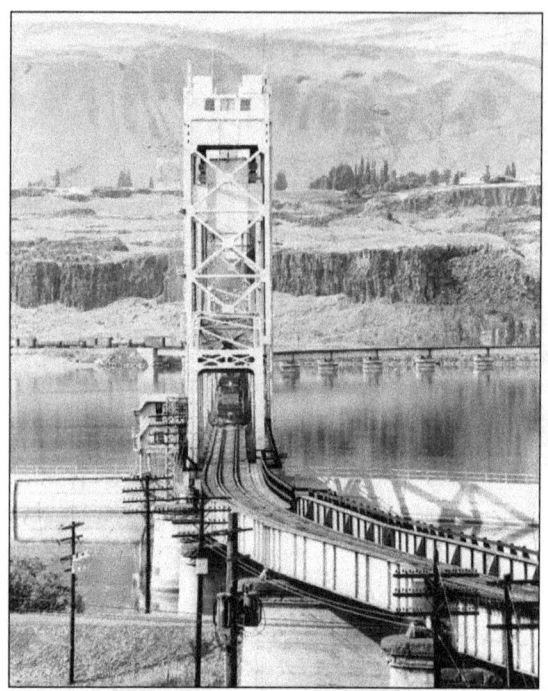

CALM RIVER. A mixed freight out of Vancouver, led by SP&S No. 4380, an Alco C636, comes over the Celilo drawbridge in August 1972 as it heads south onto the rails of the Oregon Trunk Subdivision, bound for Klamath Falls. The SP&S colors still were common at this time, but the reality was the SP&S was no more. It had been merged into the new Burlington Northern Railroad in March 1970. (Photo by Robert W. Johnston, courtesy of Walter Ainsworth.)

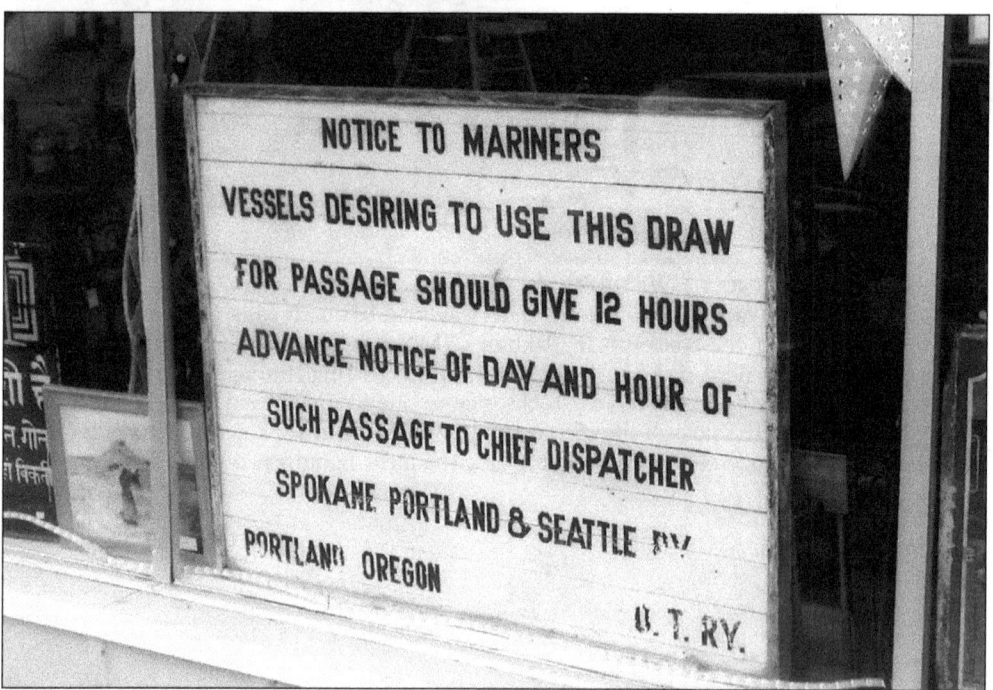

NOTICE TO MARINERS. This sign was once posted on the SP&S Columbia River drawbridge at Celilo, letting mariners know who was in charge and what lengths they would have to go to get to the other side of the railroad's river-blocking bridge between Wishram, Washington, and Celilo (O.T. Junction), Oregon. In the modern era, the drawspan is left open, and the bridge is closed only to accommodate the passage of trains. Decades after it was relevant, this sign ended up here, in an antique store in Bingen, Washington. (Photo by D.C. Jesse Burkhardt.)

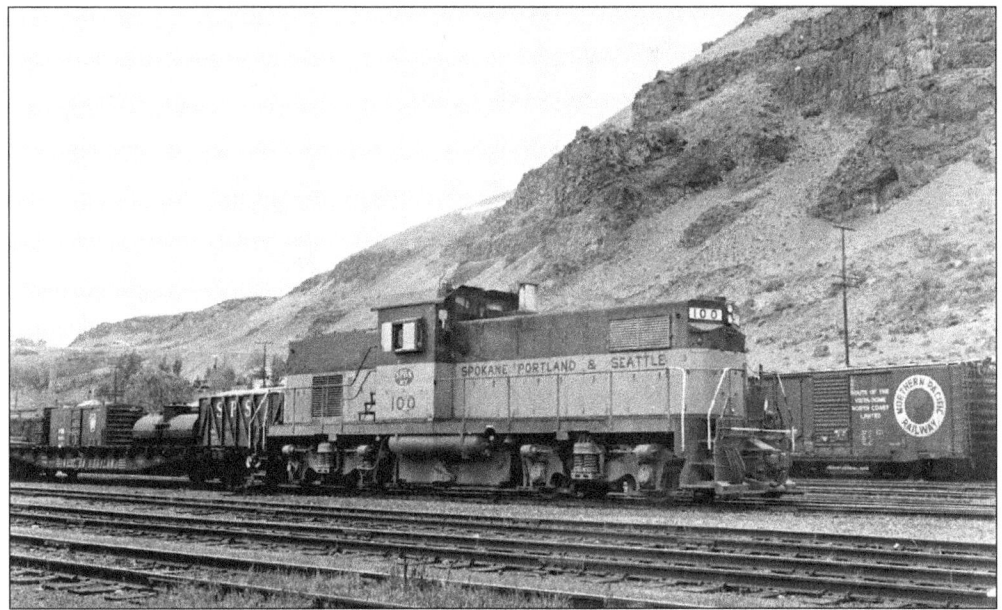

WORKING THE YARD. With the magnificent rocky cliffs towering overhead, SP&S No. 100, an Alco C415, handles switching duties at Wishram in April 1970. SP&S originally maintained its yard and locomotive roundhouse at Cliffs, about 12 miles to the east, but when the Oregon Trunk Railway built south in 1911, the roundhouse and related facilities were relocated to Wishram. Yard switching operations at Wishram ceased in August 1981, and on November 1, 1994, Burlington Northern eliminated Wishram as a crew-change terminal for train crews working between Vancouver and Pasco. (Courtesy of Warren Wing.)

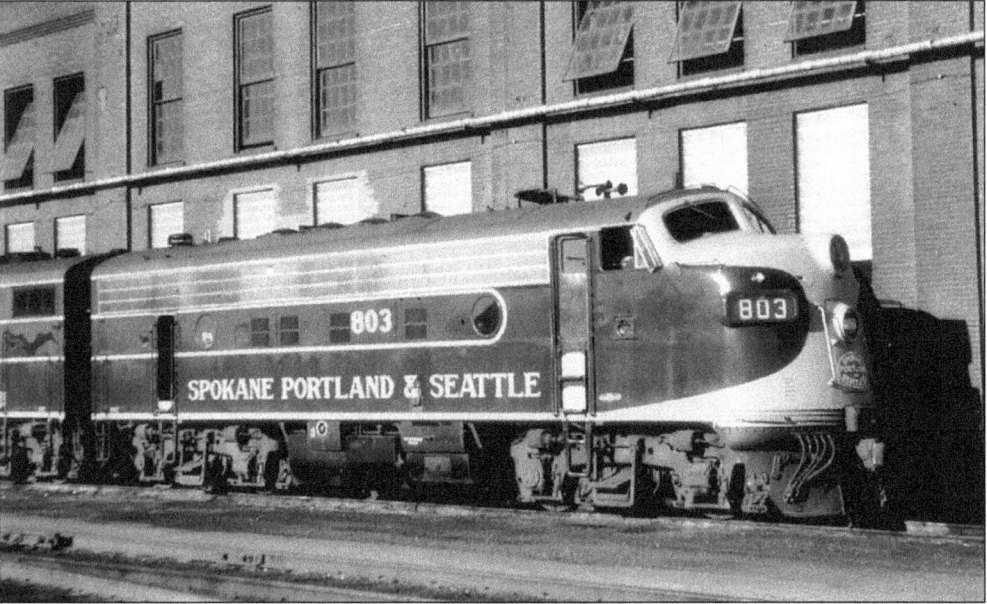

SMOOTH LINES. Looking relatively clean and fresh, SP&S No. 803, an F7A, idles alongside the locomotive roundhouse in Spokane, Washington, in July 1961. The F7s generally handled passenger trains, although that policy changed as the units aged, passenger trains were fewer, and the company needed to move freight. (Courtesy of Dan Work.)

SCHEDULE CHANGES. A newspaper advertisement from *The White Salmon Enterprise* (White Salmon, Washington) in the summer of 1928 announces changes to the railroad's passenger train schedules through the Columbia River Gorge as they applied to train times at the Bingen-White Salmon depot. Note the misspelling of "White Salmon"; someone was asleep at the switch when reading this ad proof. (Courtesy of *The White Salmon Enterprise*.)

LOW FARES ALL SUMMER. Another SP&S advertisement, this one promoting the railroad's passenger train service, complete with round-trip prices to a list of selected locations, appeared in *The White Salmon Enterprise* on May 22, 1969. (Courtesy of *The White Salmon Enterprise*.)

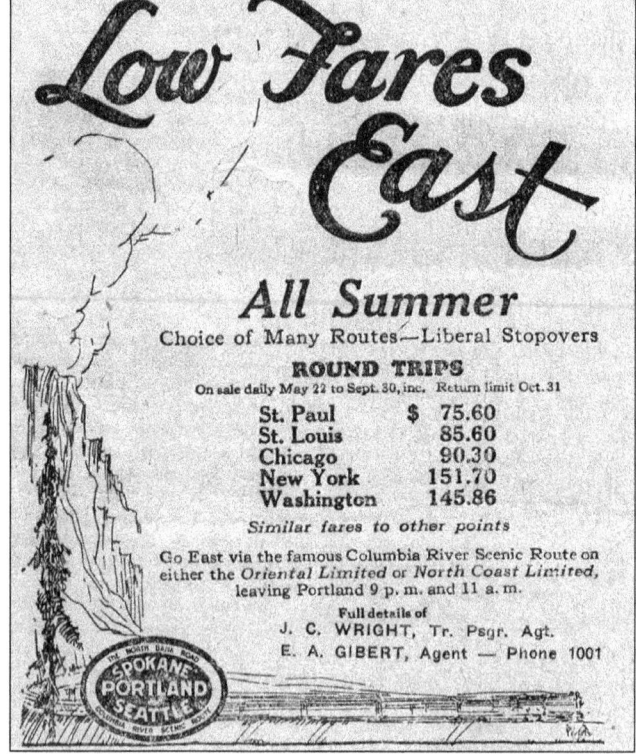

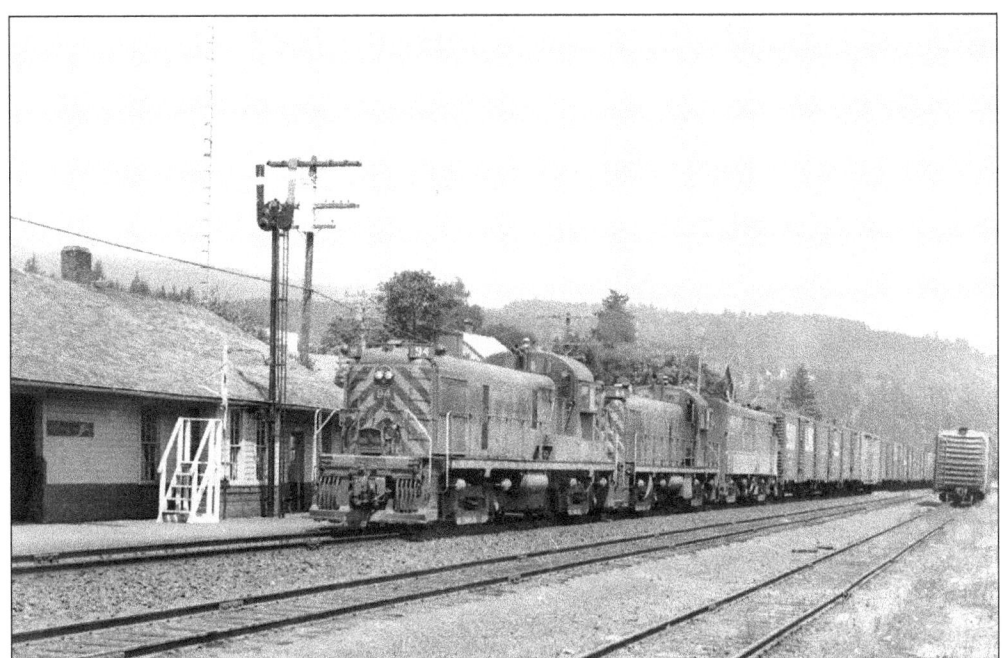

A Pause in Stevenson. A westbound freight—powered by SP&S Alco RS3s No. 94 and No. 64, along with an Alco FA unit—pauses at the depot in Stevenson, Washington, during a run to Vancouver with a long cut of boxcars in August 1965. (Photo by Robert W. Johnston.)

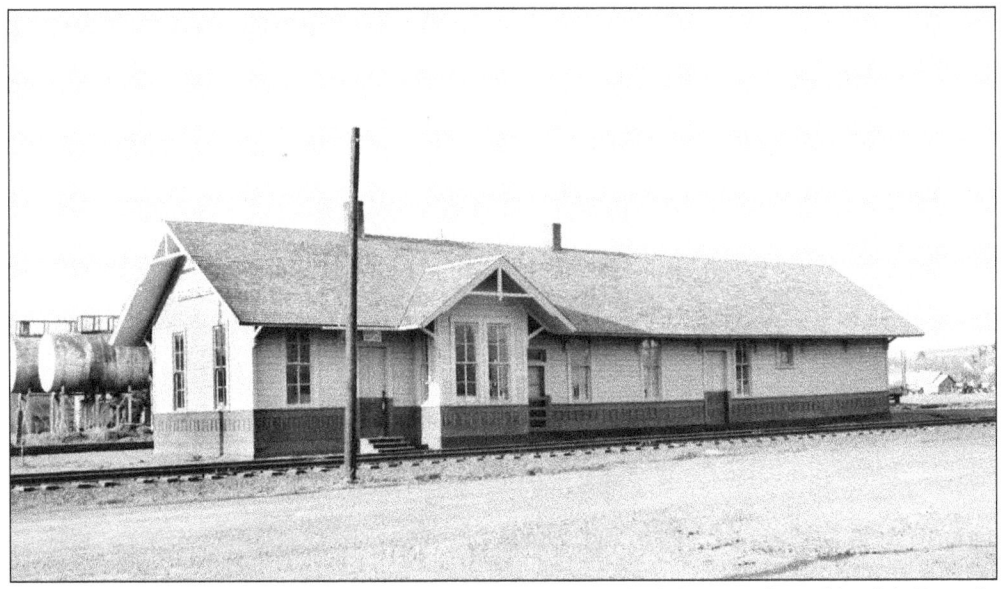

Goldendale Station. This is the SP&S station at the end of the 42-mile Goldendale Branch, as seen in July 1969. The large, well-built station shows the importance the building once had to passengers and freight shippers of the community, which is the county seat for Klickitat County. Note the small "freight station" sign above the doorway. The tracks of the Goldendale Branch were pulled up in 1992. (Photo by Robert W. Johnston, courtesy of Walt Ainsworth.)

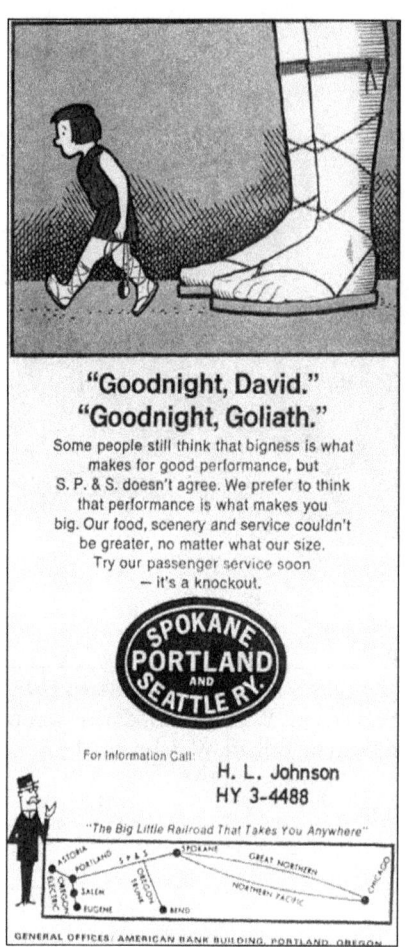

"Goodnight, David."
"Goodnight, Goliath."

Some people still think that bigness is what
makes for good performance, but
S. P. & S. doesn't agree. We prefer to think
that performance is what makes you
big. Our food, scenery and service couldn't
be greater, no matter what our size.
Try our passenger service soon
— it's a knockout.

For Information Call:
H. L. Johnson
HY 3-4488

"The Big Little Railroad That Takes You Anywhere"

GENERAL OFFICES: AMERICAN BANK BUILDING, PORTLAND, OREGON.

DAVID AND GOLIATH. This SP&S ad reminded
the traveling public and Northwest shippers that
operating over a relatively small geographic area was
not a drawback. It also provided a map that showed its
important connection partners—Great Northern and
Northern Pacific. The local telephone number in the
ad recalls an era when almost every town had its own
railway agent close at hand to call on for shipping
needs or to arrange a trip somewhere. This appeared
in *The White Salmon Enterprise* in 1968. (Courtesy of
The White Salmon Enterprise.)

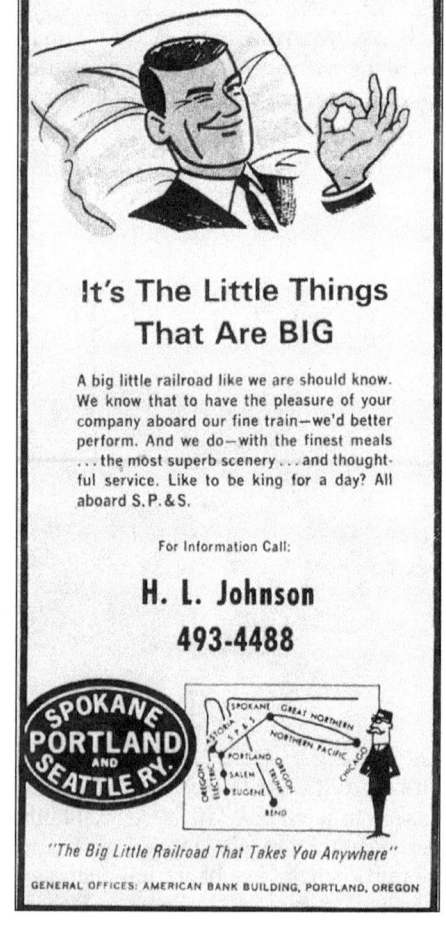

It's The Little Things
That Are BIG

A big little railroad like we are should know.
We know that to have the pleasure of your
company aboard our fine train—we'd better
perform. And we do—with the finest meals
...the most superb scenery...and thought-
ful service. Like to be king for a day? All
aboard S. P. & S.

For Information Call:

H. L. Johnson
493-4488

"The Big Little Railroad That Takes You Anywhere"

GENERAL OFFICES: AMERICAN BANK BUILDING, PORTLAND, OREGON

LITTLE THINGS. SP&S maintained an aggressive
advertising campaign in community newspapers
in the Columbia River Gorge. This ad, from *The
White Salmon Enterprise*, June 22, 1967, brags about
the railroad's fine meals and superb scenery. Note
the clever slogan, "The Big Little Railroad That
Takes You Anywhere." (Courtesy of *The White
Salmon Enterprise.*)

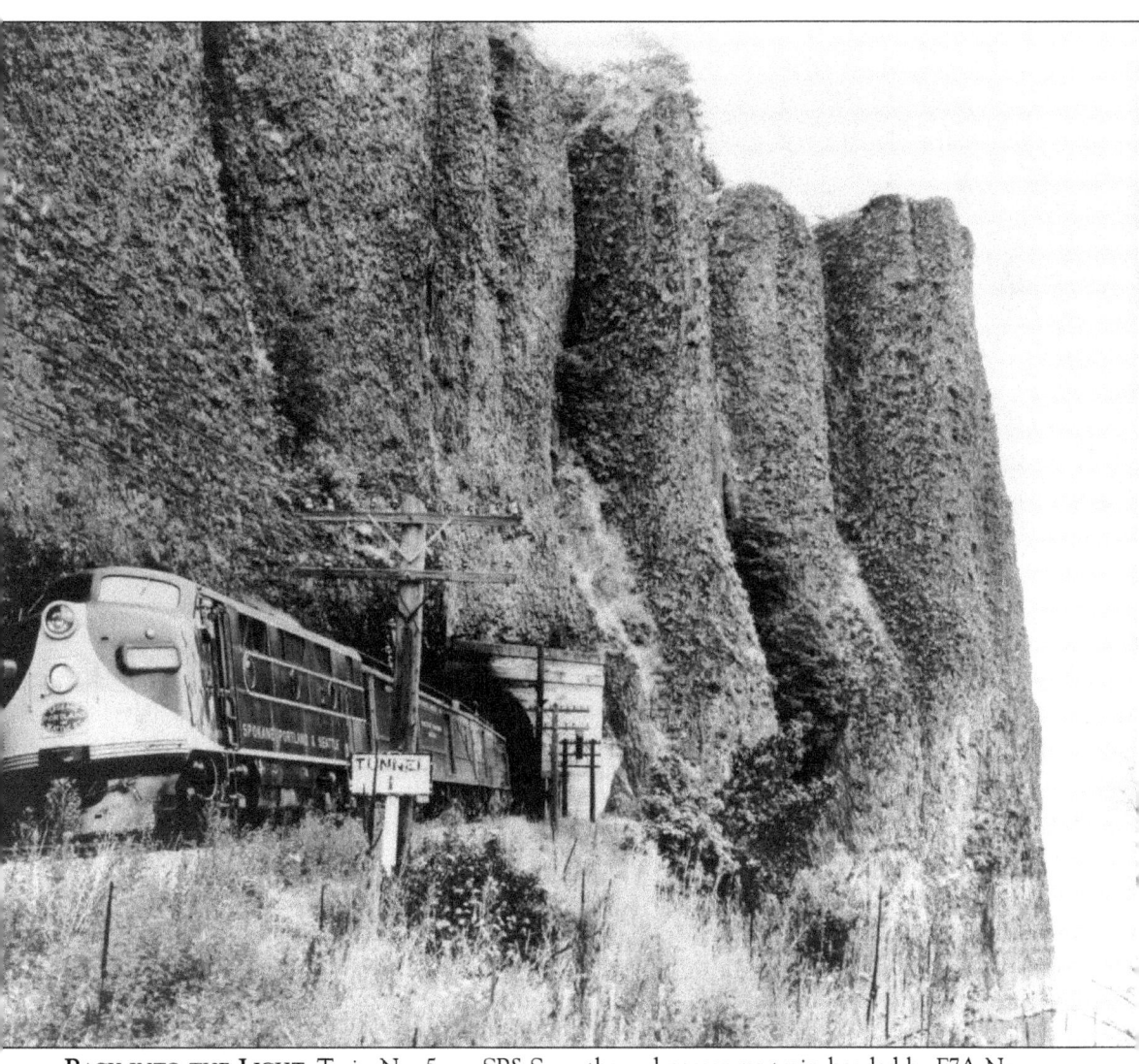

BACK INTO THE LIGHT. Train No. 5, an SP&S westbound passenger train headed by F7A No. 800, bursts out of the magnificent rocky landscape surrounding Tunnel No. 1, the Cape Horn tunnel, on its way to Portland from Spokane. The first two cars behind the solo locomotive are Railway Express Agency cars. This tunnel, at Milepost 34.7, is 2,382 feet in length and is the longest tunnel on what is now Burlington Northern Santa Fe Railway's Fallbridge Subdivision. (Courtesy of the Oregon Historical Society, #OrHi58229.)

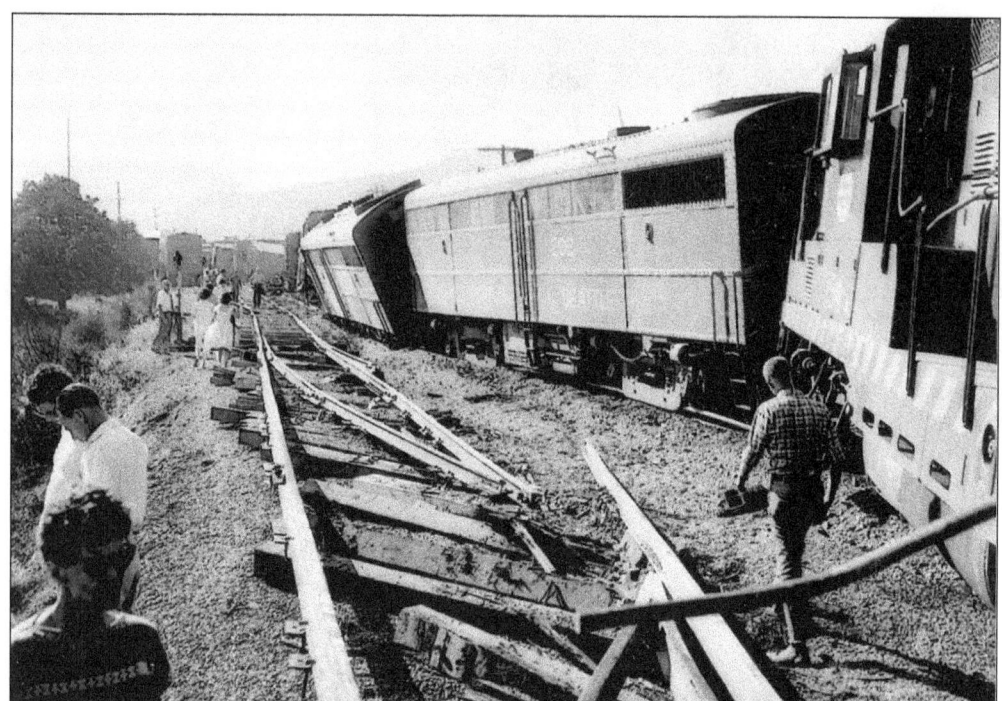

PILEUP IN BINGEN. According to local historian Keith McCoy, this accident in July 1961 occurred when a log truck was crossing the SP&S tracks in Bingen. The cab of the truck got across the tracks before an eastbound freight—alleged to be traveling at 72 mph instead of the authorized speed limit of 60 mph—hit the logs behind the cab and derailed. Boxcars piled up in a heap on both sides of the tracks. (Courtesy of *The White Salmon Enterprise.*)

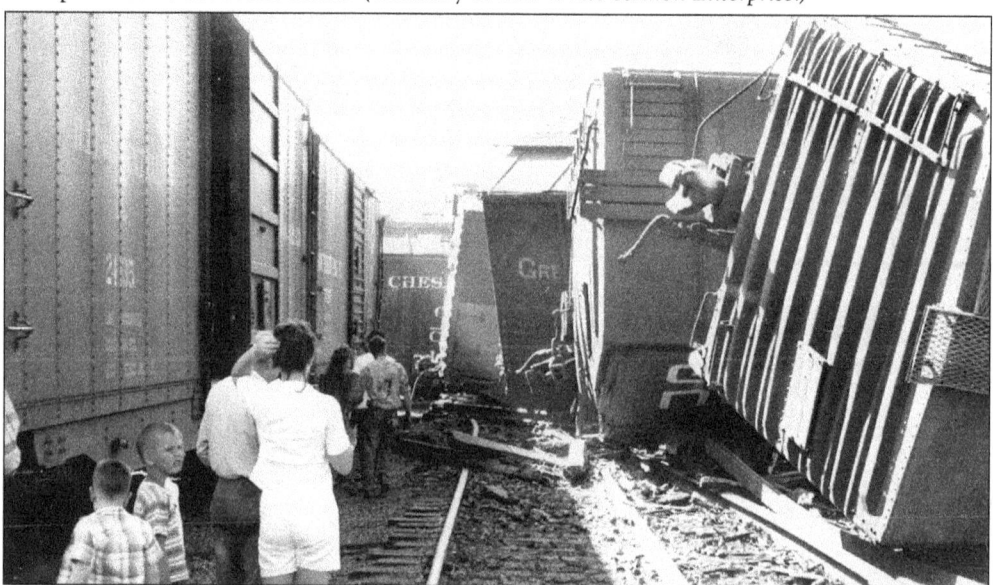

SIGHTSEEING. Local residents flocked to the derailment scene to get a close-up look at the dramatic landscape of carnage caused by the high-speed train-truck collision. Even a mother and her young boys strolled among the hulks of overturned boxcars soon after the wreck happened. (Photo by Bob Towers.)

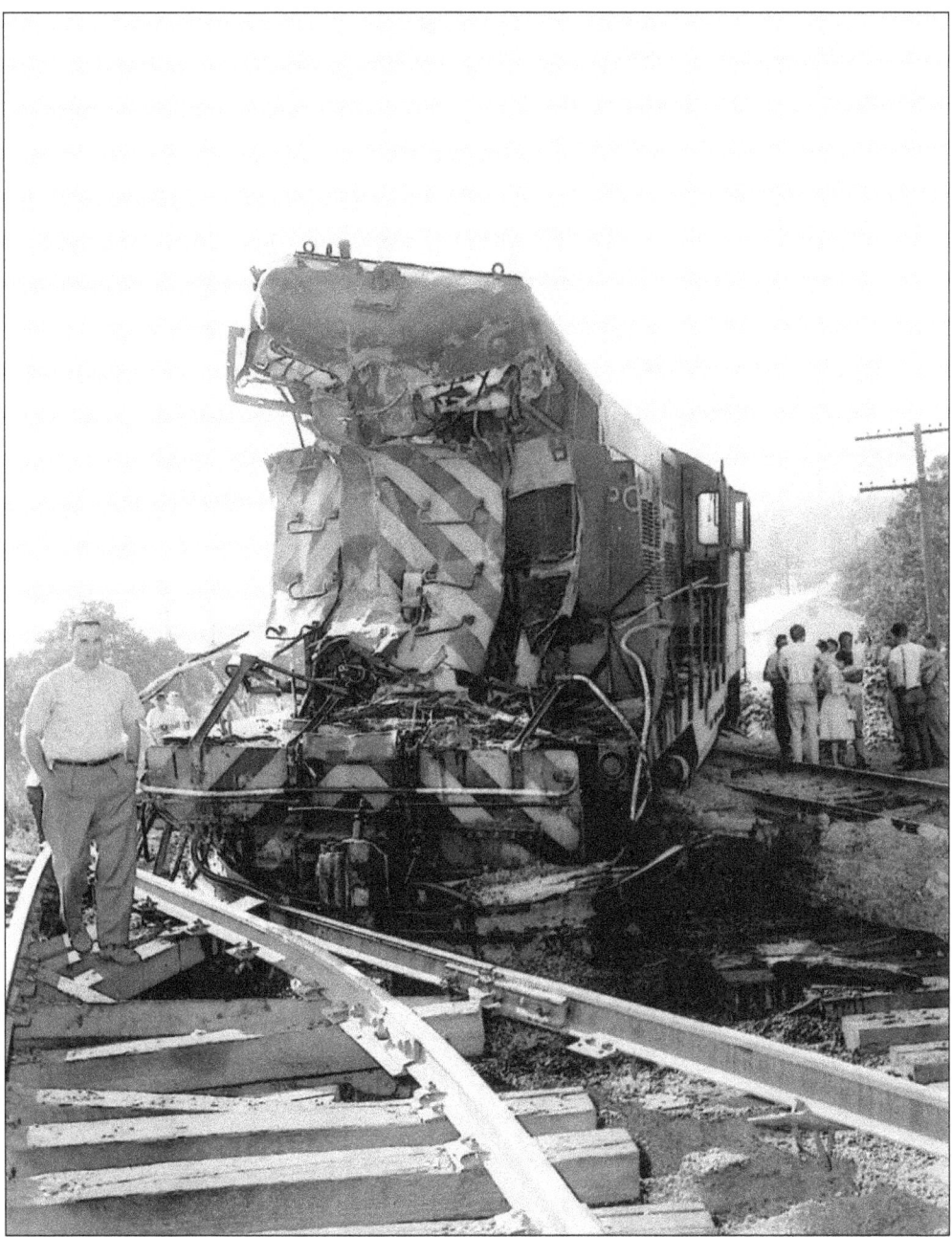

TAKING THE HIT. This is what was left of SP&S No. 154, a GP9 diesel that was the lead unit on the freight that slammed into the log truck on the crossing. The heavy logs left quite an impression on the steel face of this locomotive, and the crew was fortunate to have escaped injury. Again note the many curious onlookers uninhibitedly inspecting the scene. It's safe to say that No. 154 and a number of boxcars—23 cars left the tracks—were slated for scrap after this day's mishap. Somehow, no one was seriously hurt in the pileup, not even the unwise truck driver. (Courtesy of *The White Salmon Enterprise.*)

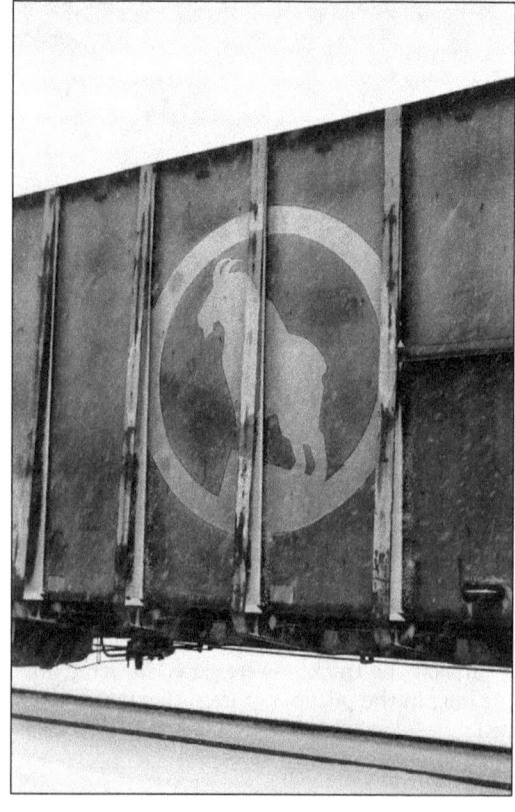

GET YOUR ORDERS HERE. Train orders are hooped up to the crew in Great Northern No. 310A as it leads a southbound freight past the Vancouver passenger station. The Vancouver terminal, operated by the SP&S, was the gateway to the Washington side of the Columbia River Gorge. The SP&S's diesels were serviced in Vancouver, and a huge amount of traffic was interchanged here with Great Northern, Northern Pacific, Union Pacific, and the Milwaukee Road. (Photo by Gil Hulin.)

GREAT NORTHERN. The classic "Rocky Mountain Goat" logo of Great Northern Railway was once a common sight on trains moving through the Columbia River Gorge, and even in the modern era, the classic GN logo is still seen on some freight cars. This woodchip car—weathered, but in surprisingly good shape after at least 35 years—was moving east through the snow at Bingen, Washington, in January 2004. (Photo by D.C. Jesse Burkhardt.)

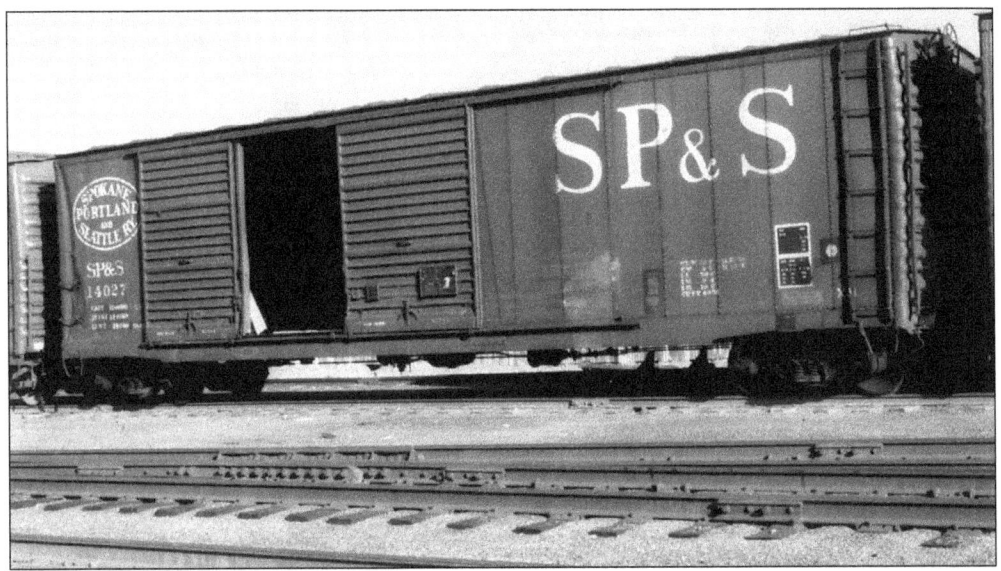

ROLLING BILLBOARD. SP&S No. 14027, a 50-foot double-door boxcar, was representative of a fleet of boxcars that were once frequently seen in freight yards all across the nation, particularly in the Pacific Northwest, in the 1960s and 1970s. Note the bold SP&S billboard lettering and the endearing oval logo on the left side of the car. (Photo by Michael Whiteman.)

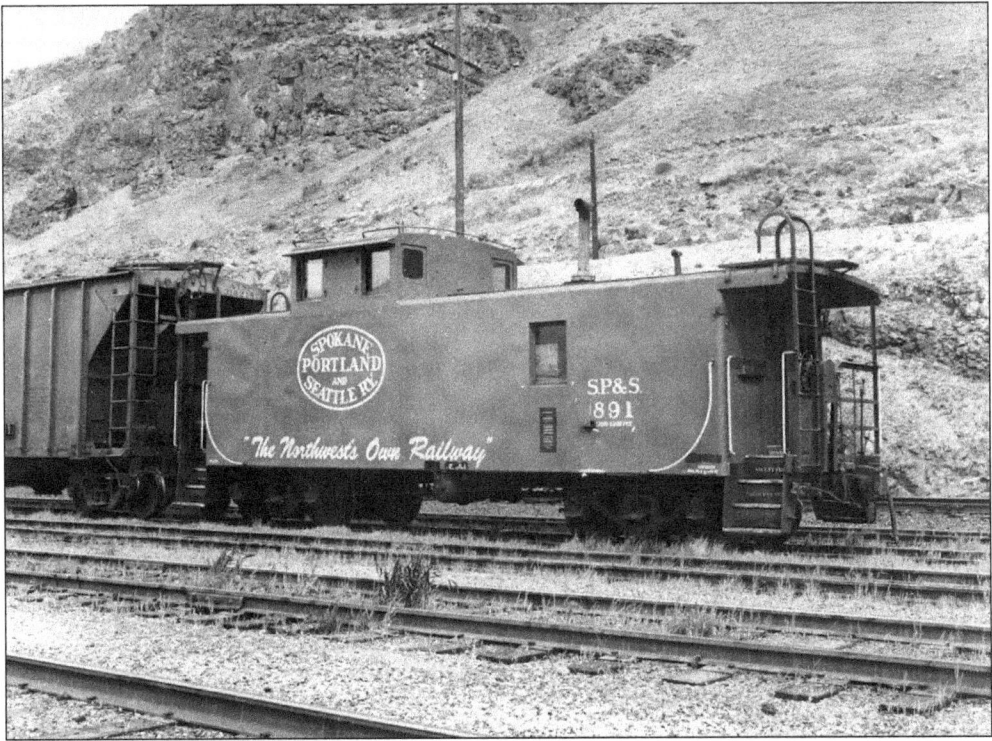

THE NORTHWEST'S OWN. SP&S caboose No. 891, built by Pullman-Standard of Hammond, Indiana, shows off the railroad's proud slogan, "The Northwest's Own Railway," as it waits at the rear of a westbound freight in Wishram, Washington, in April 1970. This series of SP&S cabooses was patterned after the style Northern Pacific used. (Photo by Robert W. Johnston.)

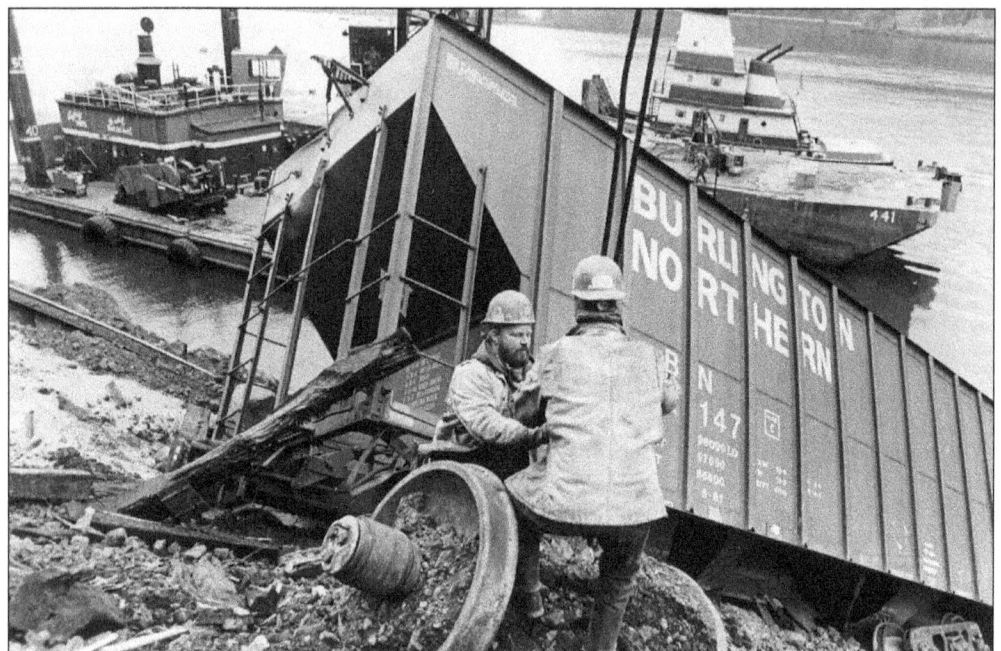

ATTACH HERE. A derailment clean-up crew works to clear wrecked cars from alongside the Burlington Northern mainline a few miles east of Bingen in March 1991. Six grain cars went over the side, some into the Columbia River, but no one was injured. To access the site, a powerful crane was floated in on a barge, and workers attached cables to lift the wayward cars off the riverbank. BN took over the SP&S on March 2, 1970. (Courtesy of *The White Salmon Enterprise*.)

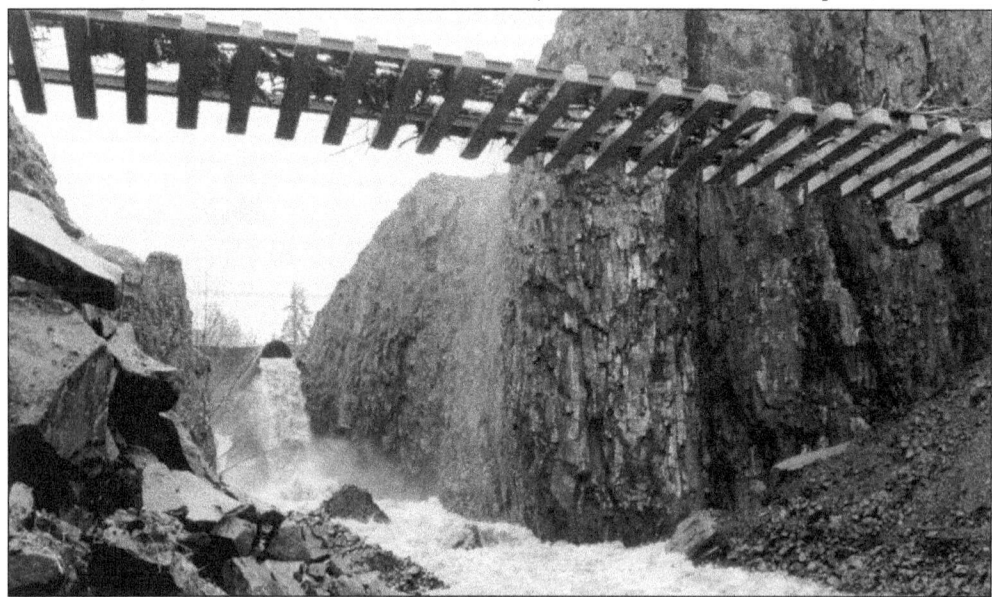

WASHED OUT. This section of Burlington Northern Santa Fe's Columbia Gorge mainline washed out near Milepost 81, about halfway between Lyle and Bingen, on February 8, 1996. Cascading water from the bluffs tore out segments of the roadbed in several spots in the gorge, but this section was hit the worst, with the track suspended about 30 feet in the air. Amazingly, hotshot repair crews had the line back in service by February 11. (Photo by Chris Jaques.)

Four

MOUNT HOOD RAILROAD

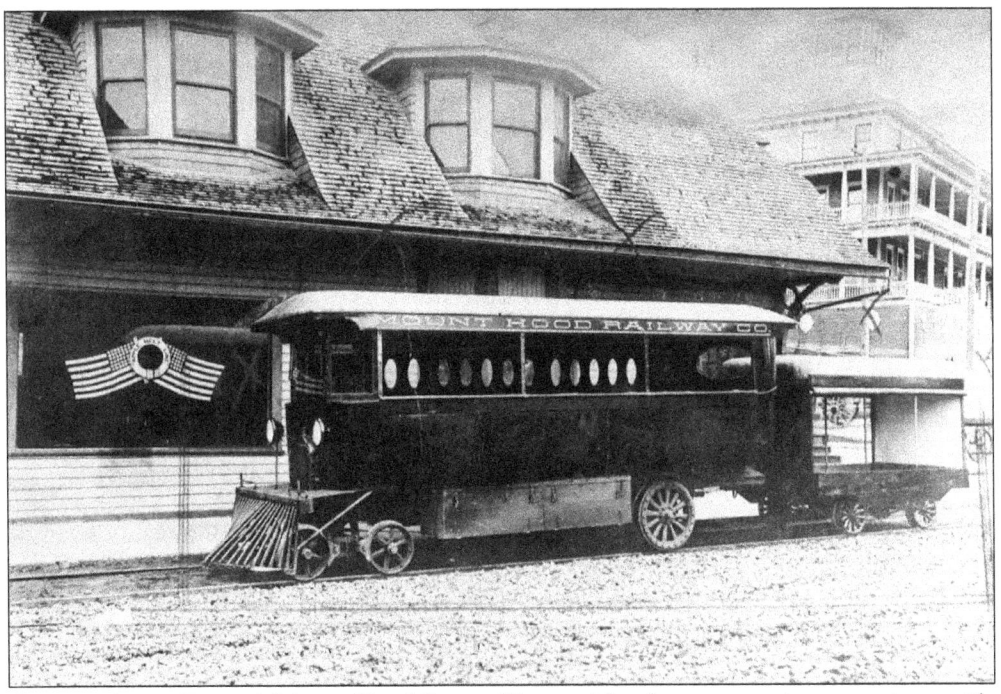

ON THE APPLE BELT. A Mount Hood "autorail" car, with a luggage cart in tow, waits outside the Mount Hood Railroad depot in Hood River. This service began in 1916, and at its peak in the early 1920s, autorail cars operated four round trips a day between Parkdale and Hood River. Regular passenger service on the shortline ended in the early 1940s. Note the railroad's rarely seen logo, with American flags and the slogan "Apple Belt Line." (Courtesy of the Hood River County Historical Museum Photo Archives.)

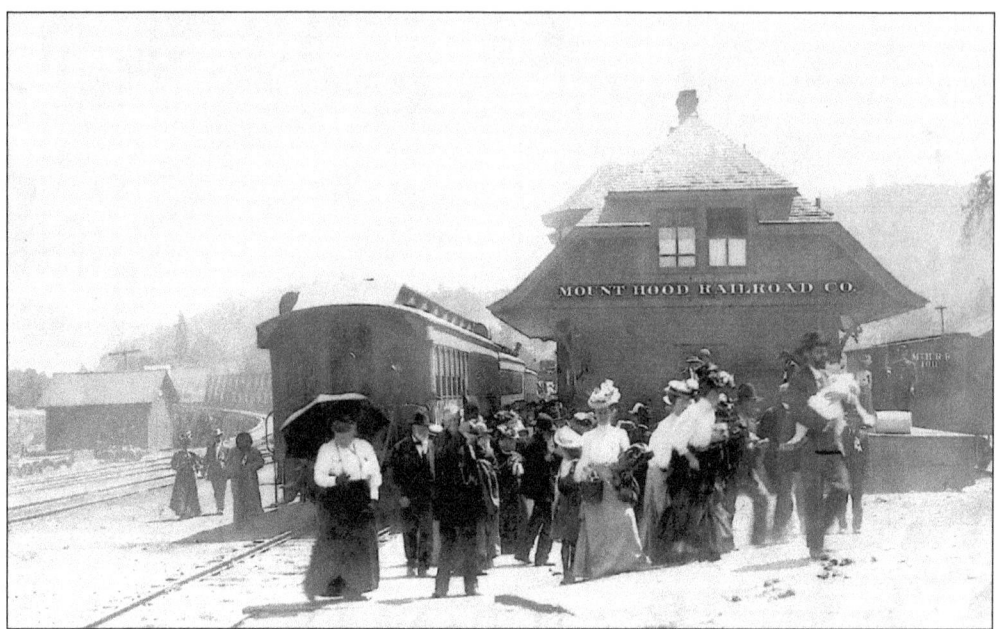

WELCOME TO HOOD RIVER. A crowd of well-dressed passengers disembarks from a train at the original Mount Hood Railroad depot at Hood River, Oregon, in this eastward-looking view from 1910. This depot, one of three built in Hood River, was constructed by the Oregon Lumber Company in 1906. (Courtesy of the Hood River County Historical Museum Photo Archives.)

LETTING OFF STEAM. A wood-burning locomotive, Mount Hood No. 1, blows off steam behind the Mount Hood Railroad's depot at Hood River in an undated image. Baldwin Locomotive Works built the locomotive in 1868. Approximately 150 men at six separate rail camps started construction of the 15-mile long stretch of railroad from Hood River to Dee in April 1905, and completed the line in 1906. The track was extended from Dee to Parkdale—another six miles—in 1910. (Courtesy of the Mount Hood Railroad.)

LOADING UP. Mount Hood Railroad No. 1 comes alongside a stack of cordwood that will be loaded into this wood-burning locomotive's tender. This locomotive is a 2-8-0 Baldwin, built in December 1868. The Mount Hood purchased it in 1906 from Union Pacific (ex-UP No. 115), and used it until 1916. (Courtesy of the Hood River County Historical Museum Photo Archives.)

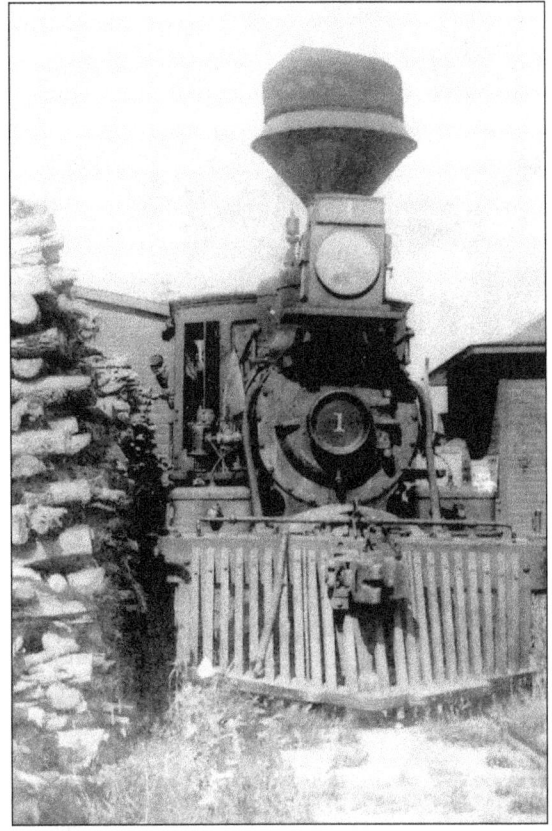

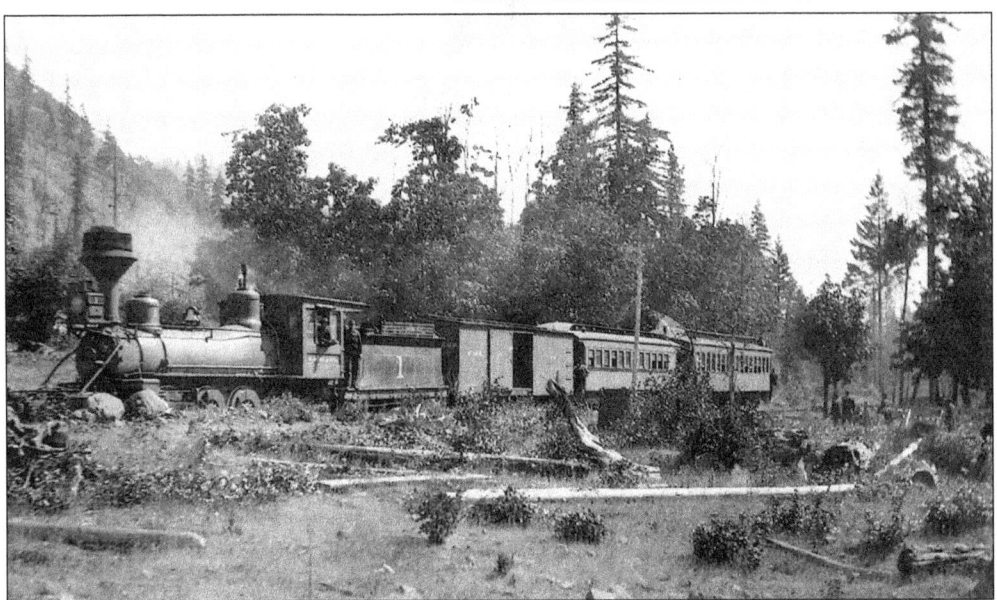

MIXED RUN. A mixed train rolls north on the Mount Hood Railroad, with MHRR No. 1, a Baldwin locomotive, pulling a boxcar and two passenger cars in the early 1900s. The location is south of the line's station at Powerdale, near Milepost 1. (Courtesy of the Hood River County Historical Museum Photo Archives.)

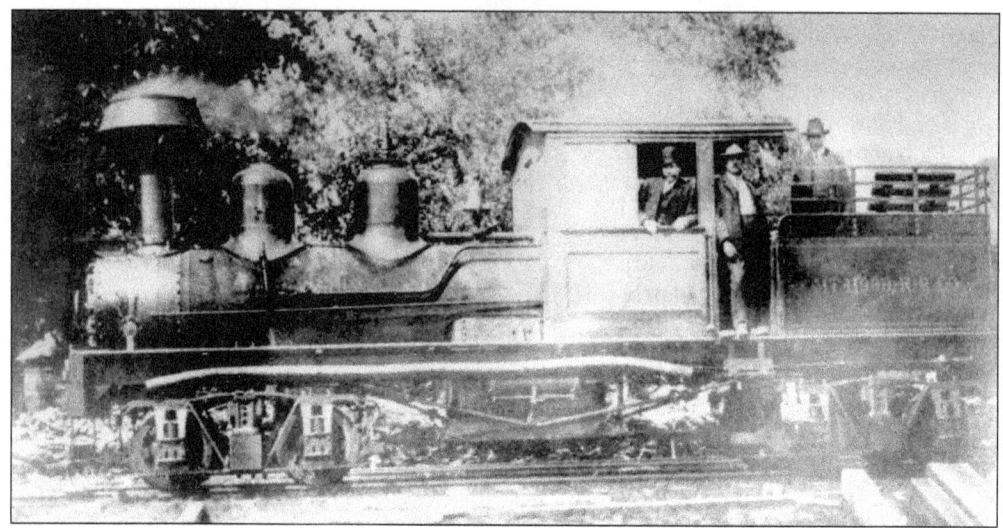

SHAY. This Shay locomotive was named "Bud," for Bud Eccles, son of one of the owners of the Oregon Lumber Company. The rail line from Hood River to Dee was built by Oregon Lumber, which operated a large sawmill at Dee, and the Mount Hood Railroad operated this Shay locomotive for its standard-gauge logging operations. Shown, from left to right, are lumber company business partners W.H. Eccles, Ham Brightson, and S.M. Osborn. (Courtesy of the Mount Hood Railroad.)

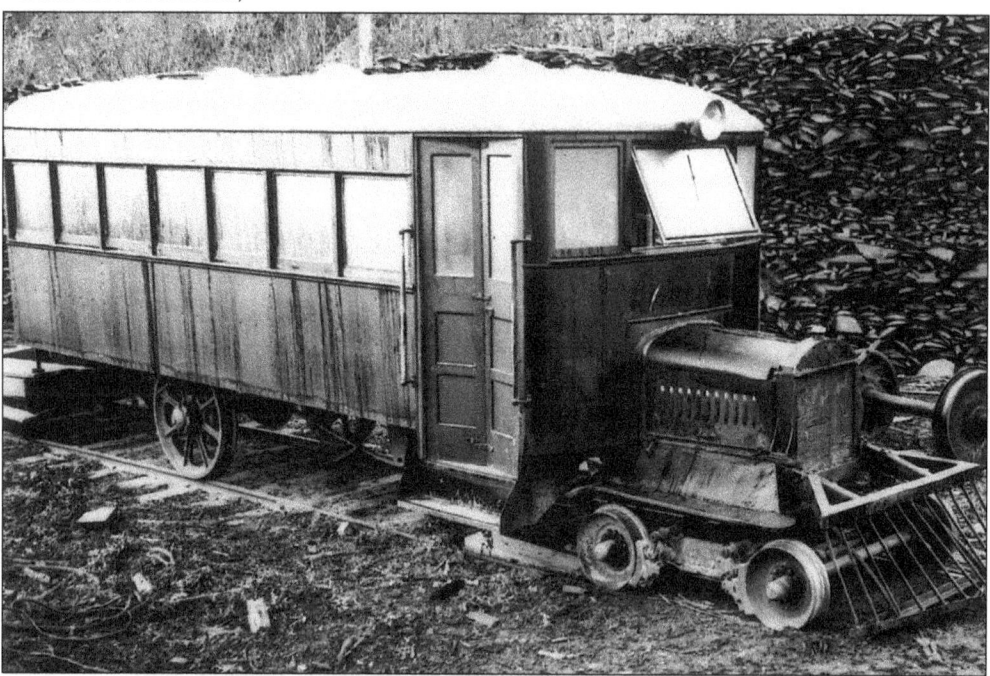

RAIL BUS. Mount Hood Railroad's "Mack Railbus" No. 10, was also known as a "jitney" or the "galloping goose." Stacked behind the jitney is slab wood, used as fuel for the wood-burning machine. These contraptions carried passengers and mail from 1916 into the early 1940s. They replaced the railroad's original heavyweight passenger cars, which were slower and more costly to operate. This jitney was sold to the Condon, Kinzua & Southern Railroad, an Oregon shortline, in 1941. (Courtesy of the Hood River County Historical Museum Photo Archives.)

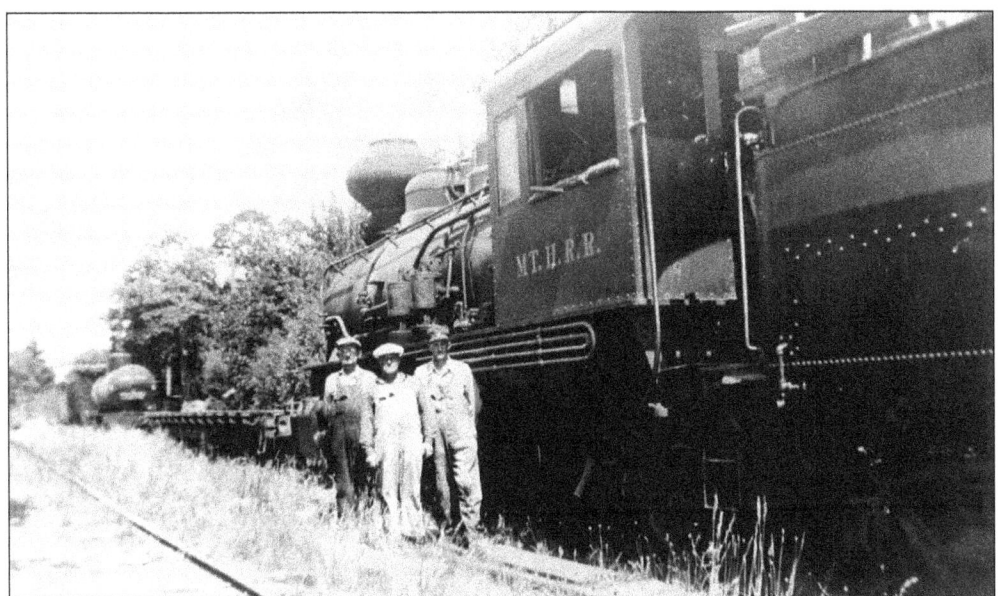

THREE ON THE JOB. A freight train crew on the Mount Hood Railroad takes a break for a photo during switching operations on the shortline in an undated photo. (Courtesy of the Mount Hood Railroad.)

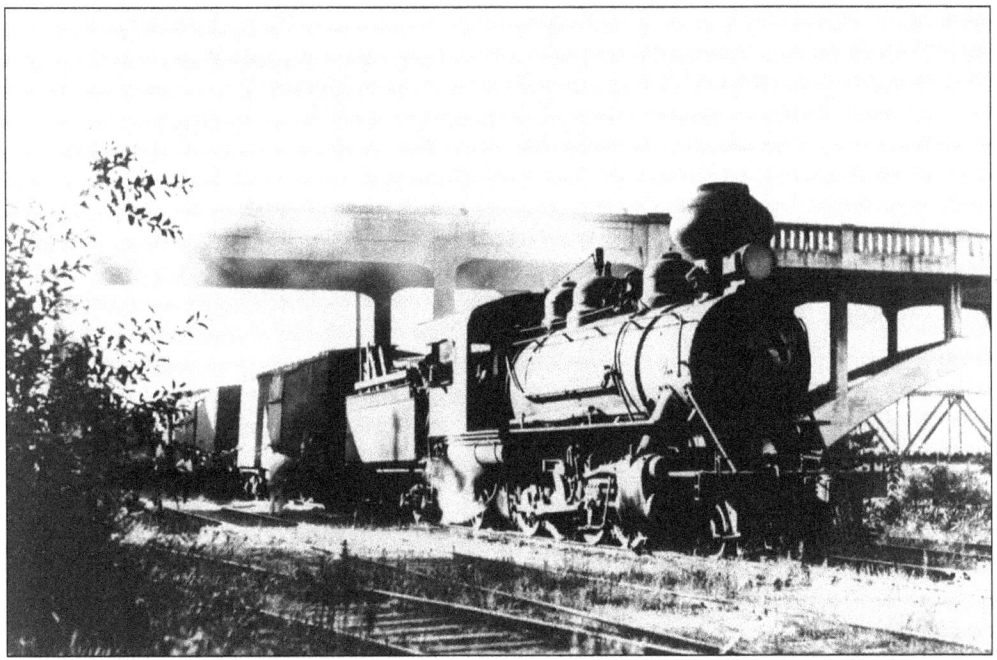

TIMELESS TASK. A crew switches boxcars in the small Mount Hood Railroad freight yard in Hood River. The bridge overhead is for automobiles, and the truss visible on the right (through the arch of the auto bridge) is the Union Pacific mainline through the Columbia River Gorge. The UP bridge crosses the Hood River near where it flows into the Columbia. (Courtesy of the Mount Hood Railroad.)

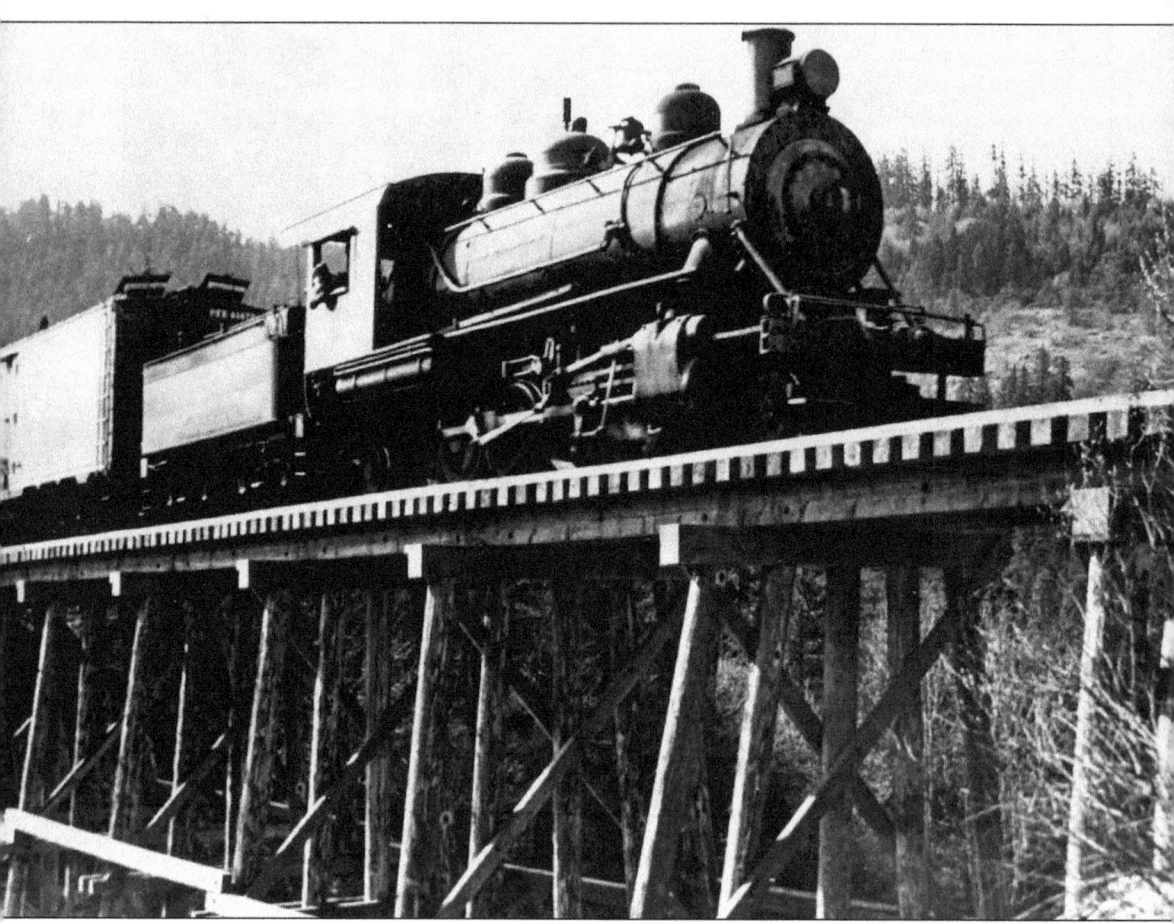

PACIFIC FRUIT EXPRESS. At Milepost 13, a freight crosses a trestle over Collins Creek on the Mount Hood line. Note the old Pacific Fruit Express reefer car behind Mount Hood No. 1. The Mount Hood rostered three locomotives with the No. 1 designation. The first was a Lima Shay built in April 1905; the second one was a 2-8-0 produced by Baldwin Locomotive Works in December 1868 and acquired by the Mount Hood in 1906; and the third No. 1 (pictured here) was a 2-8-2 Baldwin built in May 1922, which the Mount Hood purchased new. (Courtesy of the Mount Hood Railroad.)

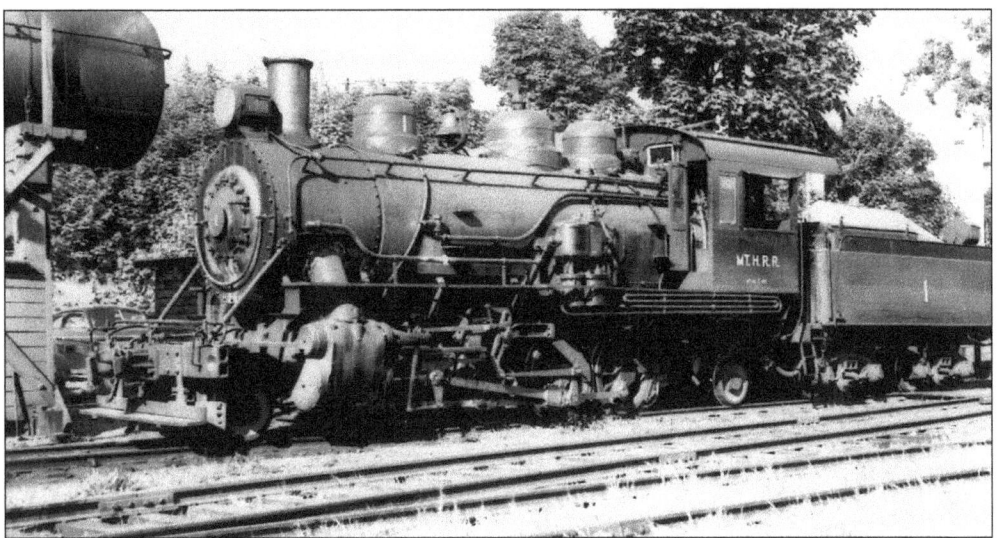

YARD TRACK. Mount Hood Railroad No. 1 sits on the locomotive service track in Hood River in 1944. This engine, built in 1922, was getting close to the end of its life span. Records show that the Mount Hood scrapped it in 1955. (Courtesy of the Hood River County Historical Museum Photo Archives.)

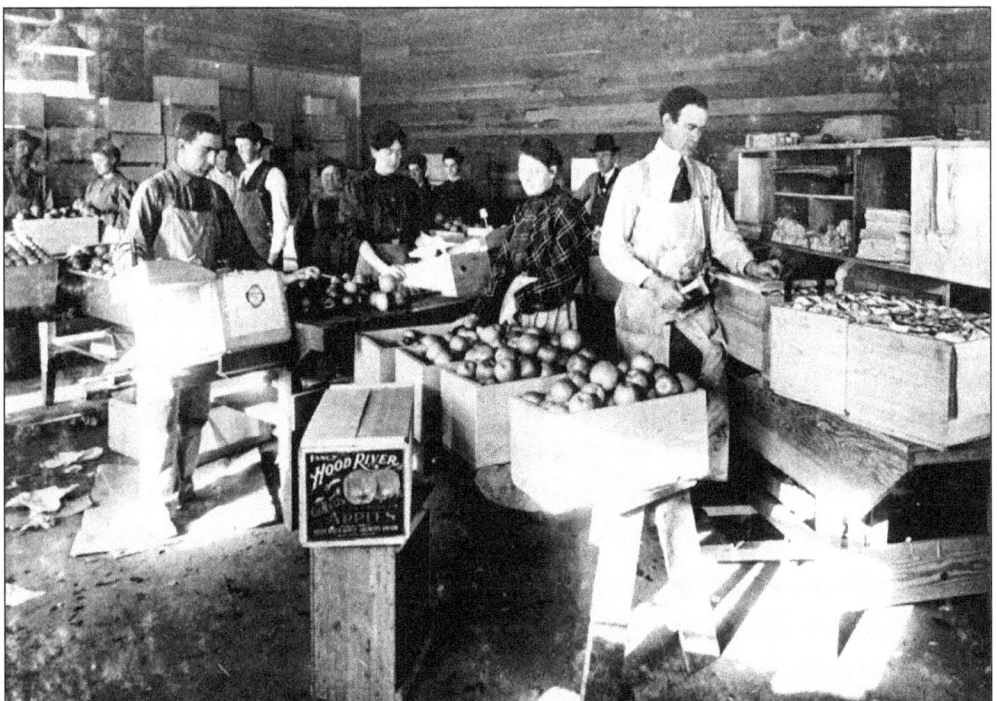

APPLES FROM THE VALLEY. Workers pack freshly picked apples into wooden crates at the Mason Packing House near Pine Grove, Oregon, in the early 1900s. The business was named after A. I. Mason, who was president of the Hood River Apple Growers Association in 1896. Note the packing label on the crate in front reading "Fancy Hood River Oregon Apples." These labels were often artistic and colorful. Fruit shipments have long been a mainstay of freight operations on the Mount Hood Railroad. (Courtesy of the Mount Hood Railroad.)

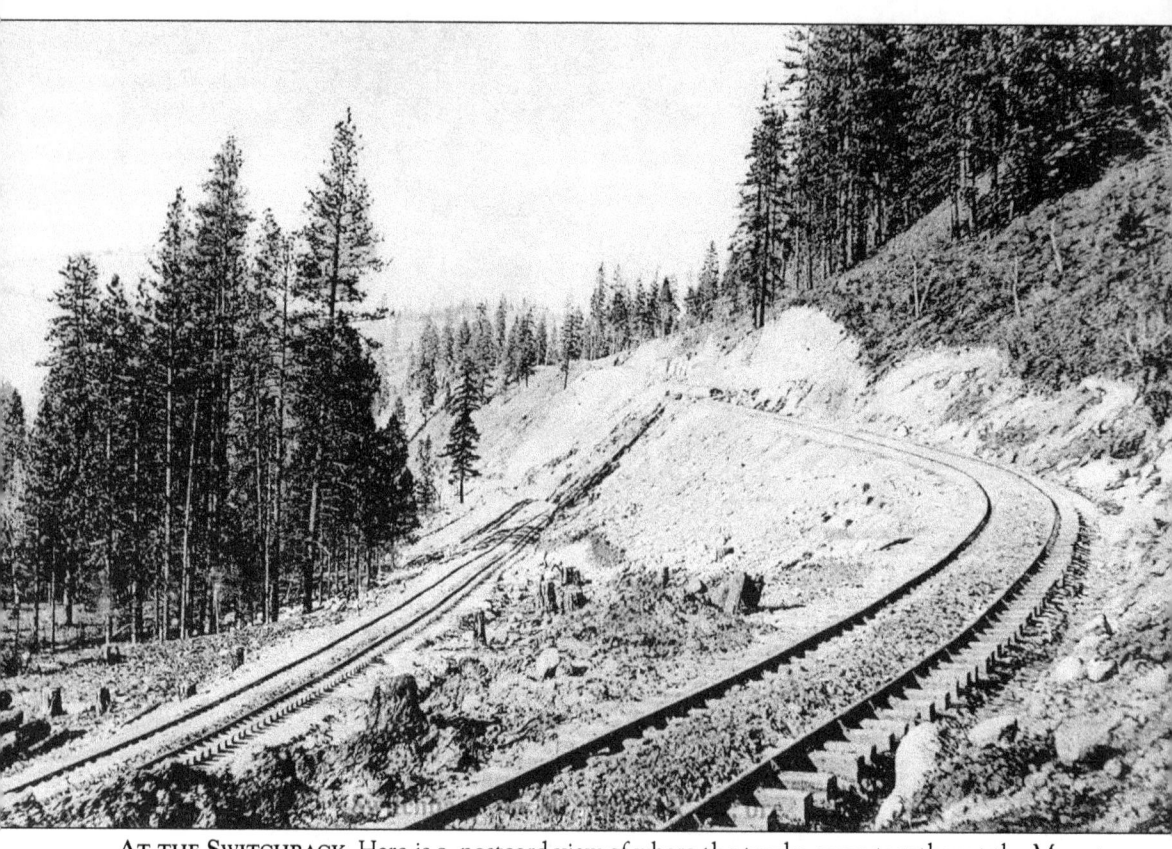

AT THE SWITCHBACK. Here is a postcard view of where the tracks come together at the Mount Hood Railroad switchback at Milepost 2.9 on the 21.1-mile shortline. The line on the left runs downgrade to Hood River, while the tracks on the right climb the grade on the way to Dee and Parkdale. Trains normally back out of Hood River to this point, then go forward up the slope from here. The printing on the reverse of the card notes that the postcard was published for Geo. I. Slocum, Hood River, Ore., by M. Rieder, Los Angeles. Today, tall trees tower over this scenic site. (Courtesy of the Mount Hood Railroad.)

TOO HEAVY. Mount Hood Railroad No. 36 rests at Hood River, Oregon, in August 1950. This 2-8-2 Baldwin, built in 1911, was purchased from Union Pacific in 1947, but proved to be too heavy for the Mount Hood's lighter steel rails. The locomotive earned a reputation as a "rail buster," and as a result, No. 36 didn't last very long on the Mount Hood. In 1954, the railroad sold it for scrap. (Courtesy of the Hood River County Historical Museum Photo Archives.)

FIRES STILLED. An out-of-service Baldwin 2-8-2, the third Mount Hood locomotive over the years that was numbered No. 1, rests in the Mount Hood Railroad freight yard with boards over its cab windows in August 1949. Although not in active use, the locomotive, built in May 1922, remained available for standby duty if needed. The track in the background, to the left of the locomotive, is the Union Pacific mainline. The Columbia River is also visible. (Courtesy of the Hood River County Historical Museum Photo Archives.)

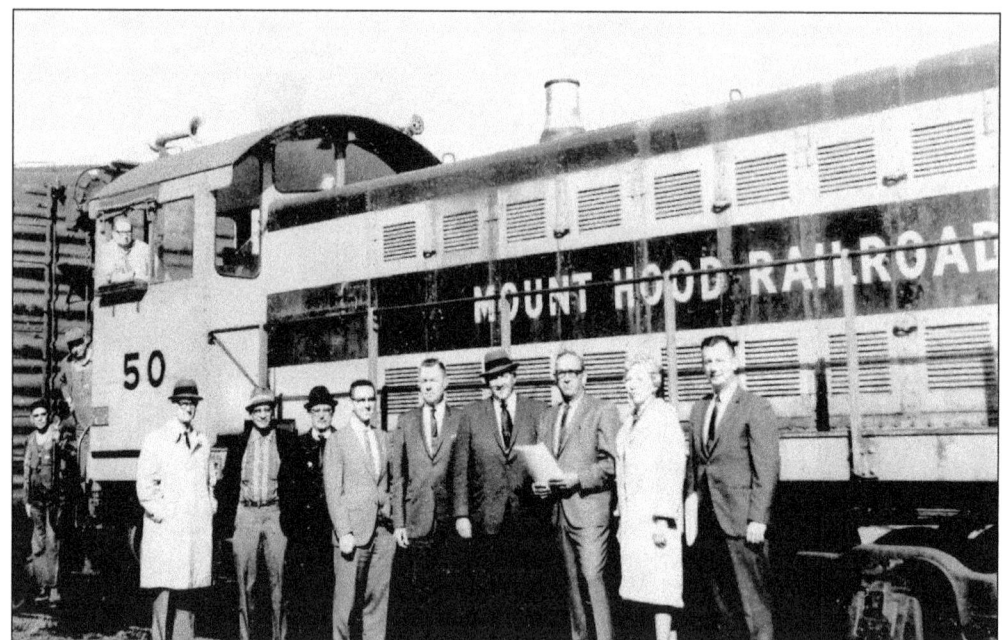

SIGNING DAY. With Mount Hood No. 50 for a backdrop, officials from both the Mount Hood Railroad and Union Pacific gather in Hood River to mark the 1968 agreement that conveyed the former shortline to the UP, which operated it as a branchline from October 16, 1968 until November 2, 1987, when it was sold again to the newly reconstituted Mount Hood Railroad. (Courtesy of the Mount Hood Railroad.)

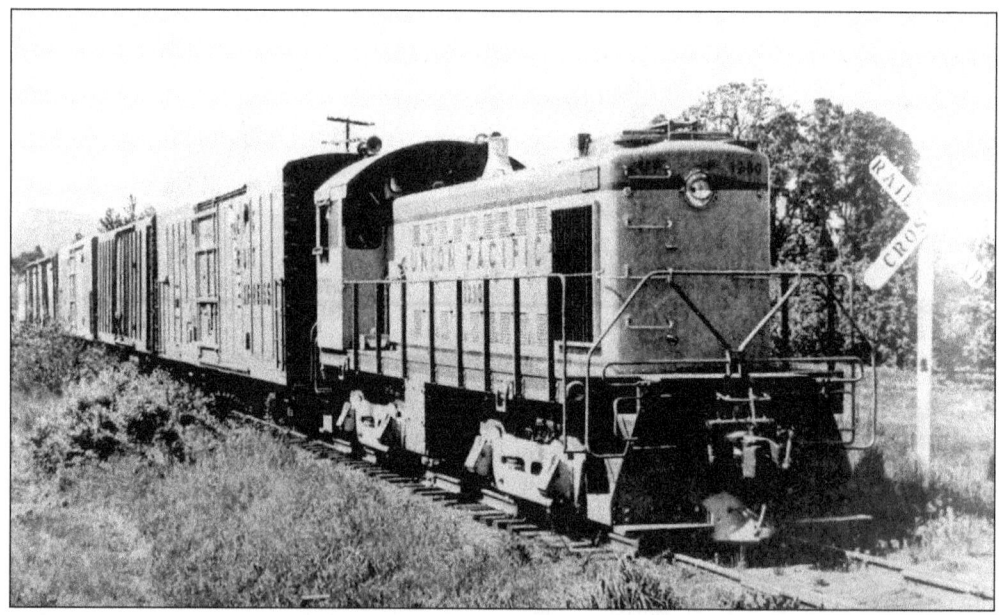

A BRANCH OF THE UP. A typical scene from the years 1968–1987, when Union Pacific operated the line from Hood River to Parkdale as a branchline. Here, UP No. 1250, an Alco S3 built in 1950, pulls Pacific Fruit Express cars near Dee. This switcher was later put into service as a yard switching unit for UP in Wyoming. After the S3 was sent elsewhere, UP employed a GP7 to handle business on the 21-mile route. (Courtesy of the Mount Hood Railroad.)

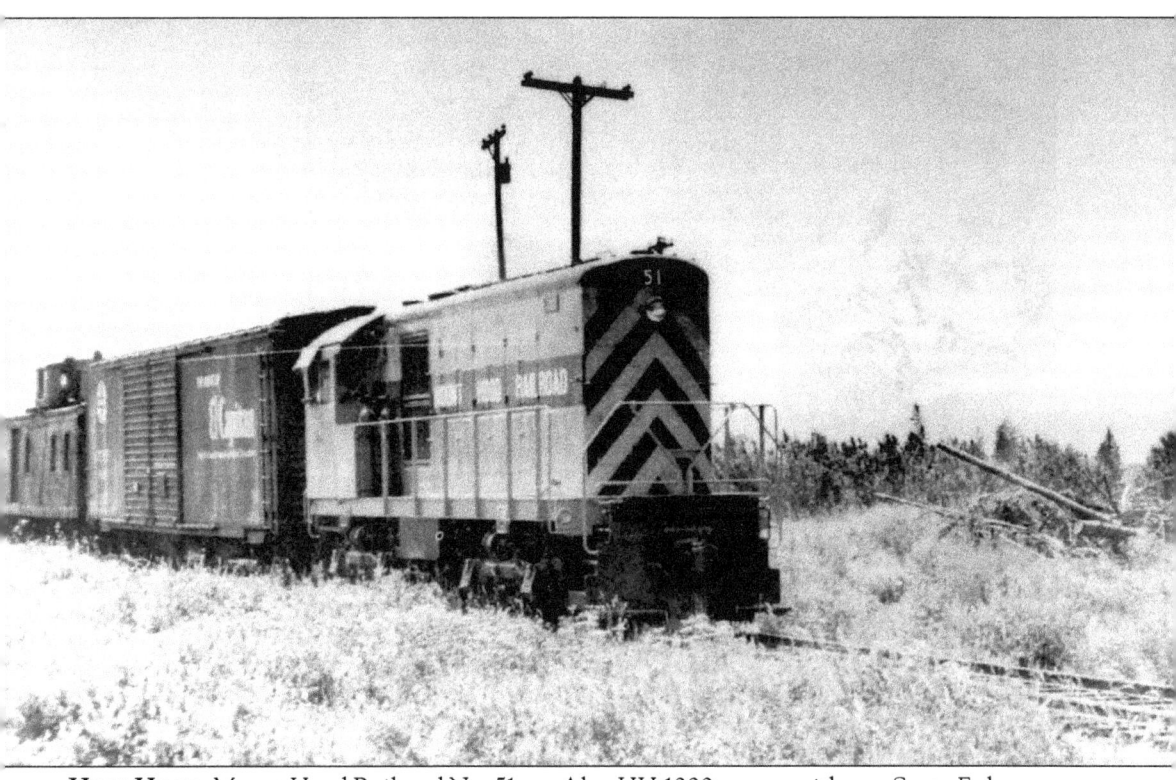

HIGH HOOD. Mount Hood Railroad No. 51, an Alco HH-1000, moves with one Santa Fe boxcar and a caboose through the Hood River Valley near Odell in this scene from 1956. Mount Hood, Oregon's highest peak, is to the right of the locomotive. The Mount Hood's locomotive roster notes that this 1,000-horsepower unit was built in July 1940 and was originally owned by the Newburgh & South Shore Railroad, a Cleveland, Ohio, shortline that served steel mills in the Cleveland area. (Courtesy of the Mount Hood Railroad.)

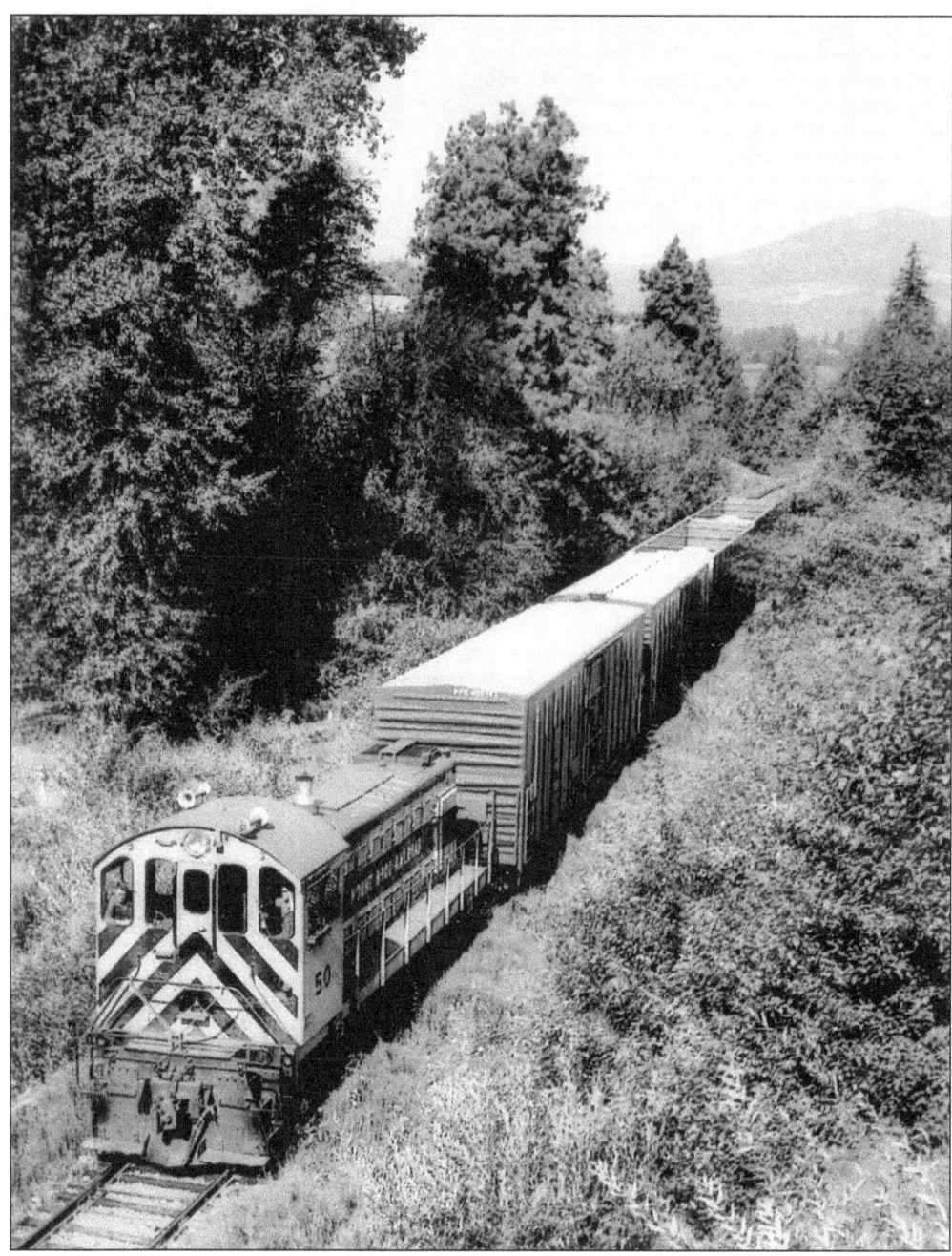

FRUIT AND LUMBER HAULER. In a typical 1960s scene, an early-generation Alco S3 diesel, Mount Hood Railroad No. 50, cuts south through the lush landscape, bringing Pacific Fruit Express reefer cars for loading at fruit packing plants in Odell and Pine Grove and empty woodchip cars for trackside lumber mills. The diesel was built by the American Locomotive Company (Alco) in September 1950 in Schenectady, New York. The American Locomotive Company and its predecessors had been building locomotives since the 1850s; the company built its last locomotive in 1969. (Courtesy of the Hood River County Historical Museum Photo Archives.)

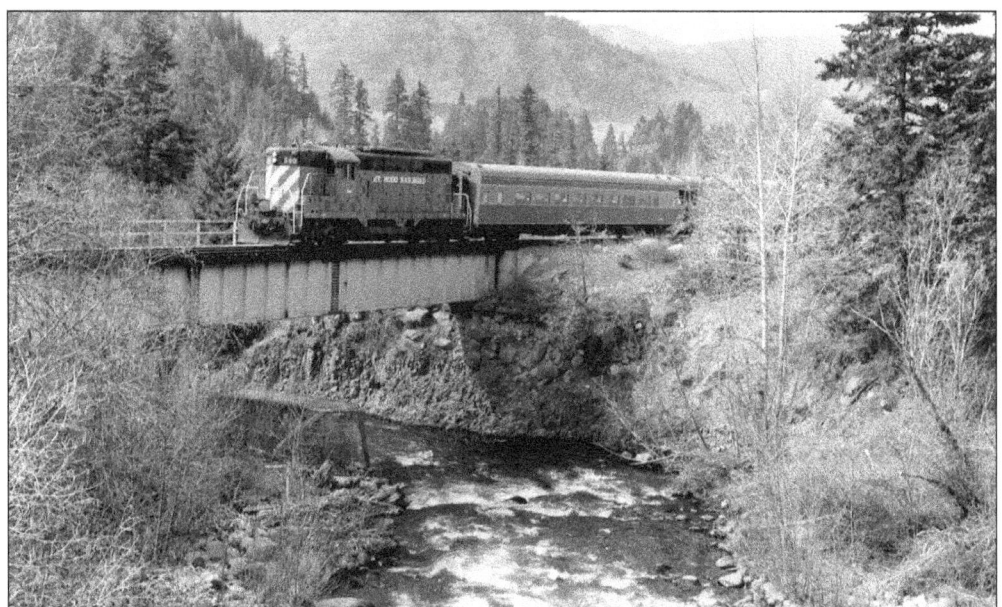

ACROSS TROUT CREEK. Mount Hood Railroad GP7 No. 560, showing its heritage as a Burlington Northern unit, crosses the east fork at Trout Creek, south of Dee, in the mid-1980s. The Mount Hood came up with its own red, yellow, and blue paint scheme in the late 1980s. The passenger cars the Mount Hood used during this early era for excursion trains were ex-Southern Pacific "Daylight" cars. (Courtesy of the Mount Hood Railroad.)

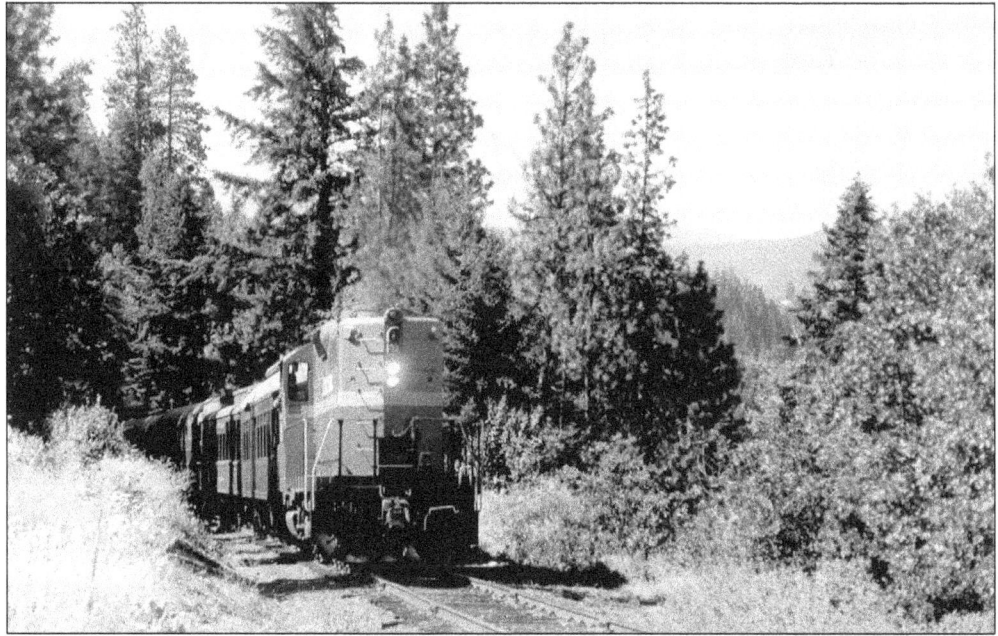

LEAVING SWITCHBACK. A Mount Hood Railroad excursion train powers uphill from the Switchback station on the route to Parkdale, Oregon, in the summer of 1995. The railroad climbs relatively quickly to get to this spot; the passenger depot in Hood River is at 99 feet elevation, while the elevation at Switchback is 307 feet. Mount Hood, the railroad's namesake, is visible through the trees behind the four-car train. (Photo by D.C. Jesse Burkhardt.)

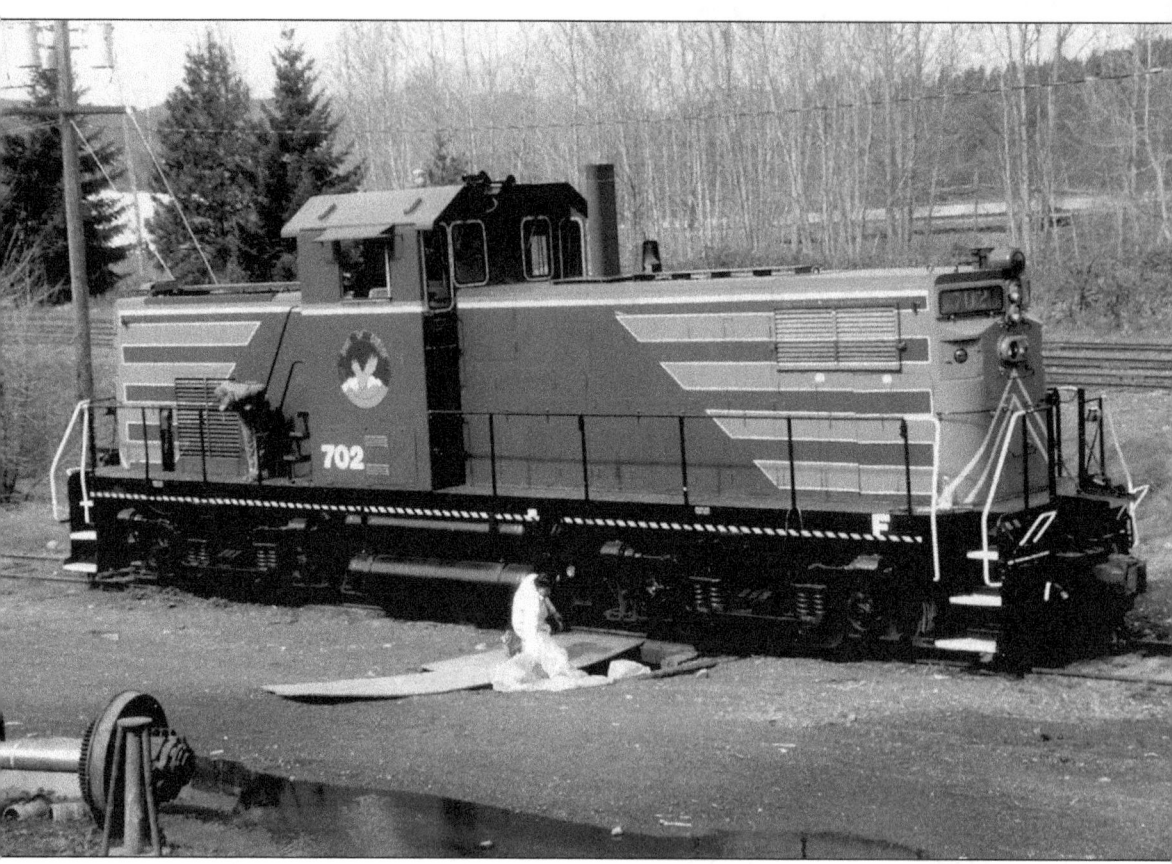

IT NEEDS SOME WORK. Mount Hood Railroad Alco C415 No. 702 gets some attention from the mechanical department on March 27, 1997, before being placed into dinner train service. The Mount Hood started running dinner excursions between Hood River and Parkdale on April 19, 1997. This locomotive was originally rostered by Southern Pacific, and after that by the Columbia & Cowlitz Railway in Washington. In 1997, the Mount Hood acquired it from Bob Steele & Associates, which had been using it for "Spirit of Oregon" dinner train service out of Tillamook, Oregon. In March 1997, the Mount Hood bought the entire dinner trainset, including sister Alco No. 701 and four excursion cars consisting of a bar car, two dining cars, and a kitchen car. The Alcos didn't stay with the Mount Hood Railroad very long; they were sold to an Iowa railroad in August 1998. (Photo by D.C. Jesse Burkhardt.)

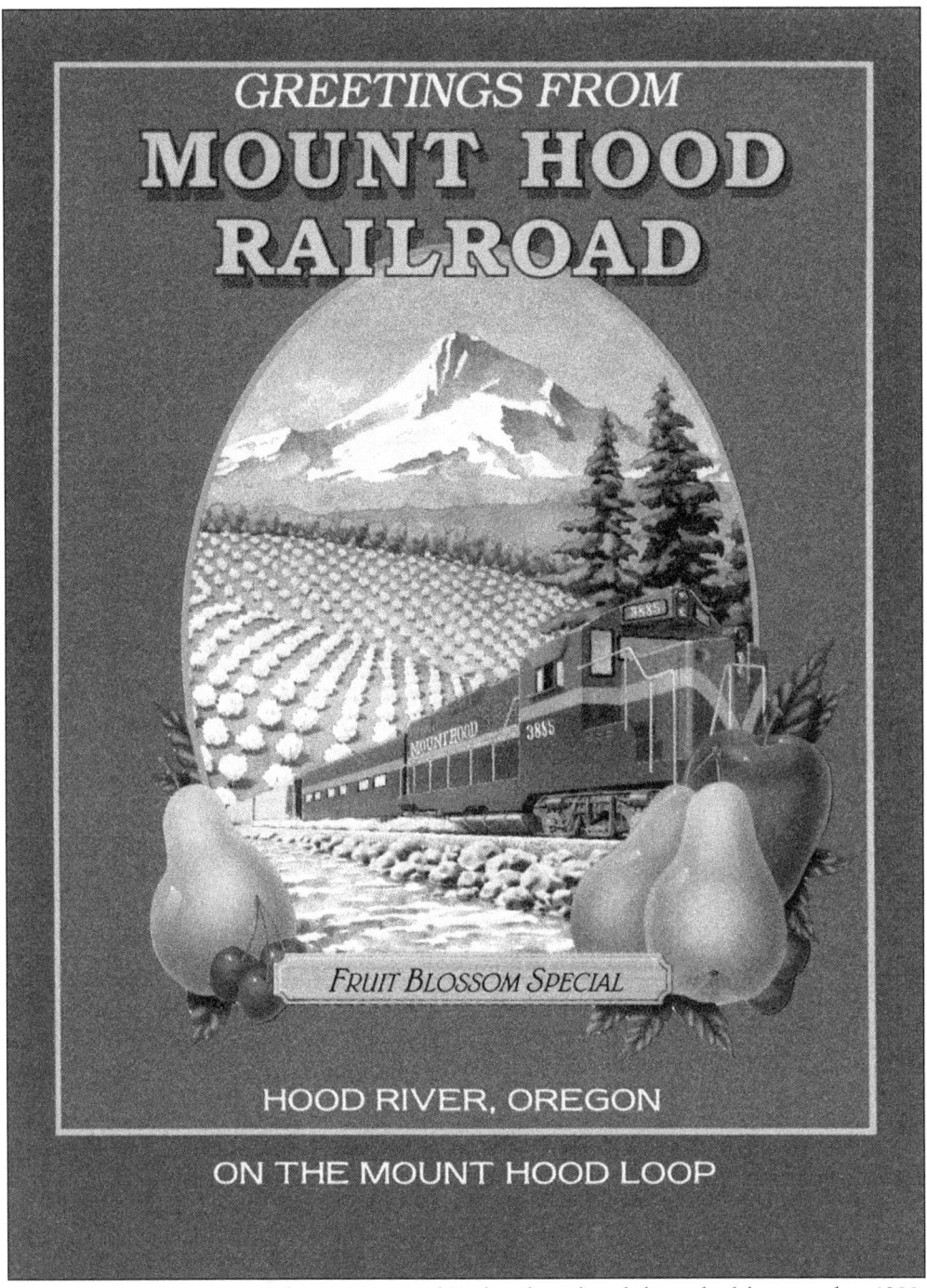

GREETINGS FROM

MOUNT HOOD RAILROAD

Fruit Blossom Special

HOOD RIVER, OREGON

ON THE MOUNT HOOD LOOP

Fruit Blossom Special. The Mount Hood Railroad produced this colorful postcard in 1988, obviously geared to promote the excursion line's "Mount Hood Loop" scenic attractions to tourists. The caption on the reverse reads: *"From the heart of the Columbia River Gorge, to the beautiful fruit orchards of the Upper Hood River Valley, Oregon's most spectacular landscapes await passengers on the Mount Hood Railroad."* Note how the train pictured is hauling a passenger car as well as flatcars of lumber. Smart. (Courtesy of D.C. Jesse Burkhardt.)

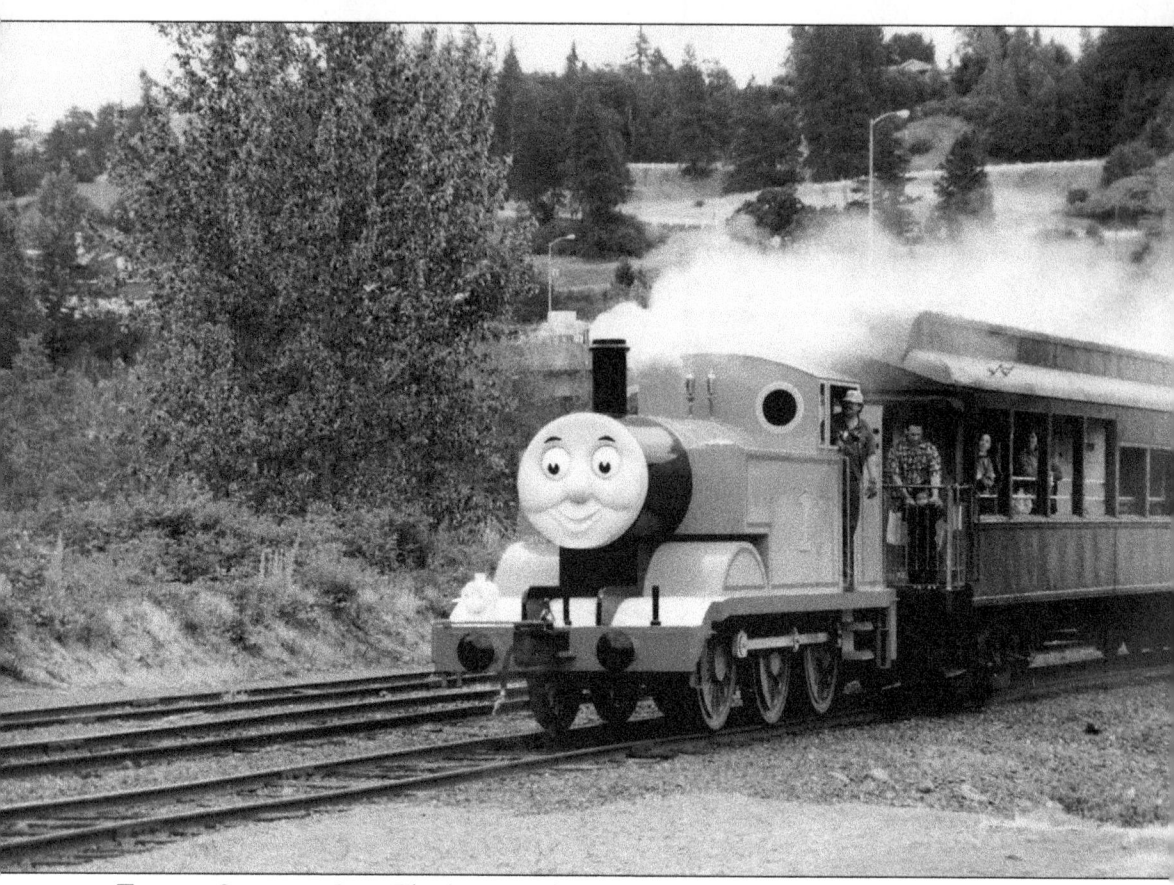

THOMAS COMES TO LIFE. The famous "Thomas the Tank Engine" made its first visit to Hood River, Oregon, in the summer of 2002. The train ran roundtrip excursions from the Hood River depot to Switchback, a distance of 2.9 miles each way. The mythical British locomotive blows a lot of smoke, but it is not actually powering the train. That duty was left to one of the Mount Hood Railroad's regular GP9 diesels, which is pushing from the other end. Visits by Thomas have become an annual and highly popular event on the Mount Hood Railroad. (Photo by D.C. Jesse Burkhardt.)

Five

THE LOGGING LINES

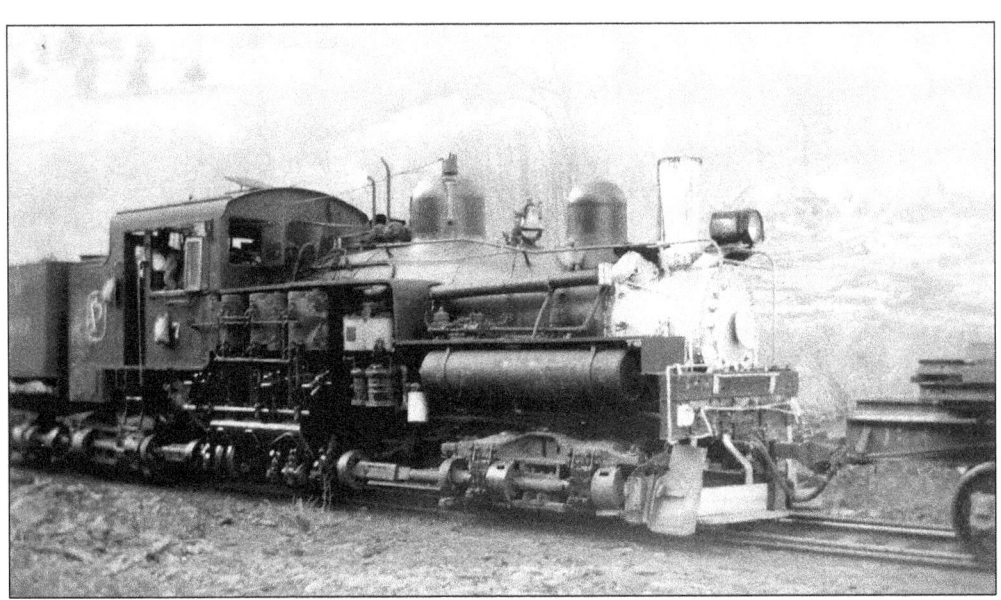

WORKING IN THE WOODS. Lima Shay locomotive No. 7, owned by the Klickitat Log & Lumber Company, is shown at work in the woods north of Klickitat, Washington. Log trains powered by Shays fed raw material to the Klickitat mill until 1964. (Courtesy of Keith McCoy.)

VIEW FROM ABOVE. A rail line built to reach the tall timber north of the Broughton Lumber Company mill at Hood, Washington, takes off toward the trees on a spindly wooden trestle. This logging line was constructed in the early 1920s and removed in the late 1930s. (Courtesy of Cam Thomas.)

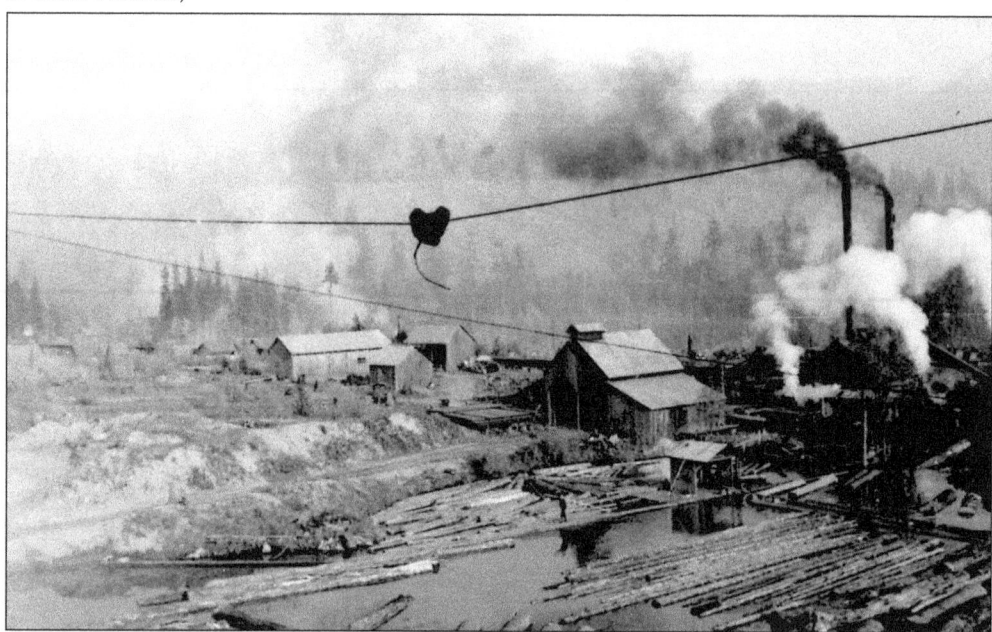

LOCOMOTIVE SHED AND CAMP. View of the Broughton Lumber Company mill, log pond, and logging camp at Willard, Washington, c. 1930. The tall building in the center of the photograph was the locomotive shed, used to house and service the locomotives that moved log trains supplying raw material to the Willard mill. (Courtesy of Cam Thomas.)

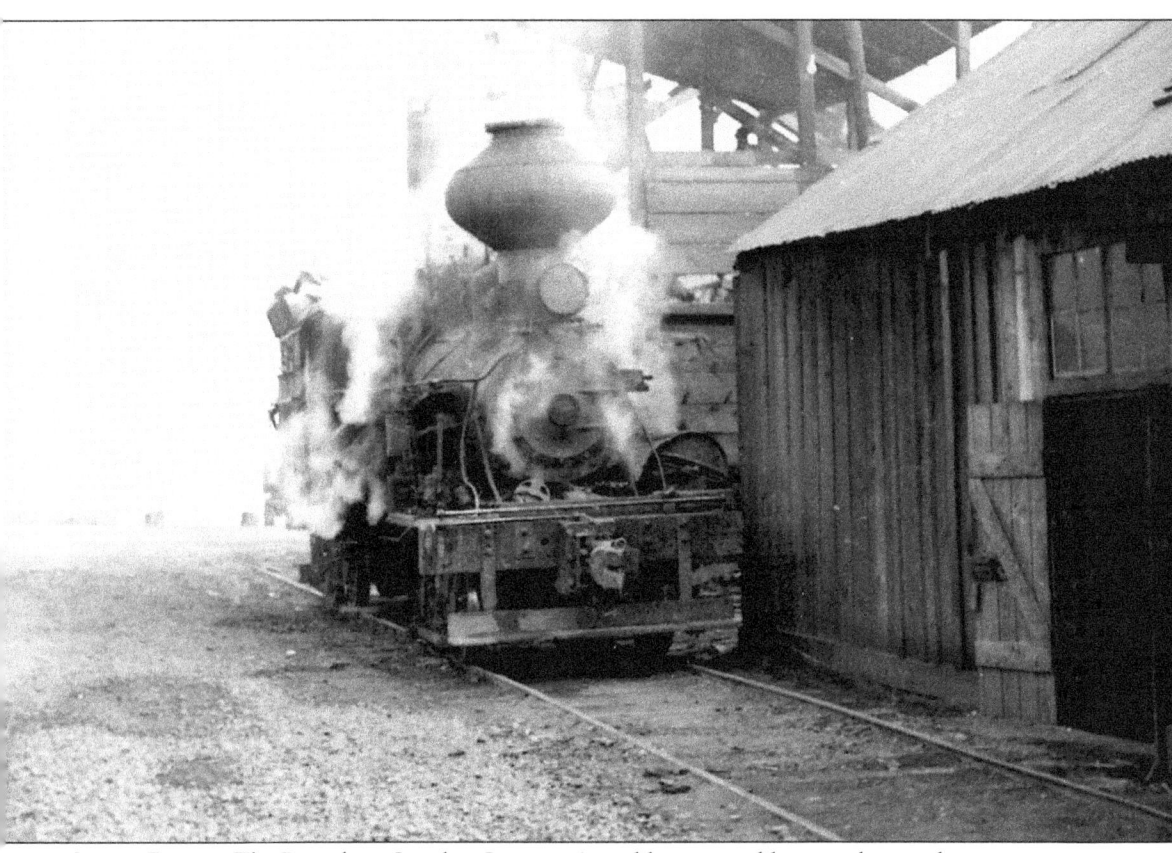

STEAM RISING. The Broughton Lumber Company's workhorse wood-burning logging locomotive, a Heisler built in 1909, is partly obscured by steam as it rests at the "fuel rack" between switching assignments. Note the tender stacked high with a fresh load of wood, while the shed to the right is brimming with a seemingly endless supply of wood for the Heisler locomotive's firebox. (Courtesy of the Gorge Heritage Museum.)

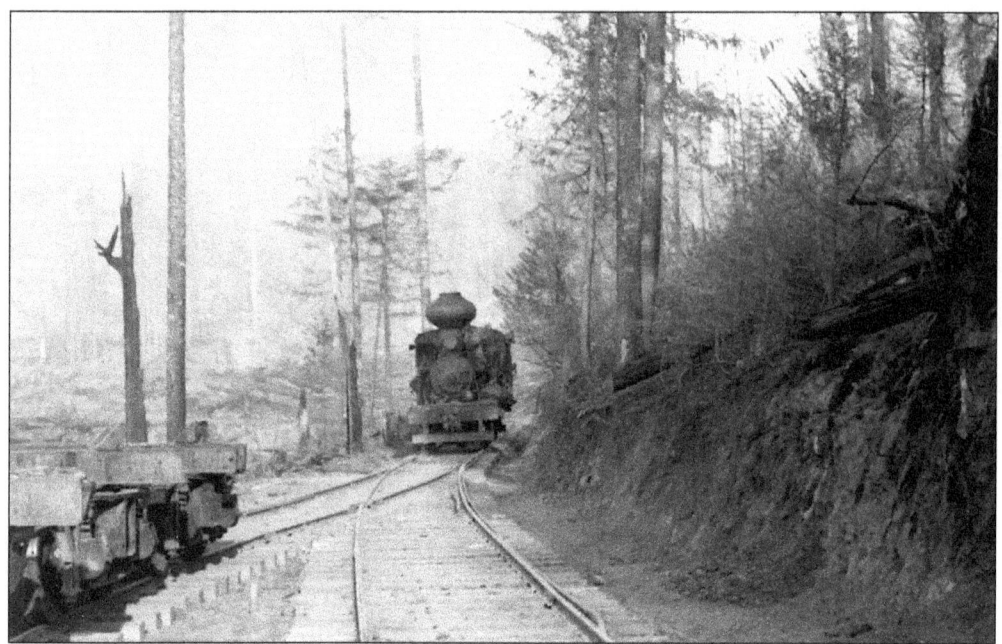

READY TO SWITCH. On duty outside Broughton's mill at Willard, this locomotive is preparing to hook up to some of the skeleton flatcars on the storage track to the left. The Broughton Company logging railroad ceased operations in 1941, but this locomotive remained on Broughton property until it was sold to a logging museum in Ashford, Washington, in 1970. (Courtesy of Cam Thomas.)

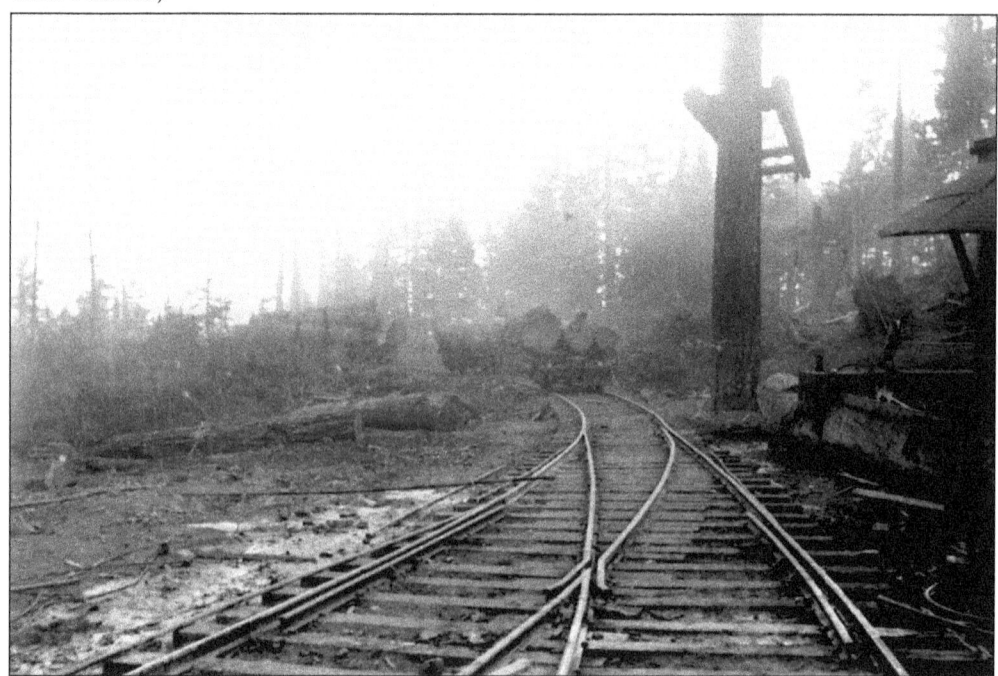

AT THE LANDING. Logs were brought to this loading area before being placed on flatcars and hauled to the Broughton Lumber Company mill. Note the loading arms, called a "hayrack boom," attached to a handy spar tree in this scene from the mid-1930s. (Courtesy of Cam Thomas.)

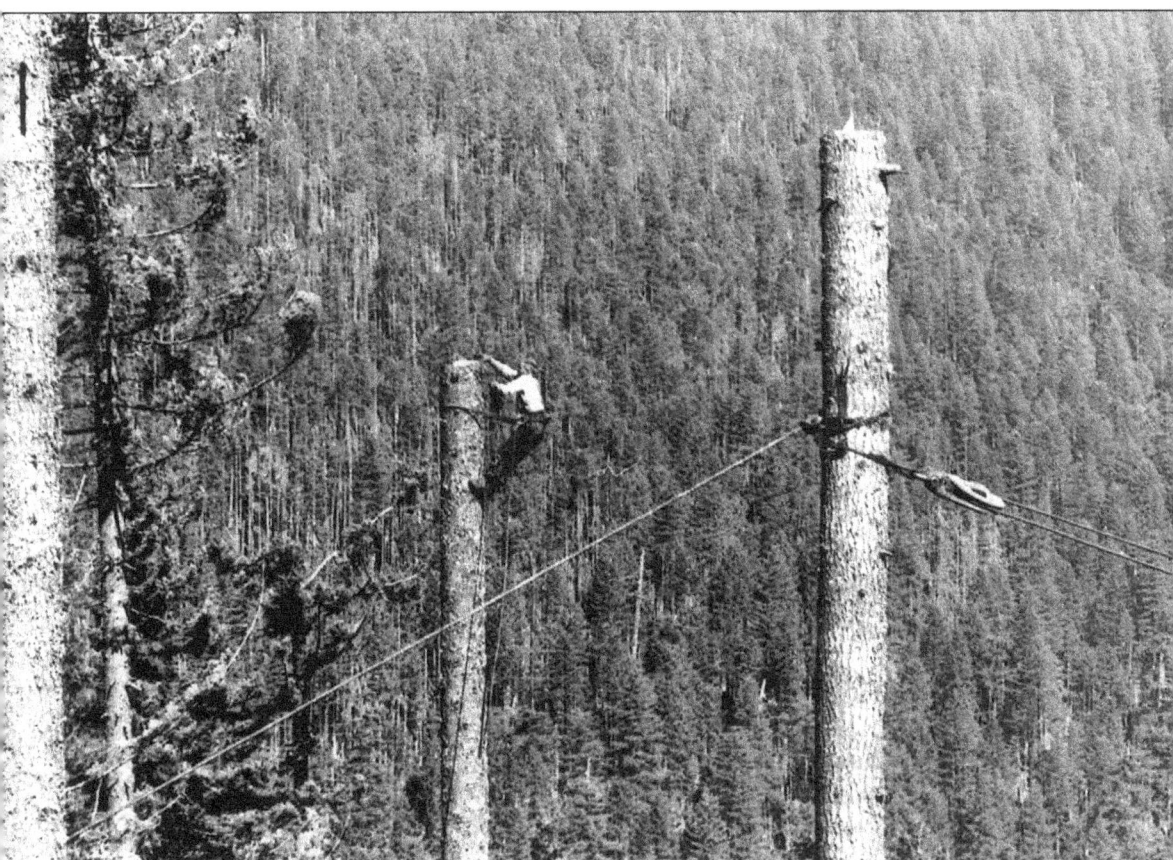

TRUST YOUR EQUIPMENT. With little more than a set of stout leather straps to support him, a Broughton Lumber Company employee with steady nerves climbs high to prepare a spar tree with a heavy block and cable rigging, used to move freshly cut trees during the company's logging operations. Rigging the spar trees was hazardous duty, but it must have been a wonderful view from up there! (Courtesy of Cam Thomas.)

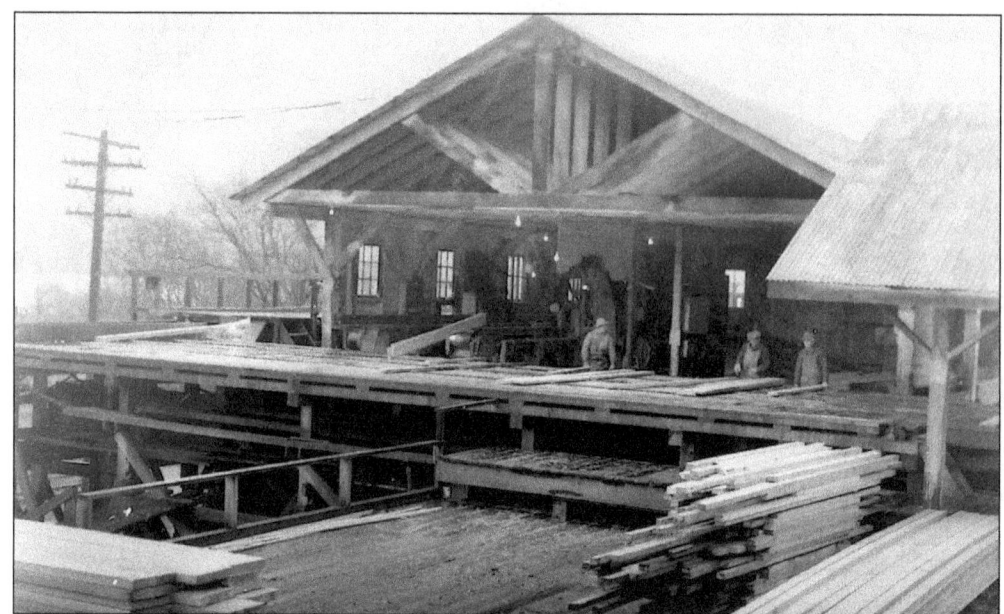

GREEN CHAIN. Workers are busy at Broughton Lumber Company's mill at Hood, Washington, c. 1940. The mill started operations in 1923, and by 1925, the Broughton Lumber Company was cutting 45 million board feet of lumber a year. (Courtesy of Cam Thomas.)

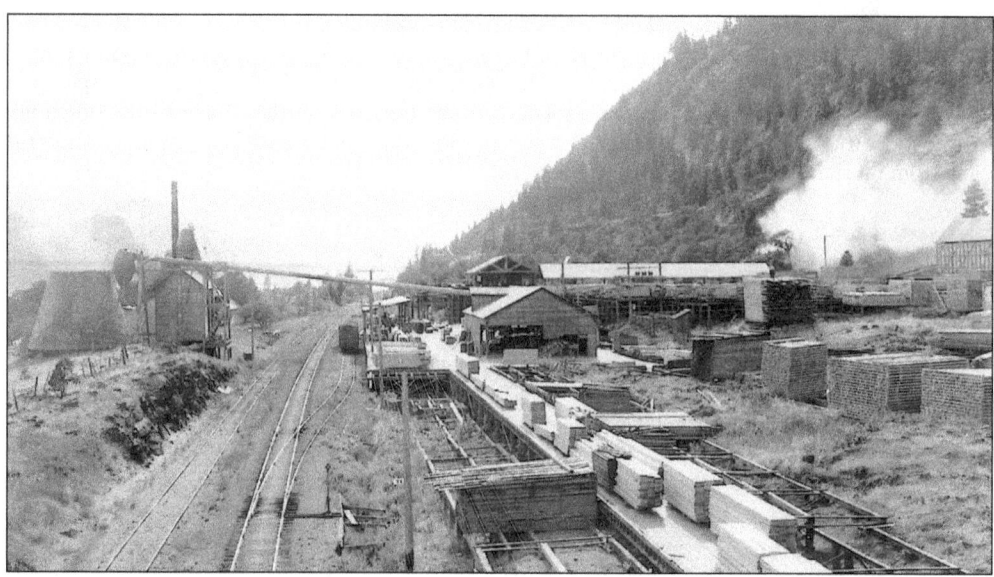

MILL IN ACTION. This view looks west over the Broughton Lumber Company mill at Hood, at Milepost 71 on the SP&S mainline to Vancouver, in the mid-1940s. Finished lumber is stacked and ready to be loaded. Note the boxcars on the siding to the right of the mainline, and the steaming kiln on the left of the tracks. This mill operated from 1923 to 1986. (Courtesy of the Gorge Heritage Museum.)

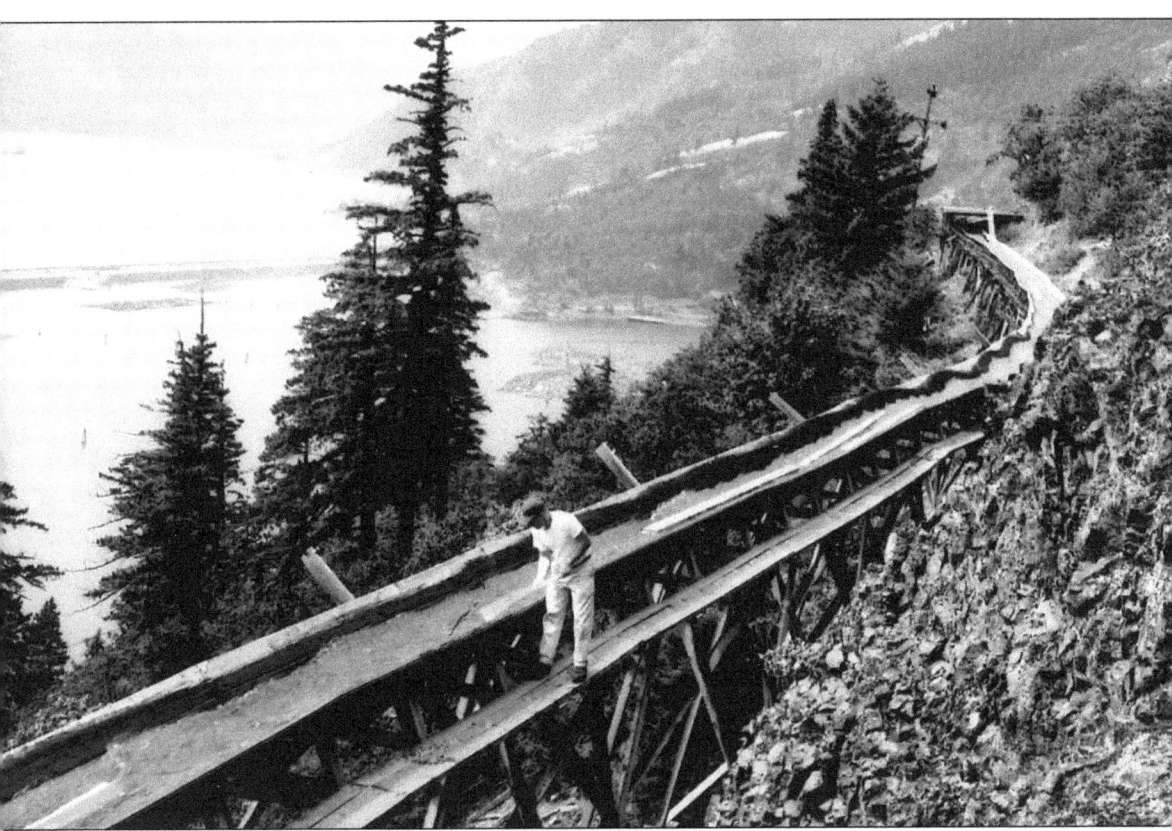

RIVER IN THE SKY. With the Columbia River stretching out below, an unidentified worker moves along a 12-inch-wide walkway while tending to a portion of the nine-mile-long Broughton Lumber Company flume, which conveyed timber cants from Willard, Washington, to a Broughton planing mill at Hood. In Hood, the cants were processed into finished lumber and shipped east or west on the SP&S Railway. The flume was constructed out of Douglas fir and cedar, with the water coming from the Little White Salmon River. It flowed at about nine miles per hour and transported as much as 150,000 board feet of lumber per day. The flume operated from 1923 until December 19, 1986, when the mills closed and Broughton logging operations ceased. (Courtesy of the Hood River County Historical Museum Photo Archives.)

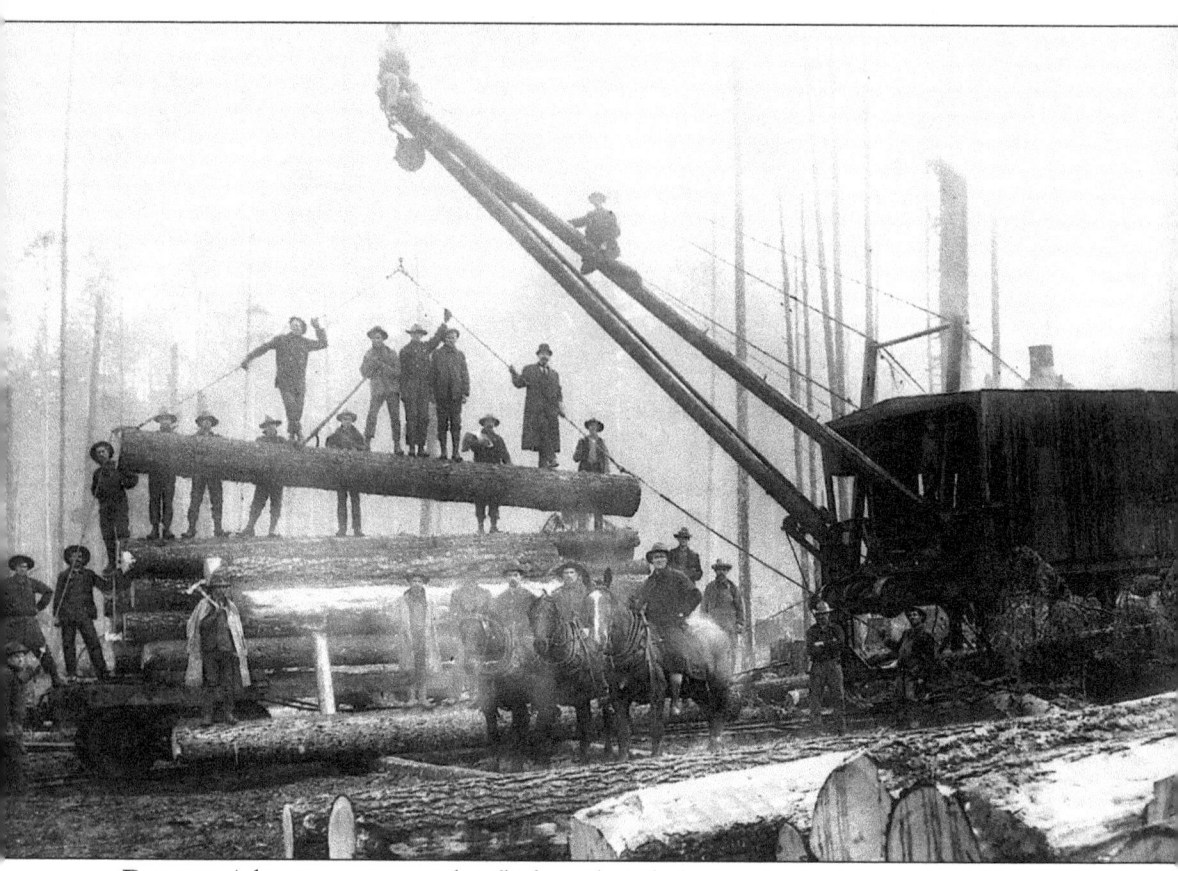

DONKEY. A logging crew poses briefly for a photo before getting back to work with this steam "donkey," which used a boom, hooks, and guide ropes to load logs onto flatcars west of Dee, Oregon. This photo was taken c. 1908 along the Oregon Lumber Company line south of Hood River, Oregon. After the trees were cut, yarders pulled out the stumps and helped clear the land for planting and settlement. There are nearly 30 men pictured in this scene, and it's clear that the logging operations created a huge number of jobs in those days. (Courtesy of the Hood River County Historical Museum Photo Archives.)

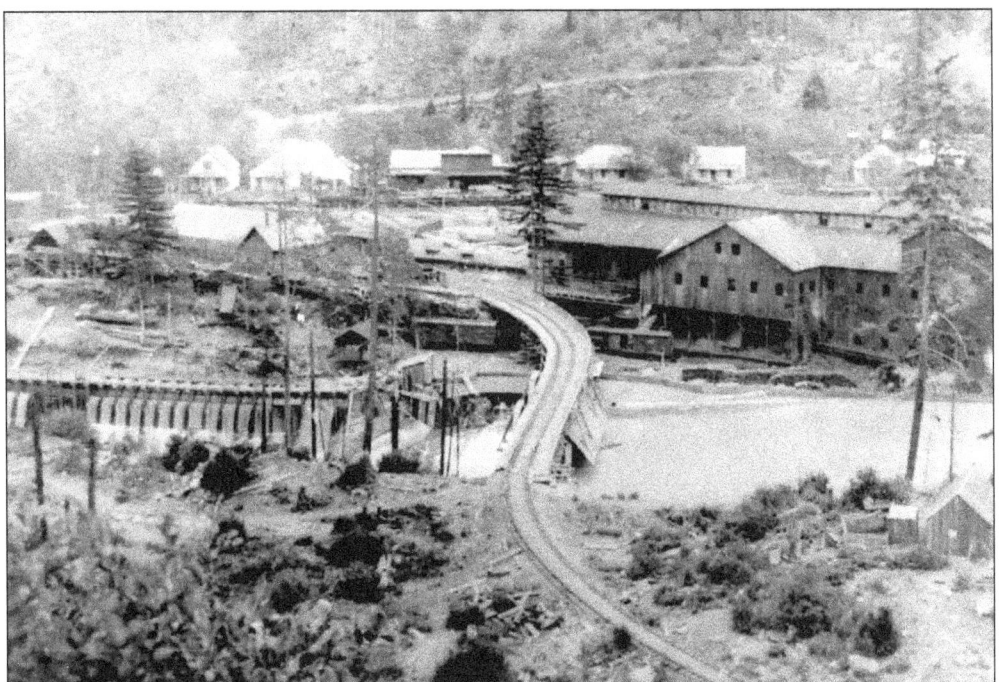

COMPANY TOWN. This shows the Oregon Lumber Company sawmill site and company facilities in Dee, with the rail line cutting through the property and across the Hood River. For about 50 years, Dee was a lively mill town with a company office, post office, beer hall, fruit packing facility, two-story hotel, and about 20 homes. (Courtesy of the Mount Hood Railroad.)

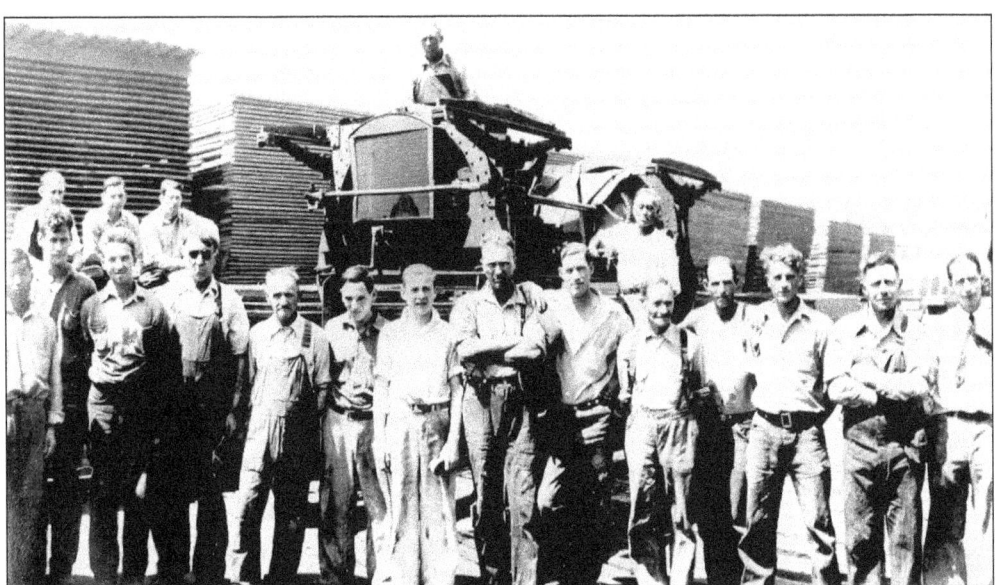

COMPANY CREW. Workers at the Oregon Lumber Company mill at Dee, pose in a company photograph taken on July 25, 1932. The town of Dee was named for Thomas D. Dee, a business associate of mill owner David C. Eccles and a stockholder in the Oregon Lumber Company. The name for the town was chosen when the lumber company's mill was built here in 1906. (Courtesy of the Mount Hood Railroad.)

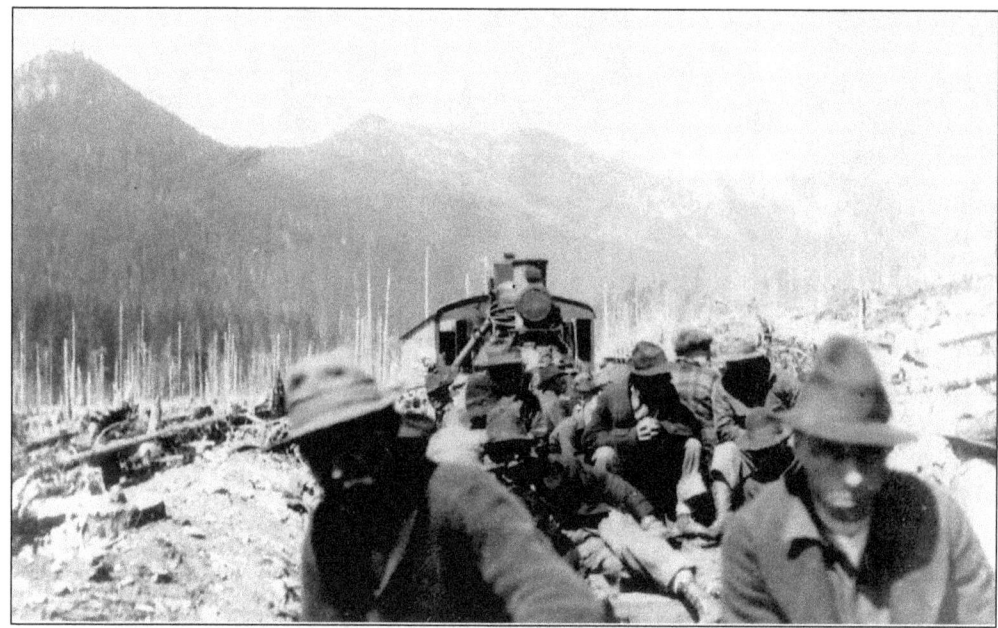

To the Work Site. Rugged men take a ride to their work camp in the woods on the same flatcars they will soon be loading with logs. This scene is from a segment of the Oregon Lumber Company's logging line out of the Dee area. Note the caulk logging boots the men are wearing. (Courtesy of the Mount Hood Railroad.)

Heisler on the Job. Oregon Lumber Company No. 100, a Heisler locomotive built in July 1920, switches at a log-loading site in the Hood River Valley. Note the spark arrester on the smokestack, no doubt employed to reduce fire danger in the dry woods. The locomotive has a long cut of flatcars laden with logs in tow; the logs will soon be on their way to the Dee sawmill. (Courtesy of the Mount Hood Railroad.)

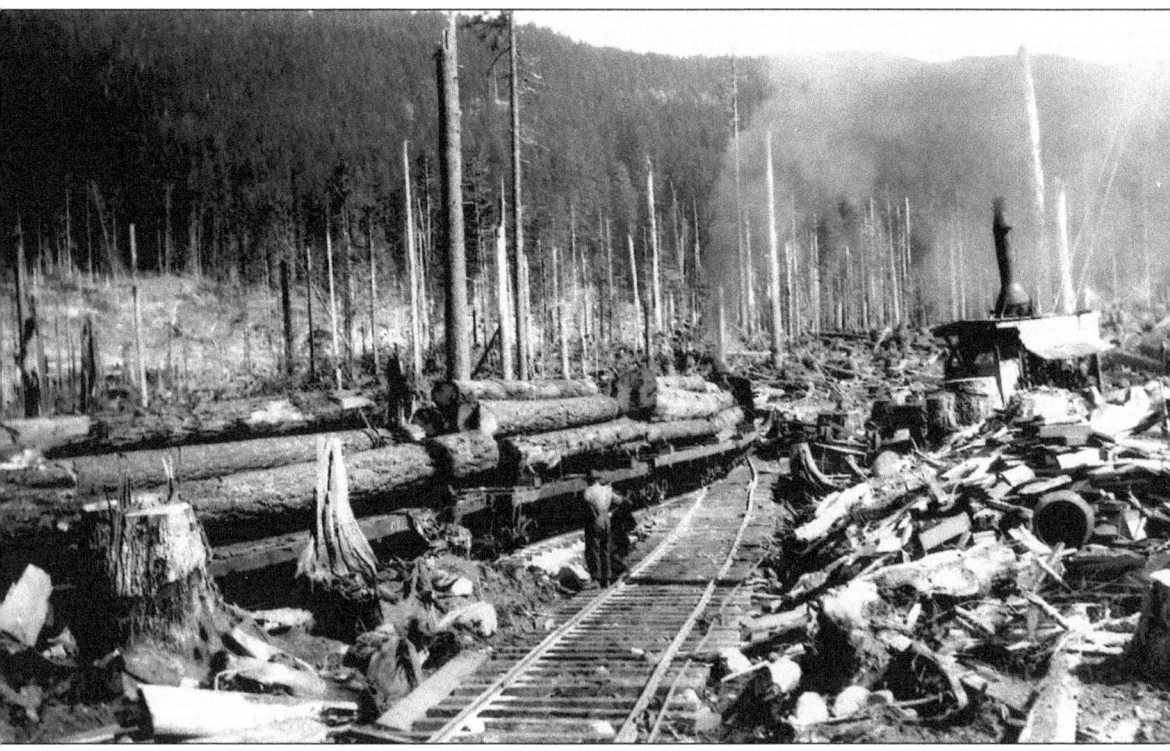

HEAVY LOAD. A loaded logging train is ready to leave "Camp No. 1" in the woods south of Dee. For several years after its construction in 1906, the railroad line out of Dee was used solely as a private carrier to reach the Oregon Lumber Company's timber holdings. A loading platform for old-growth trees was located here in the early 1900s, and logs were loaded onto flatcars and transported to the sawmill at Dee. (Courtesy of the Hood River County Historical Museum Photo Archives.)

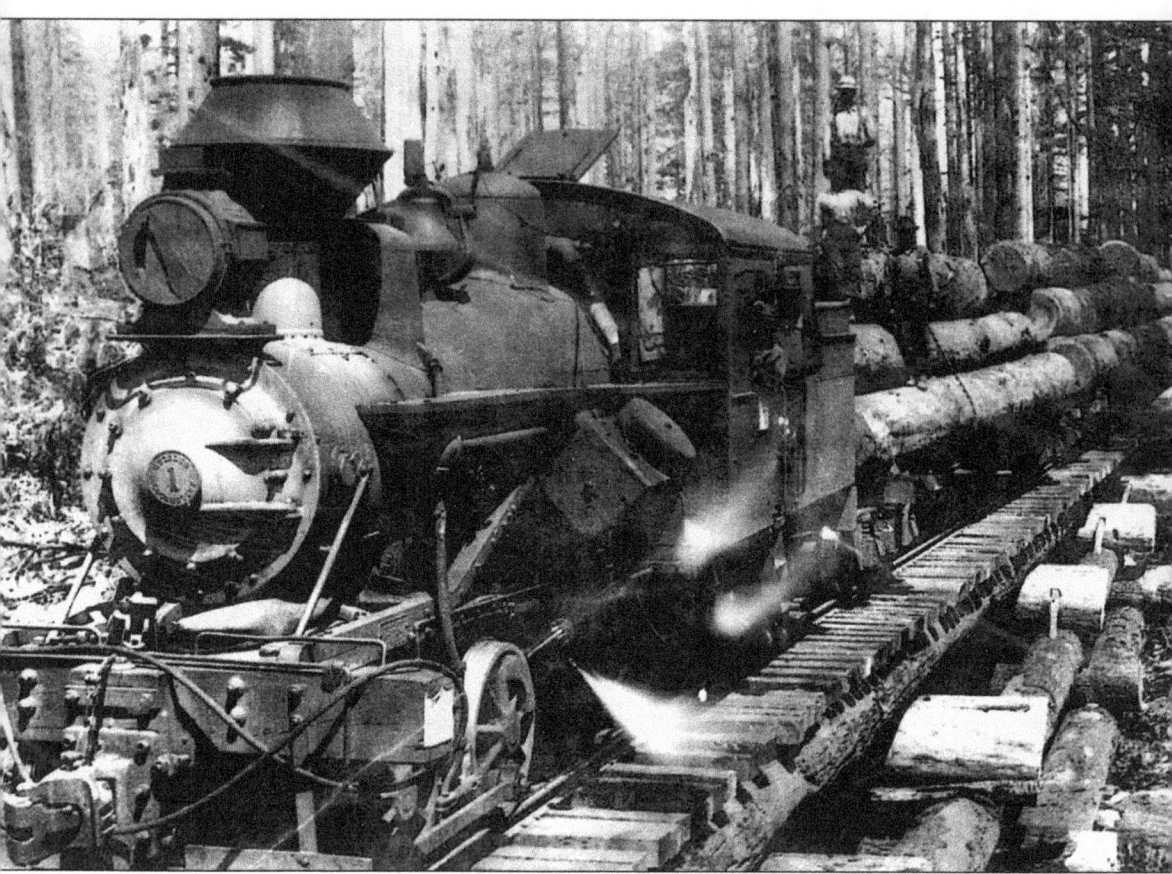

KLICKITAT HAULER. Built by the Heisler Locomotive Company, No. 1 was employed in log-hauling service in the forests around Klickitat, Washington. In 1923 the J. Neils Lumber Company mill at Klickitat was operating three shifts six days a week, and logging trains like this one were bringing in ponderosa pines. The rainfall, sun, and soil of the Klickitat area were said to be especially good for growing high-quality ponderosa pines, one of the reasons why the J. Neils Company, a Minnesota business, bought the mill and its logging railroad from the Western Pine Lumber Company in June of 1922. The Heisler Locomotive Works, based in Erie, Pennsylvania, was formed in 1907 and continued producing locomotives for logging operations until 1941. The Heislers were considered to be the fastest of the geared locomotives. (Courtesy of the Gorge Heritage Museum.)

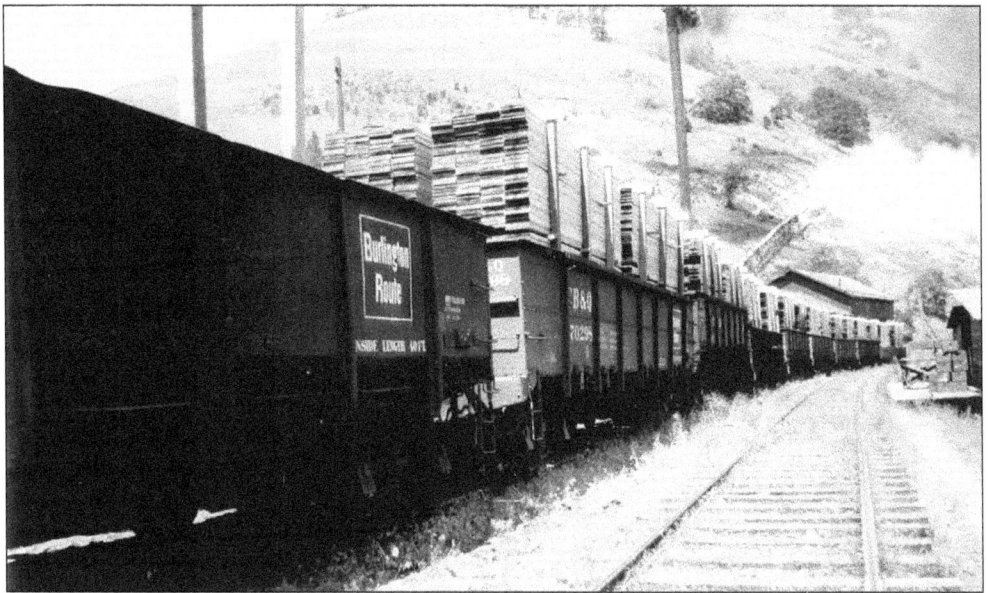

GONDOLA LINE. Chicago, Burlington & Quincy "Burlington Route" gondolas loaded with finished lumber stretch down the tracks out of sight at Klickitat as they await shipment out on the SP&S Goldendale Branch. In the background, one of the J. Neils Lumber Company mill's smokestacks belches out thick smoke. The small building on the right of the tracks is identified as "Robinson's old pop shop." (Courtesy of the Klickitat Historical Preservationists.)

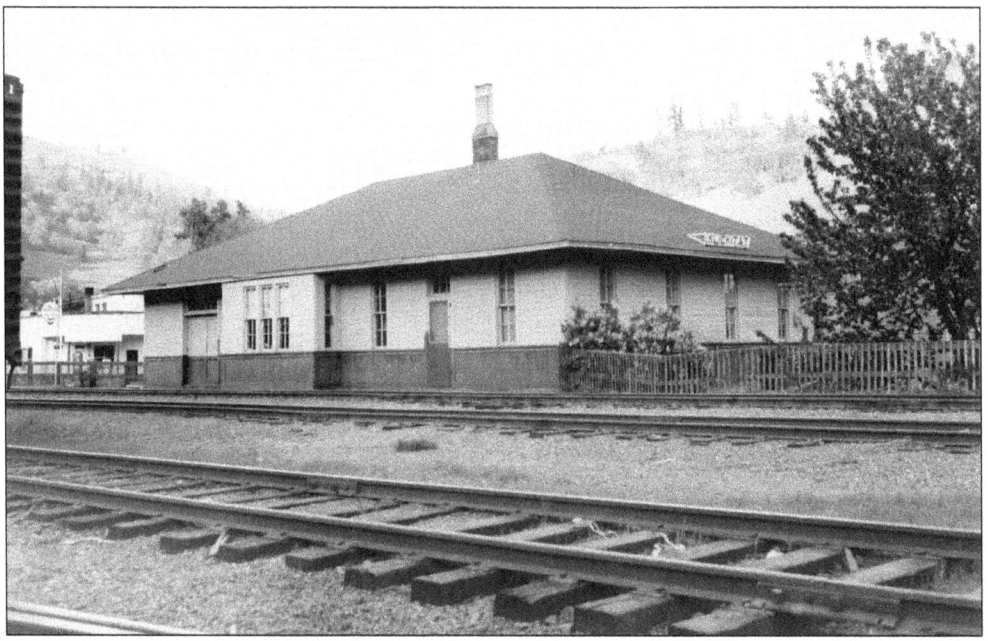

QUIET FOR NOW. Here is the Spokane, Portland & Seattle station in the town of Klickitat, Washington, as seen in July 1969. The SP&S provided daily service to the town's lumber mill, which was less than a quarter mile north of this station. (Photo by Robert W. Johnston, courtesy of Walt Ainsworth.)

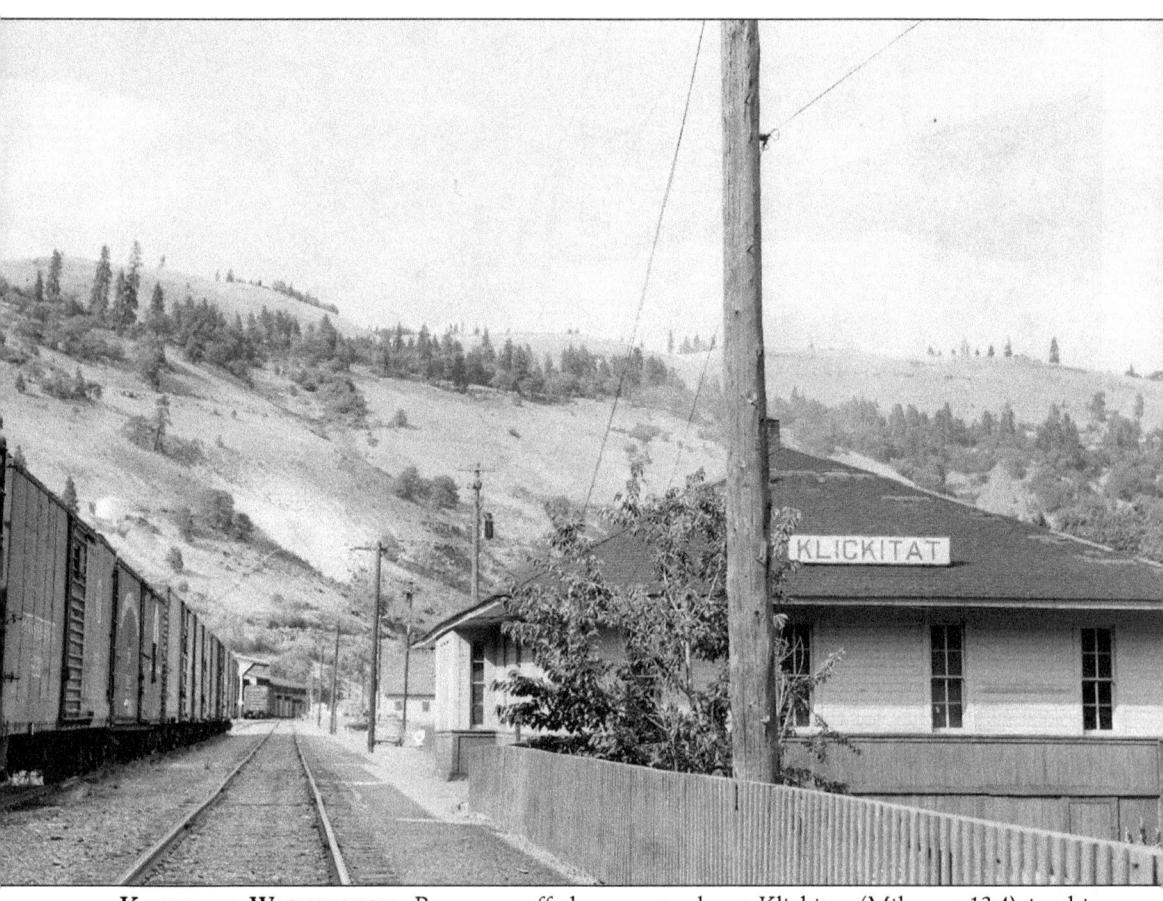

KLICKITAT, WASHINGTON. Boxcars stuff the spur tracks at Klickitat (Milepost 13.4) in this scene from the summer of 1958. The boxcars are waiting to be loaded with lumber from the St. Regis mill visible down the tracks to the left. St. Regis took over the operation from the J. Neils Lumber Company in January 1957. The SP&S based a local crew at nearby Lyle to serve the mill and other stations along the 42-mile branchline to Goldendale. (Courtesy of Walt Ainsworth.)

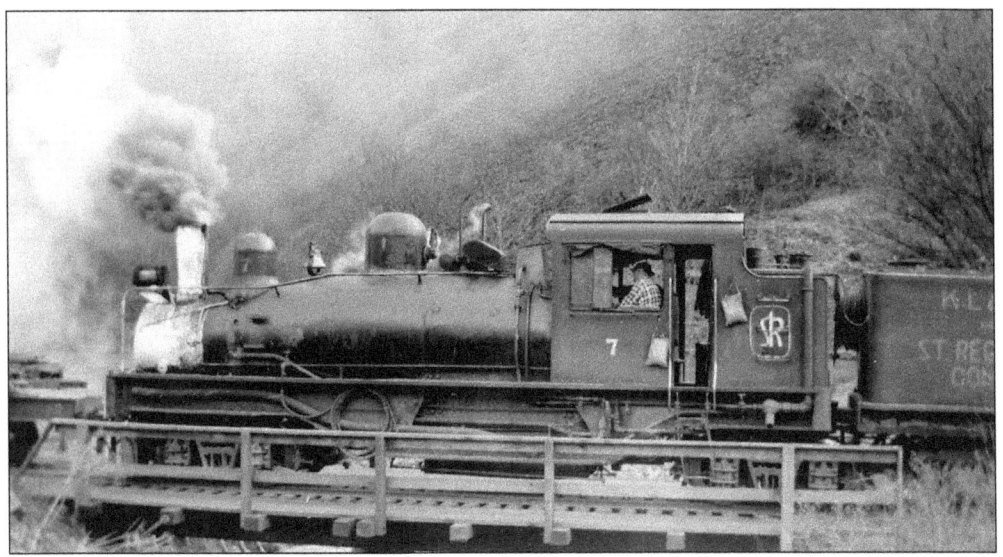

LOGGER'S FRIEND. St. Regis Paper Company No. 7 pours out the smoke as it switches cars at the log-loading site at the end of the line. This locomotive, which first went into service in the Klickitat area in 1942, served until May 2, 1964, when trucks took over. The Shay's gears allowed these engines to climb with logs on steep, rugged grades, making them the favorite of logging crews. Shay No. 7 was the last of the geared Shays working in the Pacific Northwest. (Courtesy of the Klickitat Historical Preservationists.)

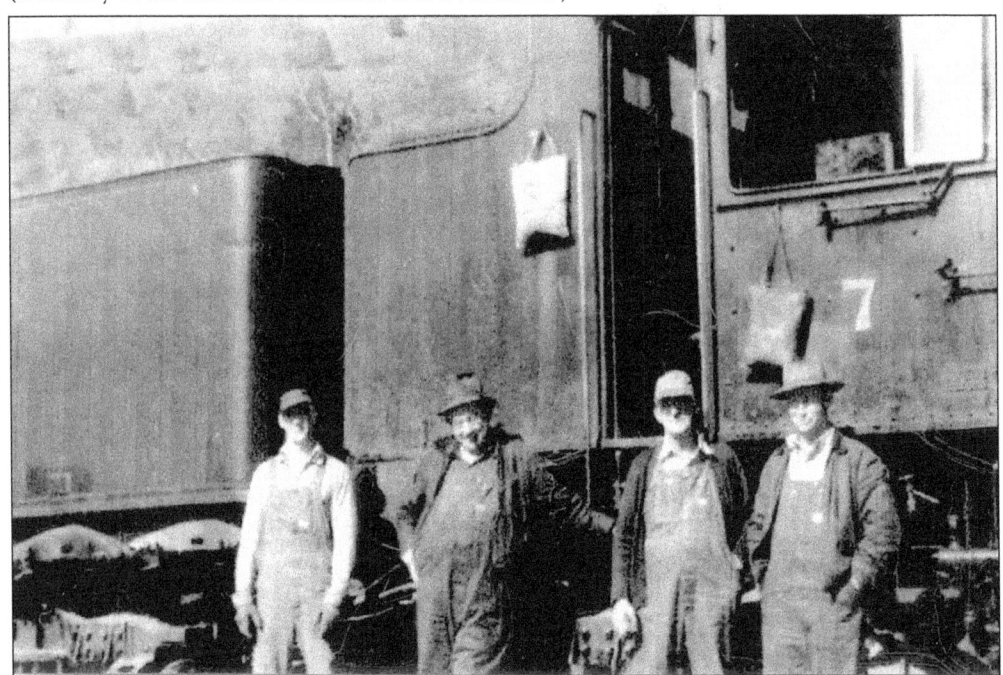

THE CREW OF NO. 7. The four-man crew of Klickitat Log & Lumber Company Shay No. 7 poses in front of the venerable locomotive. From left to right are Ronald Dutson, fireman; Norman Elsner, No. 7's engineer for 20 years; Al Redican, brakeman; and Allan Isaacson, head brakeman. The Lima Locomotive Works of Lima, Ohio, built No. 7 in 1929. (Courtesy of the Klickitat Historical Preservationists.)

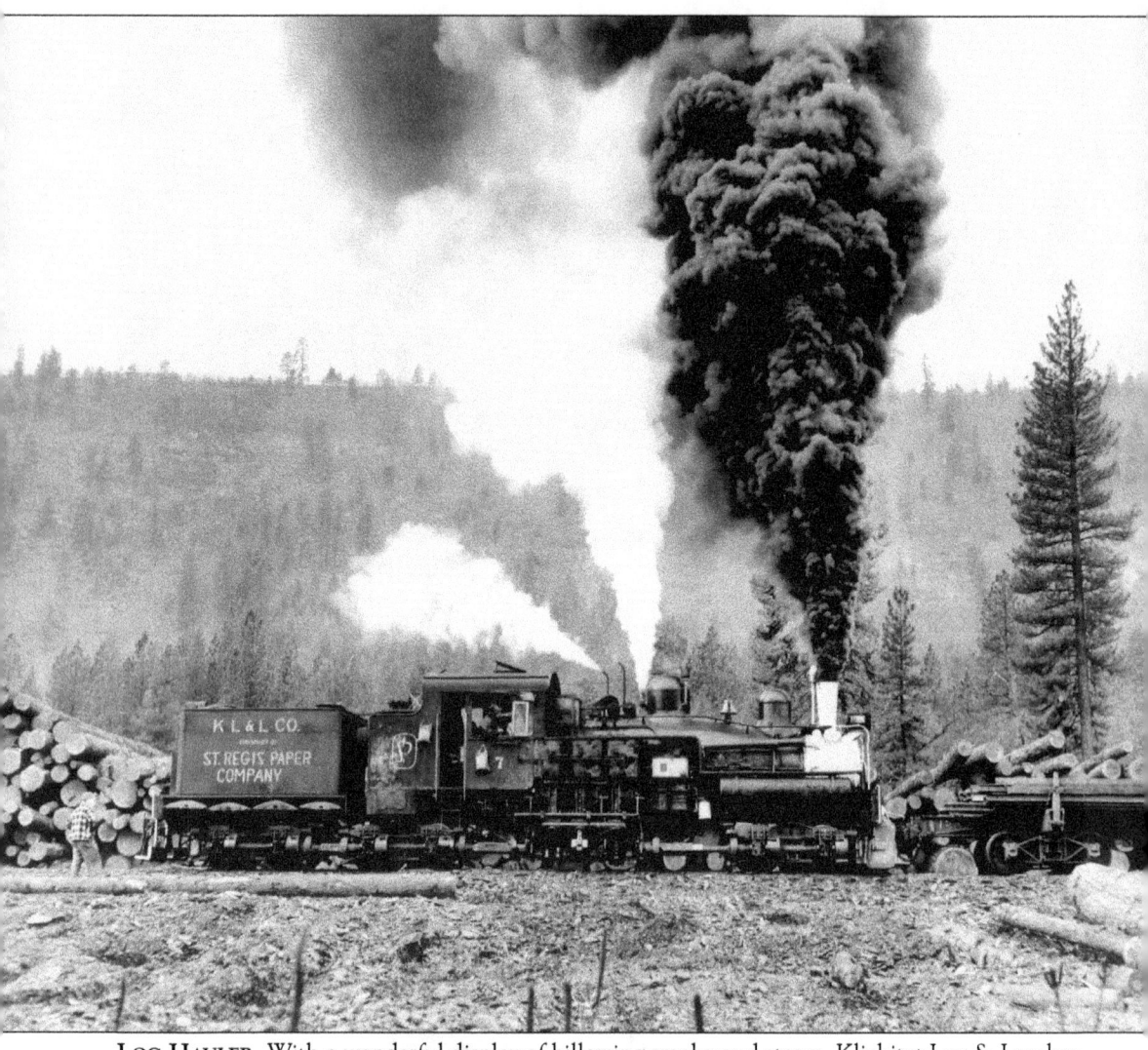

Log Hauler. With a wonderful display of billowing smoke and steam, Klickitat Log & Lumber Company No. 7 works at the end of the 18-mile logging line that wound its way through the woods north from the St. Regis Paper Company mill in Klickitat. Logs were loaded onto flatcars here for transport to the mill. As the wording on the tender reveals, the Klickitat Log & Lumber Company was a subsidiary of St. Regis. The company's logging lines reached from the Klickitat sawmill to within "whistle distance" of Mount Adams. (Courtesy of Ken Bales.)

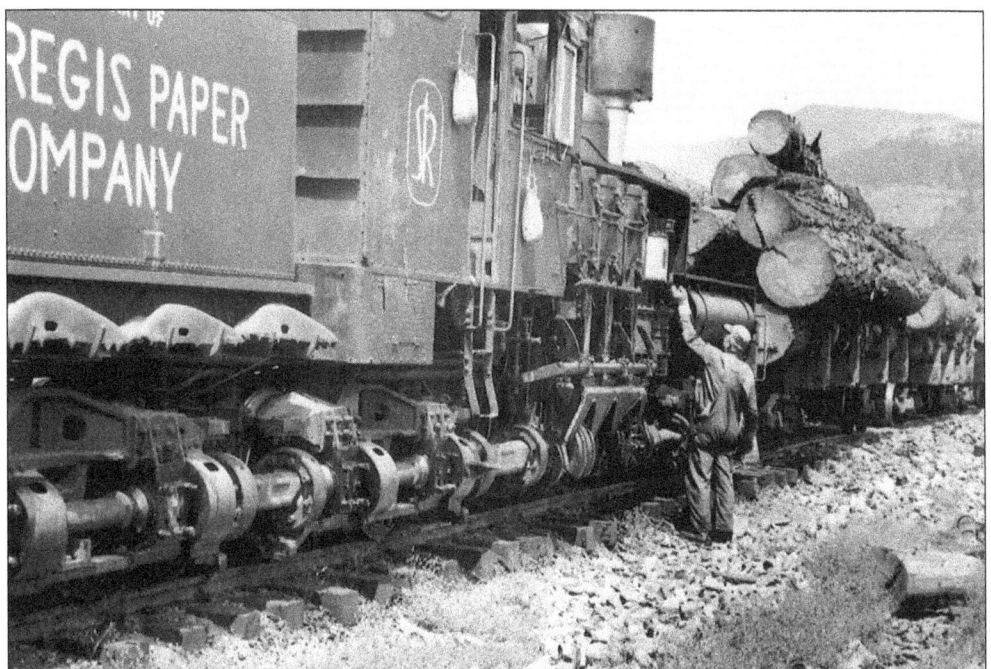

OILING UP. Engineer Norm Elsner knew virtually every part of the Shay locomotive he operated for so long. In 1961, photographer Art Bain of British Columbia, Canada, captured Elsner oiling up his locomotive before leaving the reload site for the trip back to the St. Regis mill in Klickitat. (Photo by Art Bain.)

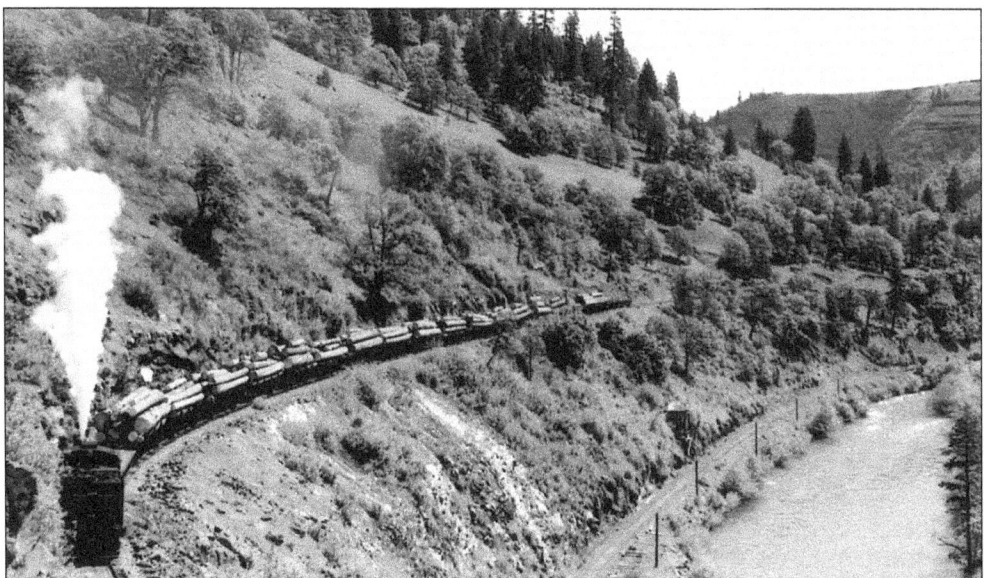

BRINGING IN THE LOADS. A log train makes its way backward through the Klickitat River Canyon north of Klickitat with another load of pine logs to feed operations at the Klickitat sawmill. Most of the mill's timber resources were on a plateau above the canyon, and trains traversed two switchbacks to get to the trees. The railroad line was built to replace an incline that relied on cables to lower logs over a 1,500-foot canyon. (Courtesy of the Klickitat Historical Preservationists.)

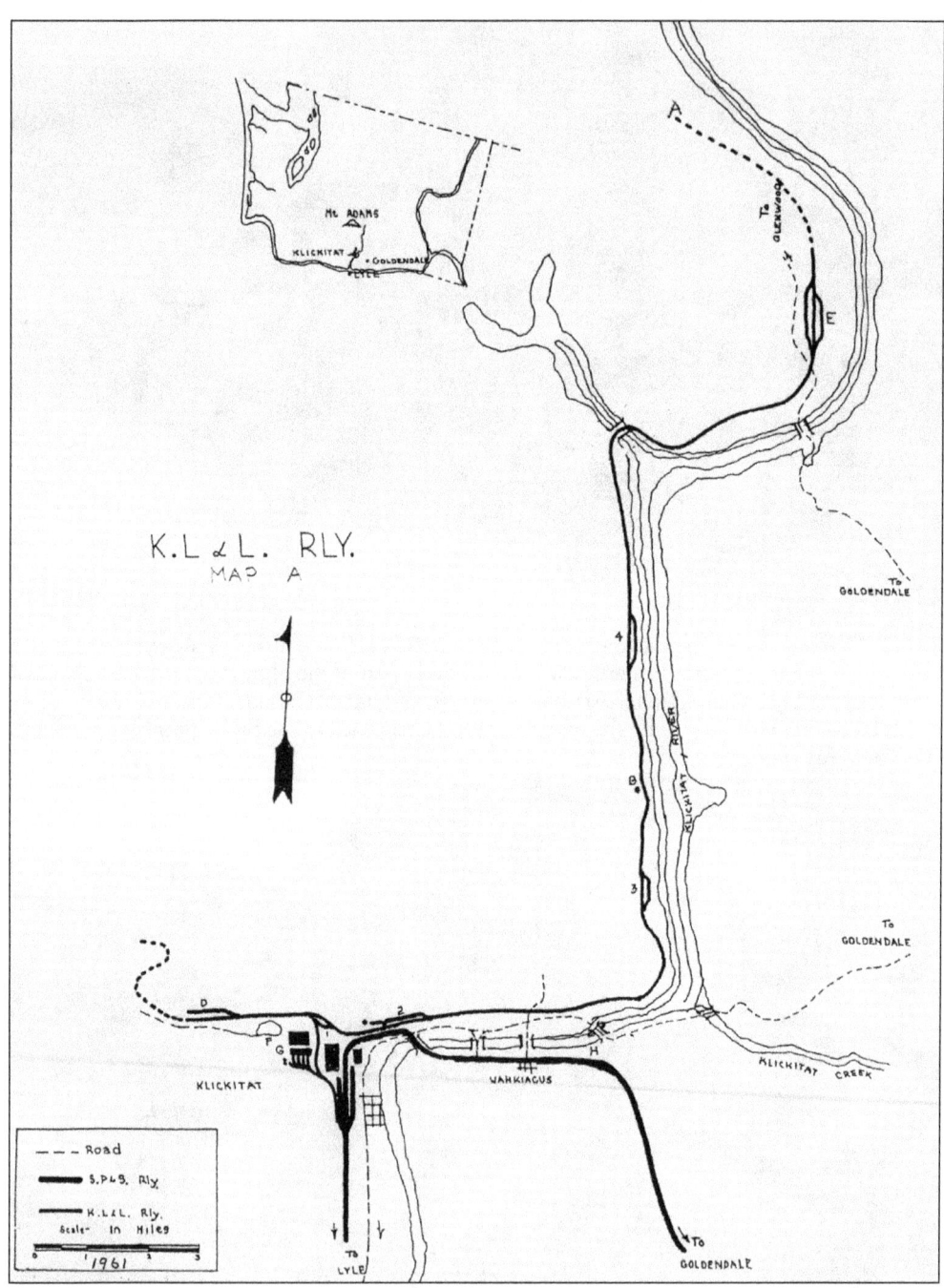

SCHEMATIC OF OPERATIONS. A hand-drawn map shows the Klickitat Log & Lumber Company lines as they existed in the early 1960s. Art Bain, a photographer from Canada, created this map during a visit to Klickitat in 1961. He identified several key locations as follows: A) abandoned section of the KL&L that went to Trout Lake; B) location of the water tank; C) trestle at Dead Canyon; D) log dump siding; E) truck reload site; F) mill pond; G) roundhouse and car shops. The numbers (1–4) show where the logging railroad's sidings were. (Map drawing by Art Bain, courtesy of Bob Stanton.)

108

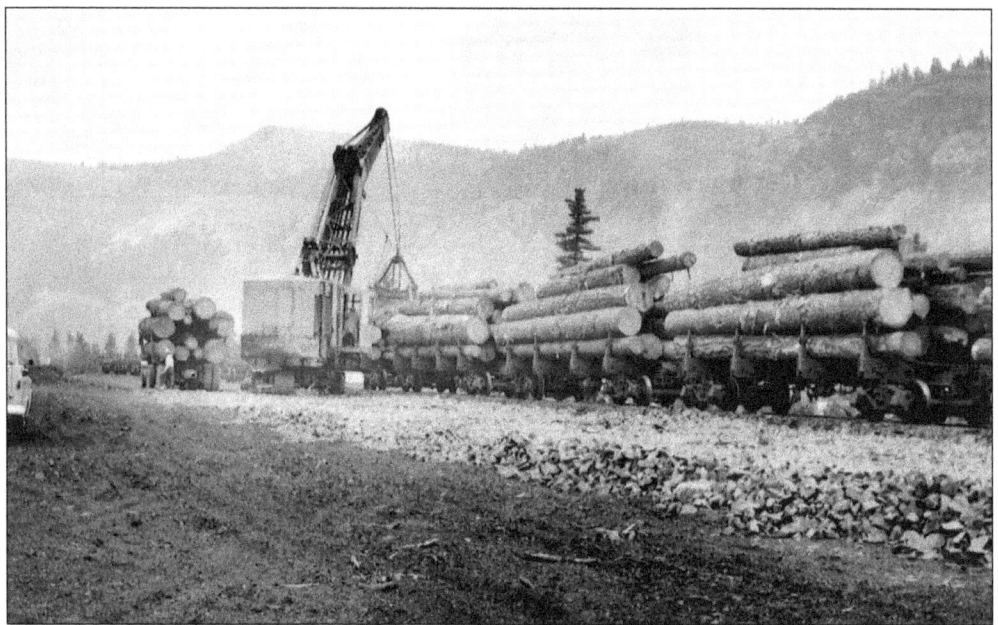

TRANSFER STATION. At the northern end of the rail line, the loader is placing logs onto flatcars at the truck reload site of the KL&L in this photo from 1961. A truck has brought in its load, and the heavy-duty crane will transfer the logs from the truck to a waiting flatcar, which will in turn be hauled by rail to the Klickitat mill. (Photo by Art Bain.)

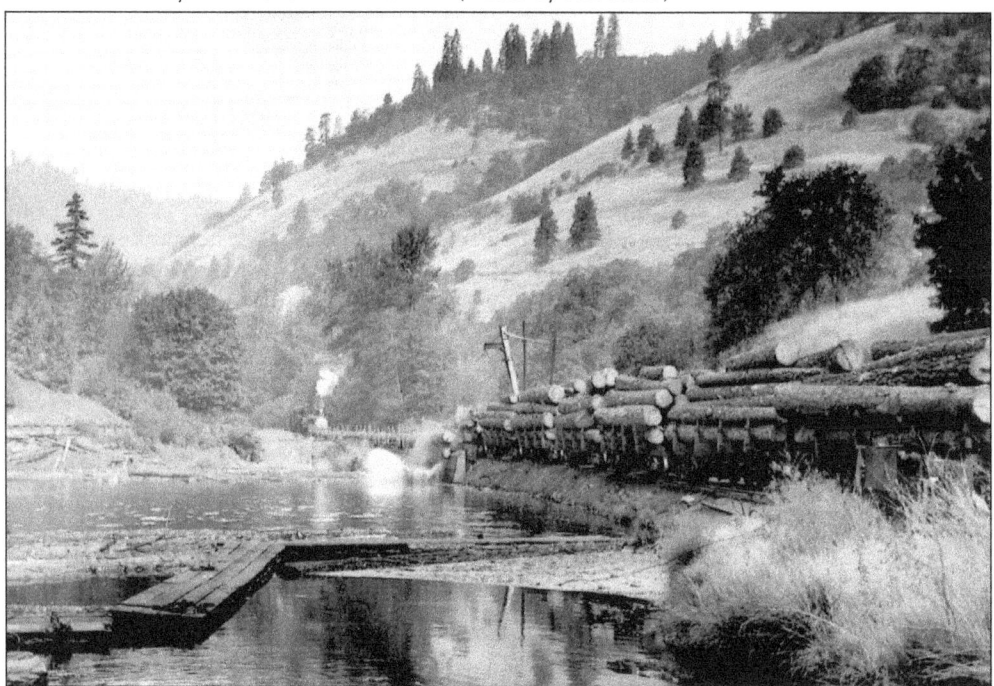

SPLASHING IN. A logging operation that has become a part of the Northwest's past: KL&L No. 7 works at the log dump, slowly edging a string of skeleton flatcars along the line as, one by one, they drop their loads of freshly cut pine logs into the St. Regis Paper Company's mill pond at Klickitat. (Photo by Art Bain.)

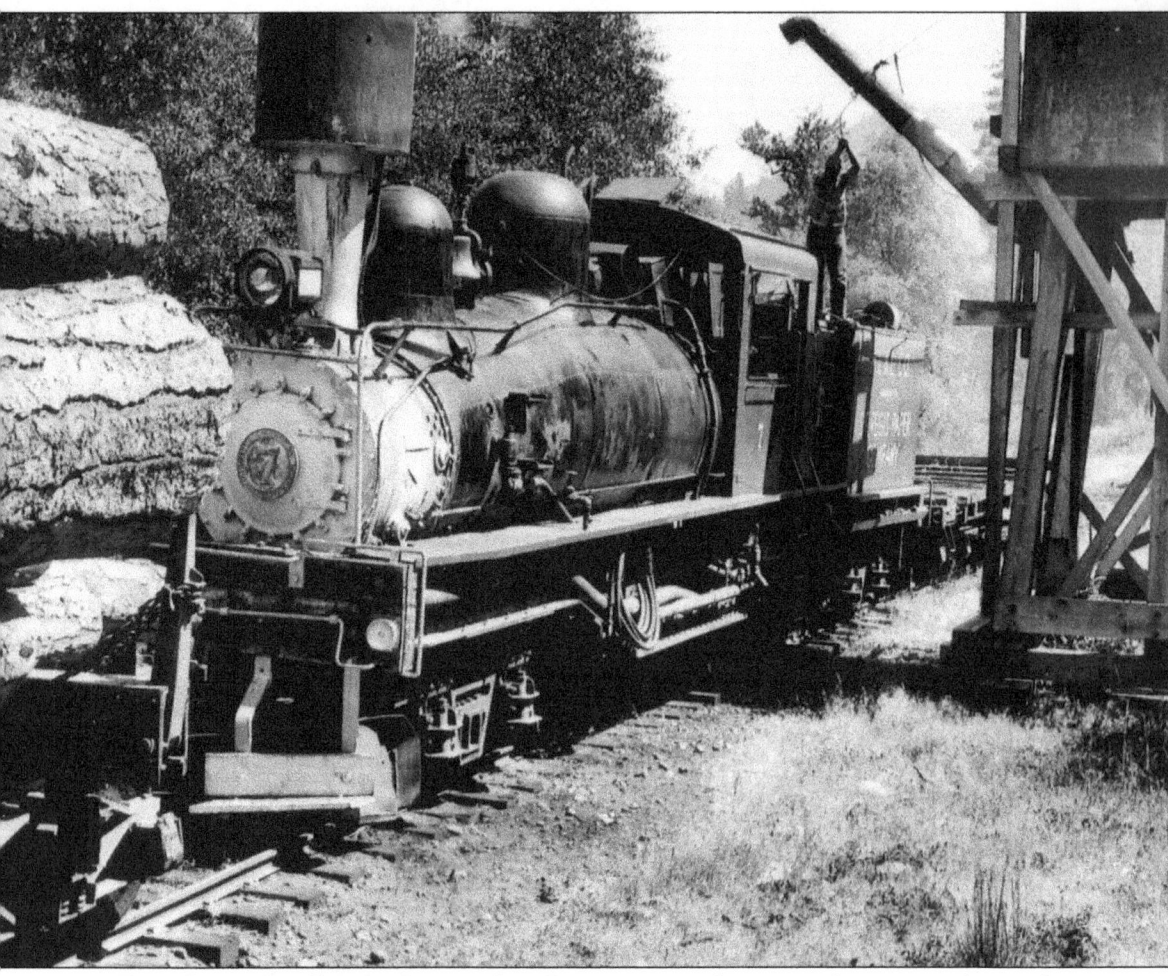

TIME OUT FOR A DRINK. Fireman Ron Dutson swings the spout of a water tank so a thirsty No. 7 can take on water before returning to the mill at Klickitat. This water tank was roughly halfway between the log pond and the truck reload site at the end of the line. At one time, logging spur lines reached as much as 75 miles out of Klickitat, stretching almost to the White Salmon River north of Trout Lake. It is estimated that No. 7 hauled 133,900 cars of pine logs to the Klickitat sawmill over its years of service from 1939 to 1964 at a rate of 30 to 35 cars daily. (Photo by Art Bain.)

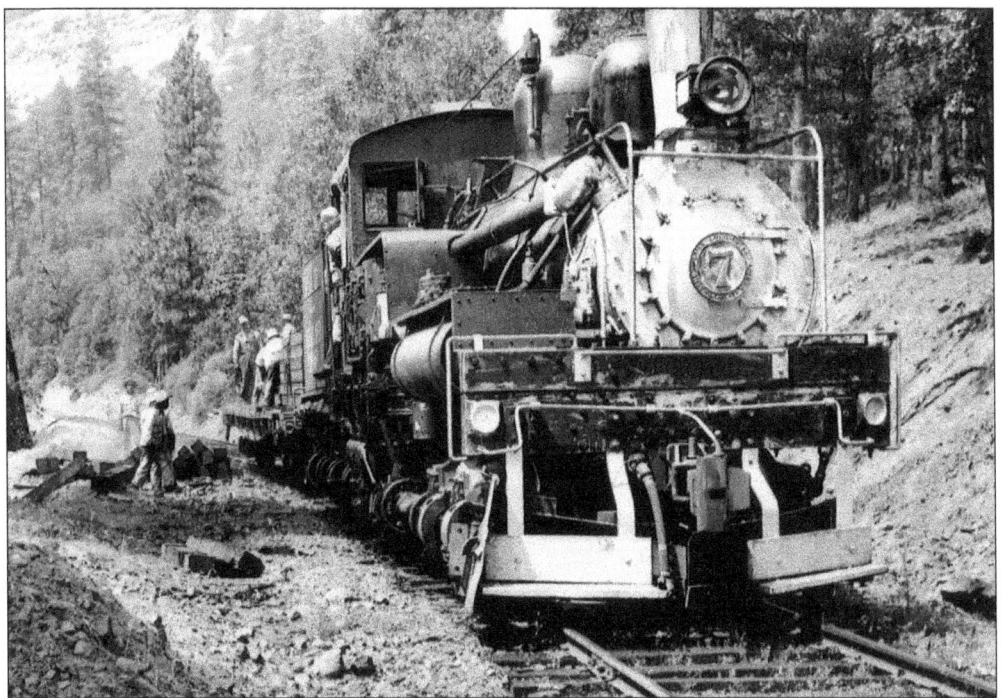

PART OF THE JOB. KL&L No. 7 had more to do than just move logs from the reload site to the sawmill. In this scene, the locomotive is hauling a flatcar, helping the track section crew distribute a load of new ties along the right of way. (Photo by Art Bain.)

BACK TO THE HOME SHED. After another day's assignments have been completed, KL&L No. 7 returns to the logging railroad's car shop and roundhouse at the Klickitat mill. The venerable 1929-era Shay is shown backing into the locomotive shed for the night. Note how the smoke from the locomotive has left its mark on the building that houses it. (Photo by Art Bain.)

STACKED TO THE ROOF. In July 1982, a forklift driver at the Klickitat mill loads lumber into a line of bright red Thrall All-Door boxcars lettered for parent St. Regis. The "All-Door" boxcars made for efficient loading by the mill crews, and according to some of the proud loading crews from the era, a car could be fully loaded within 20 minutes. Champion International purchased the mill from St. Regis in 1984. (Courtesy of the Klickitat Historical Preservationists.)

EMPTY BRIDGE. Milepost 2.1 is shown along the remains of the old SP&S Goldendale Branch, which was the KL&L's connection to the outside world. This is the Fisher Hill railroad bridge over the Klickitat River, a couple miles north of Lyle. In 1993 the rails and ties were removed from what had been a Burlington Northern branchline. The closure of the mill at Klickitat in the early 1990s was one of the key reasons why the branchline was abandoned. (Photo by D.C. Jesse Burkhardt.)

Six

CONTEMPORARY
OPERATIONS

SNAKING ALONG THE RIVER. A "bare table" train of empty container flatcars rolls east through pristine Lyle, Washington, on Burlington Northern Santa Fe rails in April 2002. The empty right of way to the right of the tracks was once the grade of the Goldendale Branch, which went north from here to Klickitat and Goldendale. (Photo by D.C. Jesse Burkhardt.)

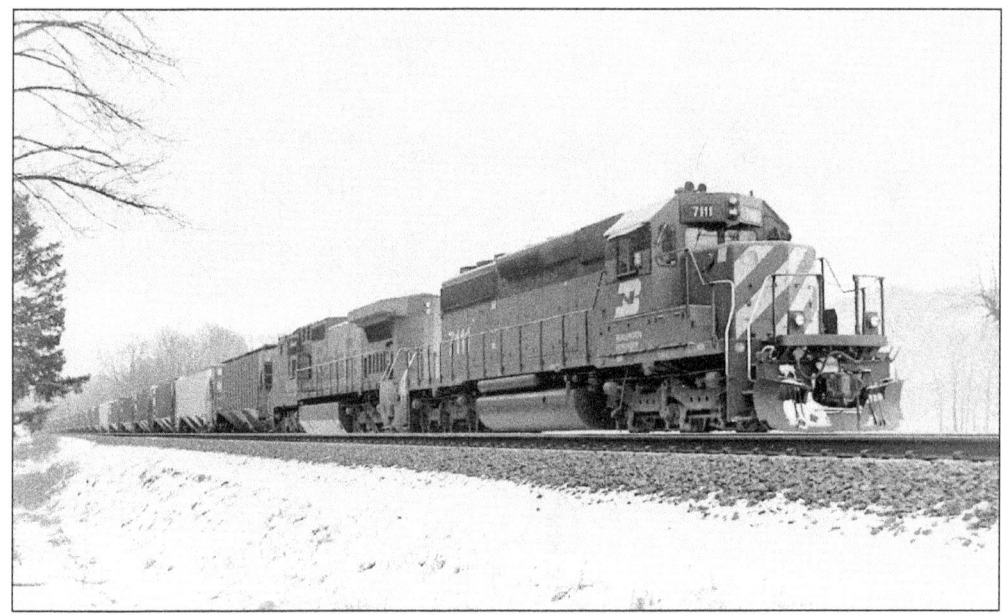

EAST FROM WASHOUGAL. With a light dusting of snow covering the landscape, a grain train rolls eastward not far out of Washougal, Washington, in February 1996. Leading the way is BN No. 7111, one of the carrier's workhorse SD40-2 locomotives that were so common through the 1990s. The Santa Fe unit trailing the SD40-2 is a more modern Dash-9 design. (Photo by Chris Jaques.)

SWITCHING AT SDS. A crewman stands alongside the *Wishram West Local*, which is waiting for two westbound freights to clear before completing its switching at the SDS Lumber Company mill in Bingen, Washington, in August 1998. The local has a pair of GP38-2s for power, including BNSF No. 2267, a refurbished engine with what was then the new Burlington Northern Santa Fe merger paint scheme. (Photo by D.C. Jesse Burkhardt.)

THE WESTERN ALLIANCE. A Union Pacific freight led by the "merger power" of Union Pacific C40-8 No. 9222, Denver & Rio Grande Western SD40T-2 No. 5358, and Southern Pacific SD40-2M No. 8630 heads westbound on a fill over the Columbia River near Rowena, Oregon, with a trainload of automobiles and auto parts. (Photo by D.C. Jesse Burkhardt.)

RACING EASTBOUND. On April 25, 1998, Union Pacific Railroad C40-8 No. 9130 blasts eastbound through Mosier, Oregon, leading a stack train on the Portland Subdivision. In the background is part of UP's competition in the form of a semi-truck hauling chemicals on parallel Interstate 84 through the Columbia River Gorge. (Photo by Chris Jaques.)

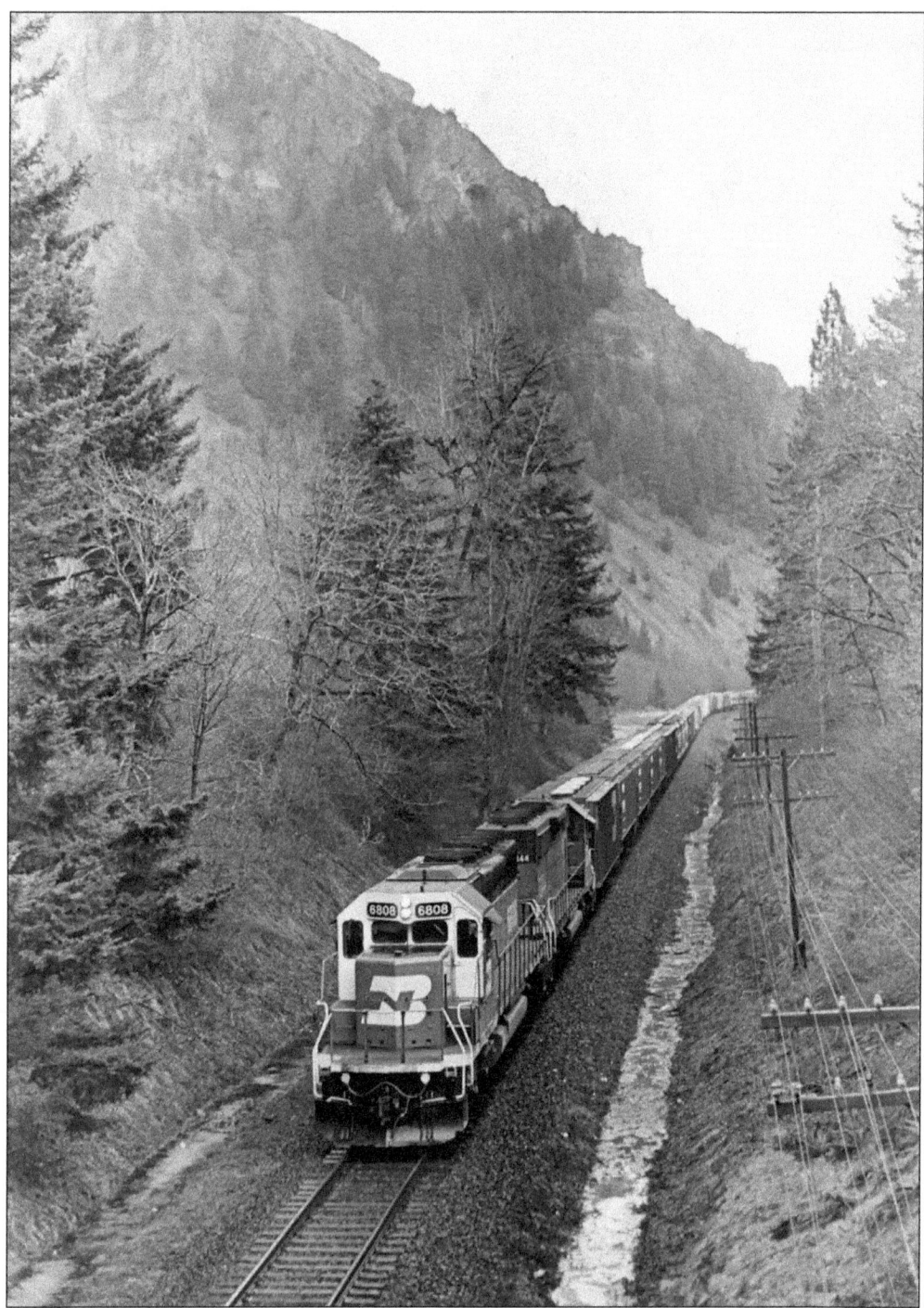

Lost in the Landscape. A Vancouver-bound grain train powers through the rugged scenery around Home Valley, Washington, on Burlington Northern Santa Fe rails. Two SD40-2s, the first with the high-visibility "white face" paint scheme, lead the train west. The date is March 3, 1996, and the ditches alongside the tracks are filled with water from the almost constant rain typical in the gorge at this time of the year. (Photo by D.C. Jesse Burkhardt.)

$1 TO PORTLAND. A mixed merchandise freight glides east on Union Pacific's Portland Subdivision in The Dalles, passing an advertising mural that boasts river passage to Portland for $1 on the "Regulator Line," the long-defunct daily steamship service between The Dalles and Portland. The Regulator steamships operated during the 1880s and 1890s, transporting merchandise and passengers along the Columbia River. The building on which the mural is painted went up in 1863. (Photo by D.C. Jesse Burkhardt.)

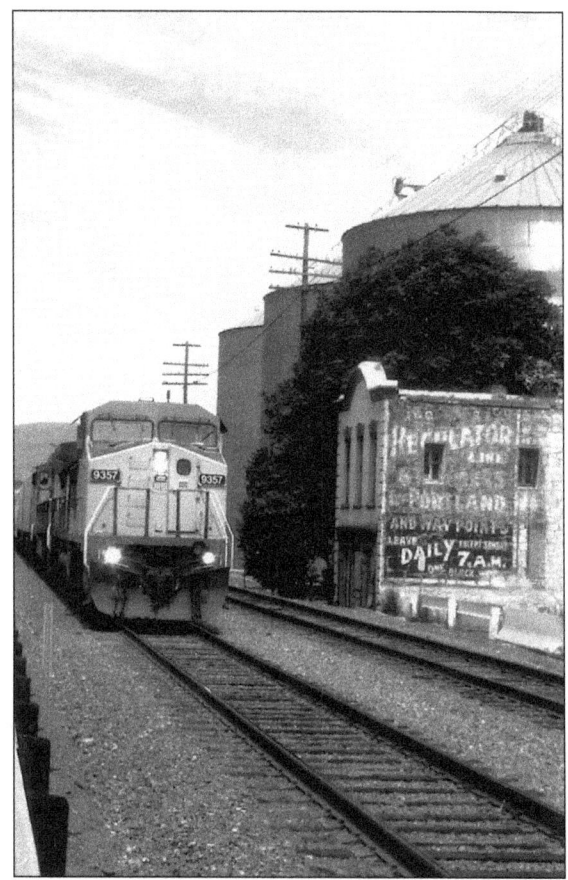

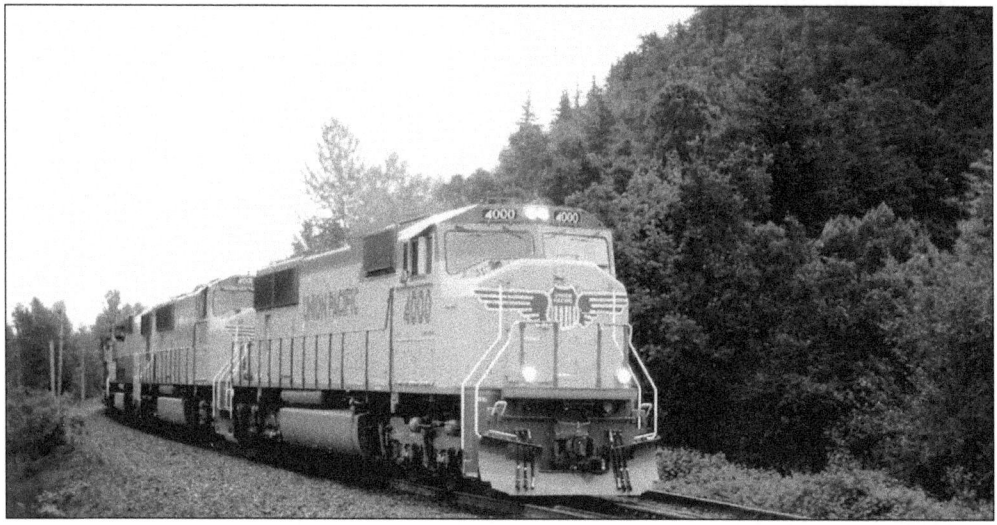

WINGS OF THE WEST. In 2000, Union Pacific went "back to the future" by reviving its historic winged shield logo. In May 2000, a stack train fronted by UP No. 4000 and No. 4001 rolled east through Bridal Veil, Oregon, on the way to Portland. The flying shield logo was originally introduced by UP in 1939, first appearing on an E3A locomotive. (Photo by Chris Jaques.)

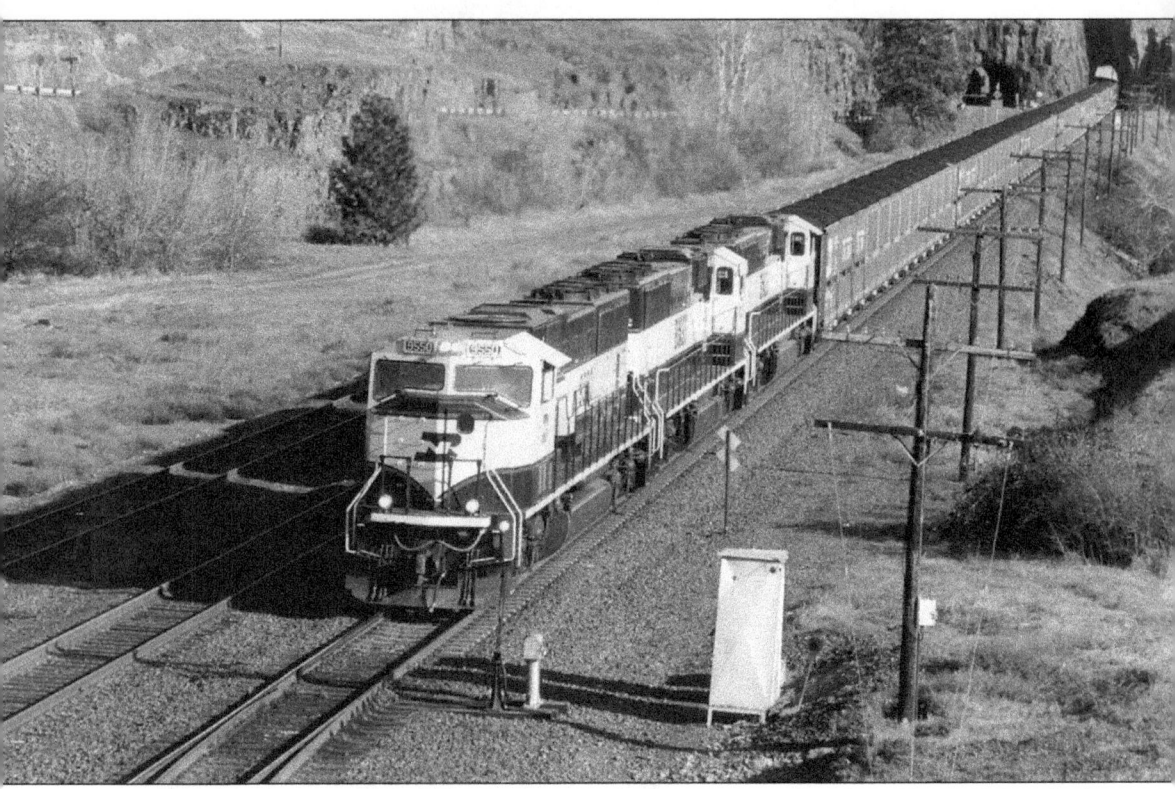

WESTWARD COAL. Pulled by three Burlington Northern Santa Fe Railway SD70MACs, a high-tech coal unit "trough train" streams seamlessly west though Lyle, Washington, on March 11, 1998. The cream-colored locomotives became symbols of the railroad's lucrative Wyoming coal operations, as they were used almost exclusively for coal train service. This load of coal is coming from Wyoming's Powder River Basin and is headed to a coal-fired power plant at Centralia, Washington, on the Seattle Subdivision about 80 miles north of Vancouver. (Photo by D.C. Jesse Burkhardt.)

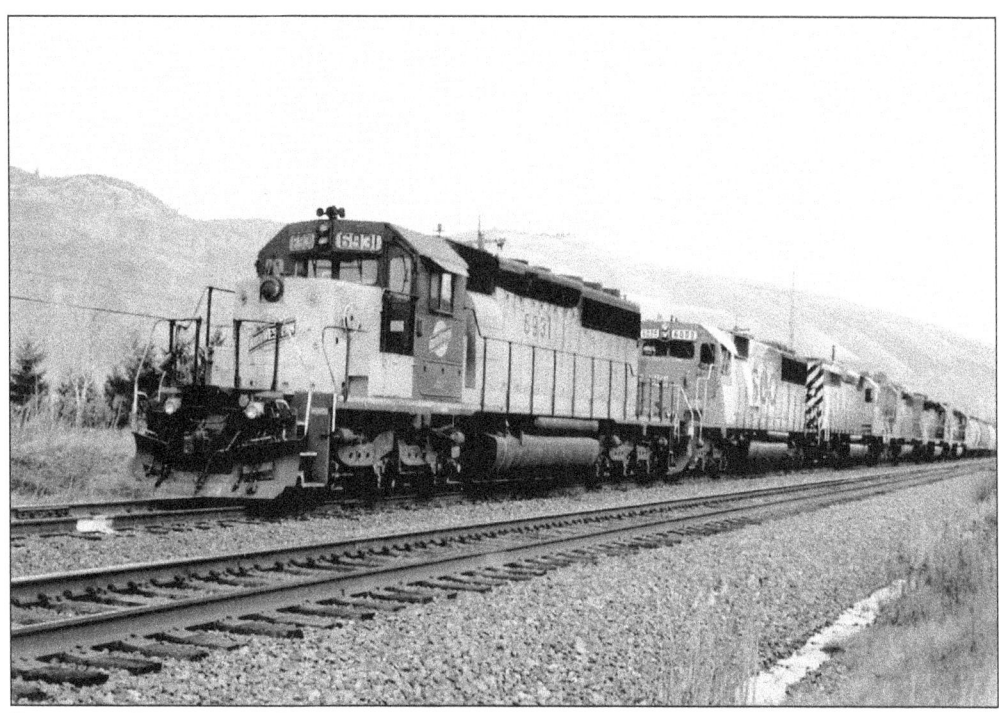

RAINBOW ASSORTMENT. In January 1999 a wild mixture of carriers provides power for a westbound potash train waiting on the siding at Rowena, Oregon, on Union Pacific's Portland Subdivision. Six locomotives are pulling this unit train, but none of them carry the Union Pacific name. Seen instead are locomotives from Chicago & NorthWestern, Soo Line, CP Rail, and Southern Pacific. (Photo by Mike Federman.)

OFF THE SIDING AT COOKS. With diesel smoke flying, a Burlington Northern westbound mixed merchandise train rolls out of the passing siding at West Cooks, Washington, on its way to Vancouver in the summer of 1995, just days before the Interstate Commerce Commission's approval of the BN/Santa Fe merger became official on August 23, 1995. (Photo by D.C. Jesse Burkhardt.)

CROWDED YARD. The Wishram, Washington, freight yard is shown in February 1996. Three westbounds are lined up and waiting, a relatively unusual sight in Wishram after Burlington Northern ended crew changes here in 1994. Nowadays, more often than not, this yard is relatively bare. For 83 years Wishram served as a crew-change point for trains traveling between Pasco and Vancouver. (Photo by D.C. Jesse Burkhardt.)

SOUTHWARD FROM WISHRAM. With caboose No. 12302 trailing, a Burlington Northern mixed manifest train crosses the Columbia River on the Celilo drawbridge as it leaves the yard at Wishram and heads south onto the Oregon Trunk Subdivision. Pulling this day's freight—visible on the bridge to the left of the caboose—are BN units No. 7110, No. 7923, and No. 7101. The date is February 18, 1996. (Photo by D.C. Jesse Burkhardt.)

STATE TO STATE. A southbound BNSF freight crosses the Columbia River drawbridge at O.T. Junction, Oregon, in June 1999, just as an eastbound UP freight passes by underneath. The end of the train is visible to the left of the bridge—still in Washington—as the locomotives rumble slowly across into Oregon. The BNSF train is on its way to northern California, on the "Inside Gateway" route of the old Oregon Trunk Railway. The bridge was built in 1911. (Photo by Zach Tindall.)

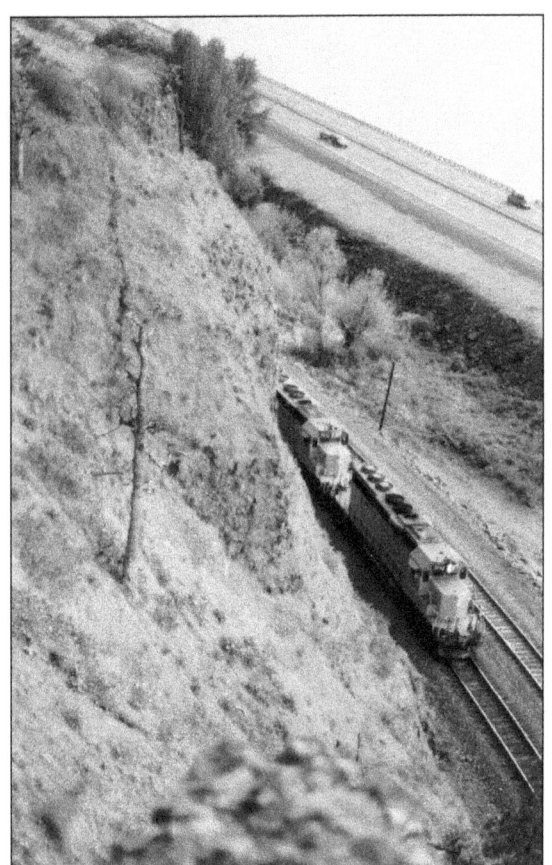

STEEP SLOPES. Here is a hawk's-eye view of rugged, beautiful bluffs and an eastbound Union Pacific freight taking the siding at Mosier, Oregon. To the right, traffic roars by on busy Interstate 84, which runs between the Columbia River and the UP line through this area. (Photo by Scott Sparling.)

BLOWING EAST. A trash-hauling train heads east through Bingen in a driving snowstorm on December 22, 2000. The containers of garbage, coming out of the Seattle metropolitan area, are bound for the Rabanco Regional Disposal Company landfill in Roosevelt, Washington, in eastern Klickitat County. The county takes in a guaranteed $6.2 million per year for allowing several municipalities to dump their trash at Roosevelt, and BNSF shares in the bounty by handling the freight. (Photo by D.C. Jesse Burkhardt.)

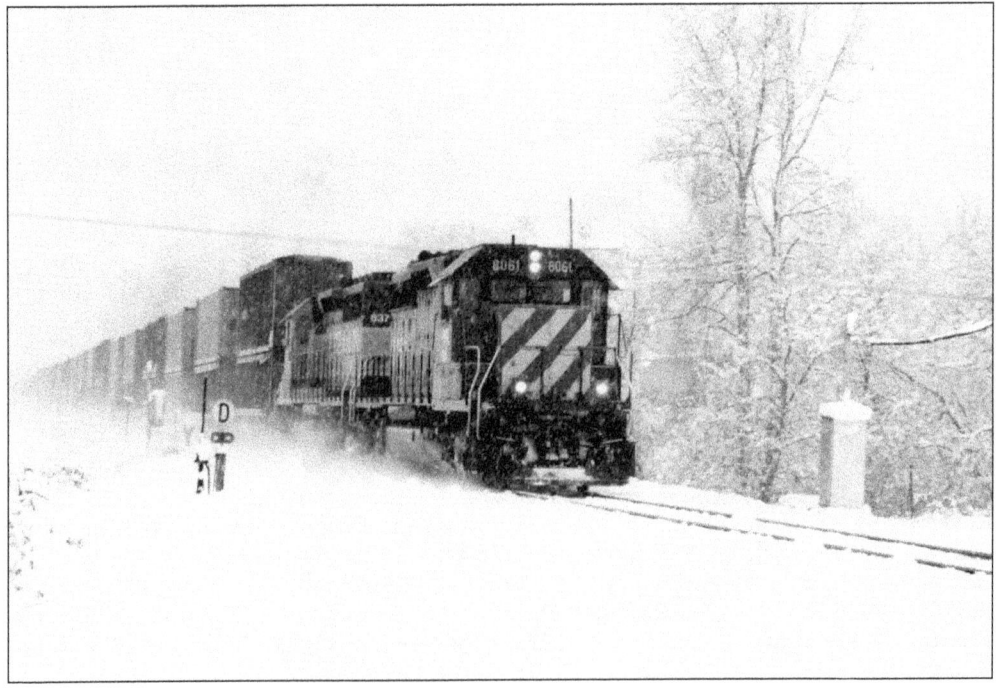

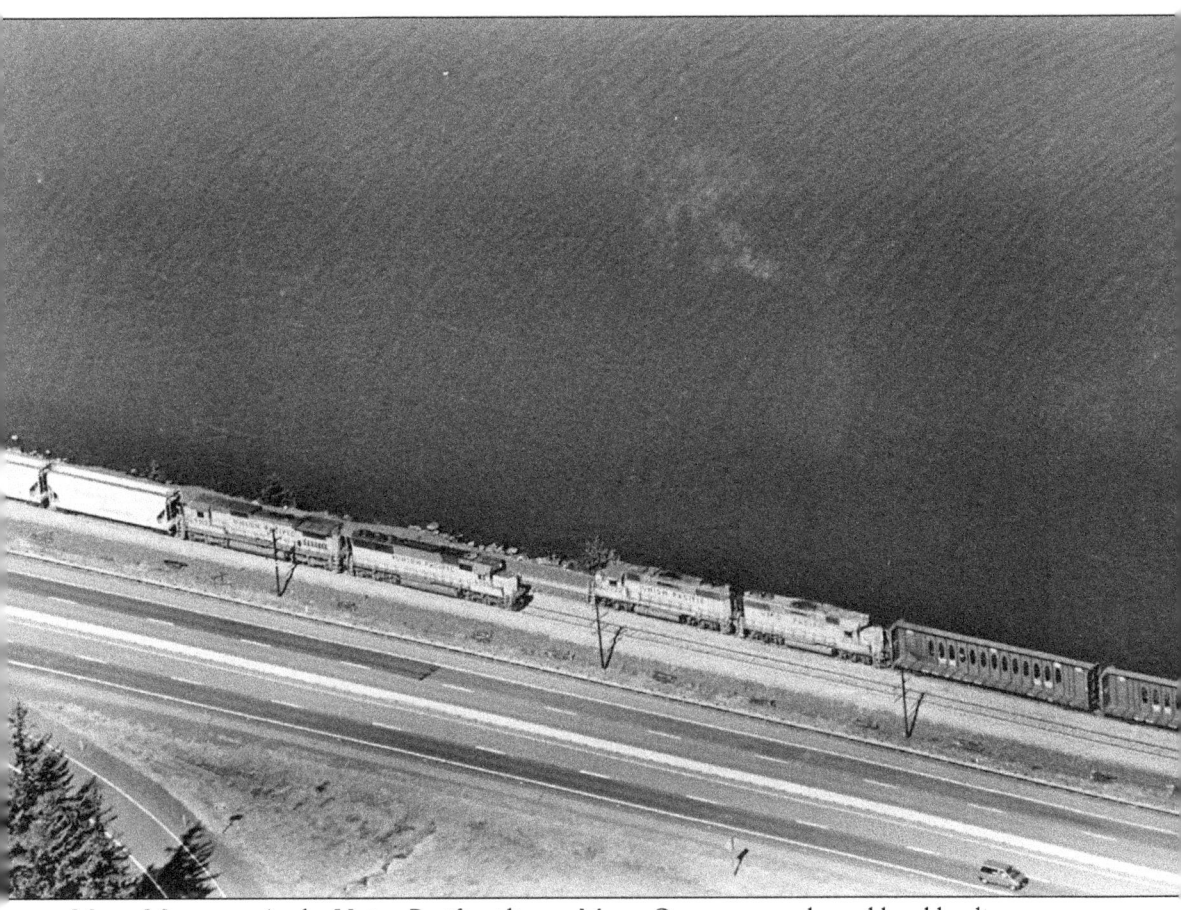

MENO MEETING. At the Union Pacific siding at Meno, Oregon, a westbound local hauling two empty center-beam flatcars meets an eastbound unit train in September 1995. UP's east-west tracks here are squeezed between Interstate 84 to the south and the Columbia River to the north. The local is using two aging GP38-2s (No. 2022 and No. 2035), while the through train employs an SD60 (No. 6055) and a C40-8 (No. 9312). This photo was taken from atop Mitchell Point. (Photo by D.C. Jesse Burkhardt.)

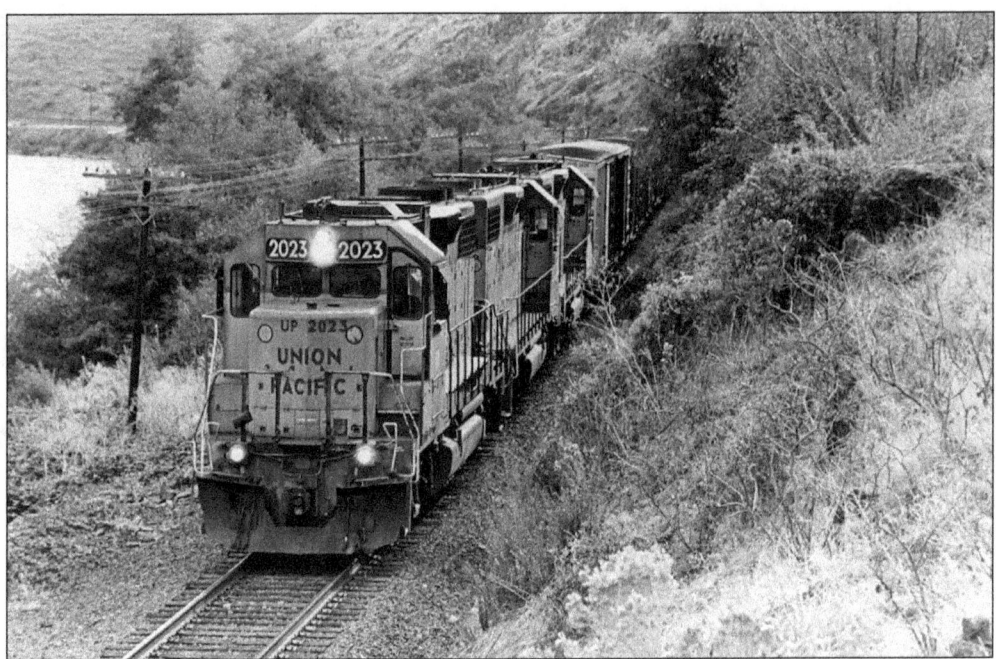

HEADED HOME TO THE DALLES. Union Pacific's *Bend Local* cuts north through the Deschutes River Canyon at Milepost 53 north of Maupin, Oregon, on its return trip to the UP yard in The Dalles in October 1997. GP38-2 No. 2023 leads an unusual three-locomotive consist; two units is the norm on this run. (Photo by D.C. Jesse Burkhardt.)

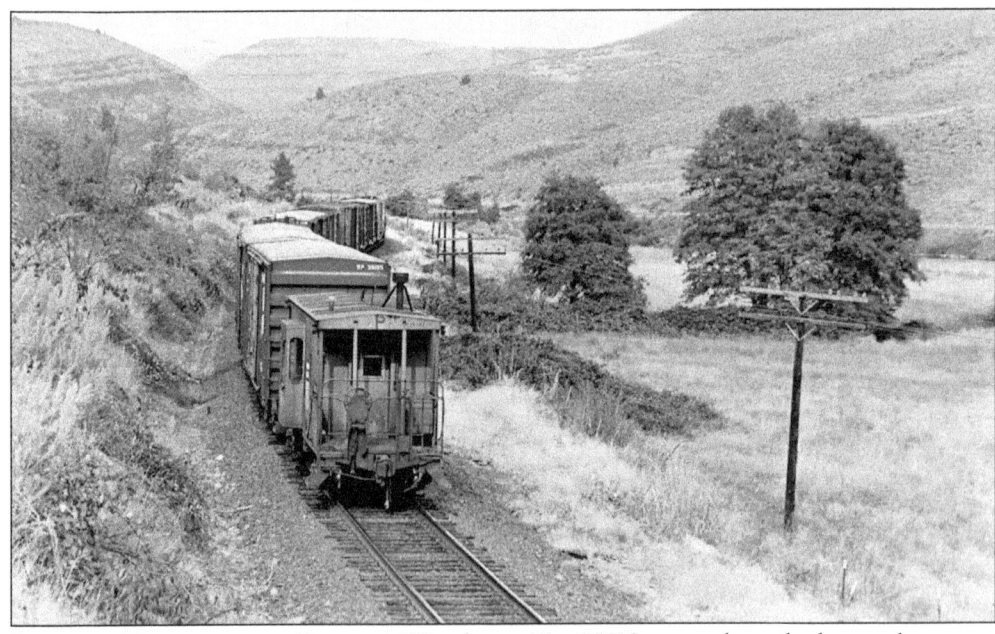

DRIFTING THROUGH THE CURVES. UP caboose No. 25823 sways through the gentle curves, headed north as it brings up the rear of this day's 12-car *Bend Local*. Three times a week, the UP operates between The Dalles and Bend via O.T. Junction, with the trip south of O.T. Junction taking advantage of trackage rights on Burlington Northern Santa Fe's Oregon Trunk Subdivision. (Photo by D.C. Jesse Burkhardt.)

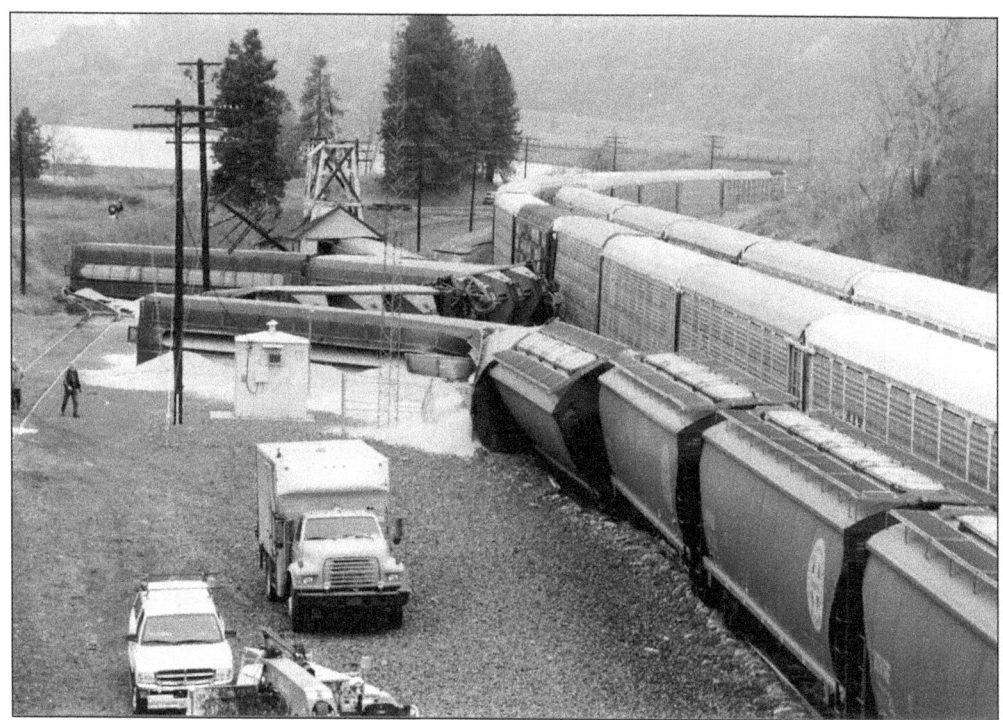

SPILLED GRAIN. Damaged grain hoppers rest on their sides in Lyle as Burlington Northern Santa Fe crews work to clear wreckage and replace damaged track from a derailment on the morning of January 20, 2003. Thirteen hoppers on a train bound for Kalama, Washington, derailed at a switch, spilling tons of grain. The BNSF mainline through the Columbia River Gorge was out of service for just one day. Note how one hopper plowed directly through the doorway of one of the old depot buildings, which was razed soon after this mishap. (Photo by D.C. Jesse Burkhardt.)

LAYING IT DOWN. Union Pacific maintenance-of-way crews put down fresh ballast along the Portland Sub mainline in The Dalles, Oregon, in February 1998. The gravel train is passing the Continental Grain silos, which were torn down in 1999. (Photo by D.C. Jesse Burkhardt.)

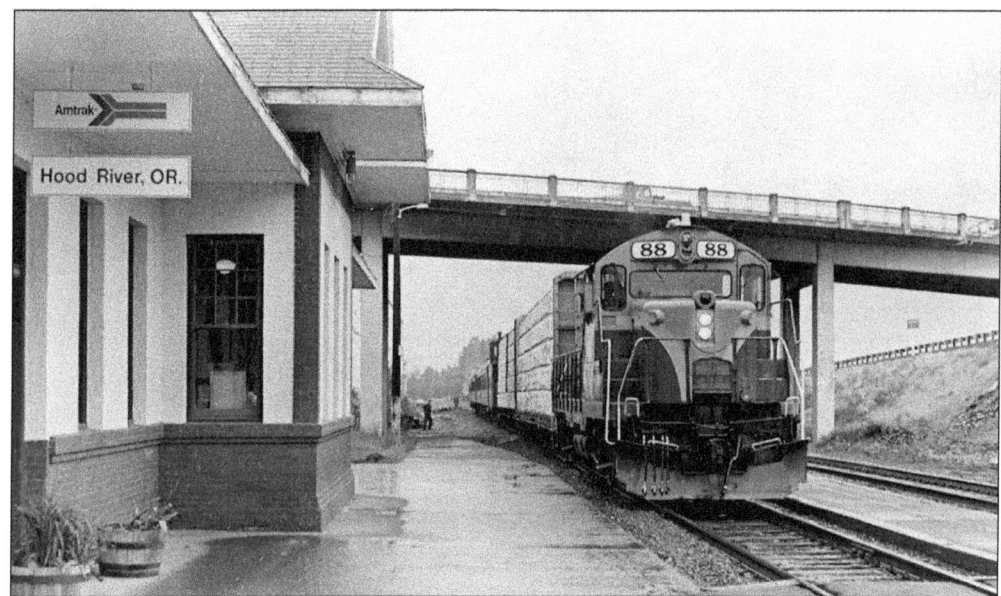

RAIN AT THE STATION. During a hard rain in August 1995, Mount Hood GP9 No. 88, pulling two bulkhead flatcars of lumber, a caboose, and several of the shortline's excursion passenger cars, passes in front of the joint Mount Hood Railroad/Amtrak depot in Hood River, Oregon. The Mount Hood Railroad purchased the 21-mile Hood River-Parkdale line from Union Pacific on November 2, 1987, for $650,000. The historic depot was built in 1911. (Photo by D.C. Jesse Burkhardt.)

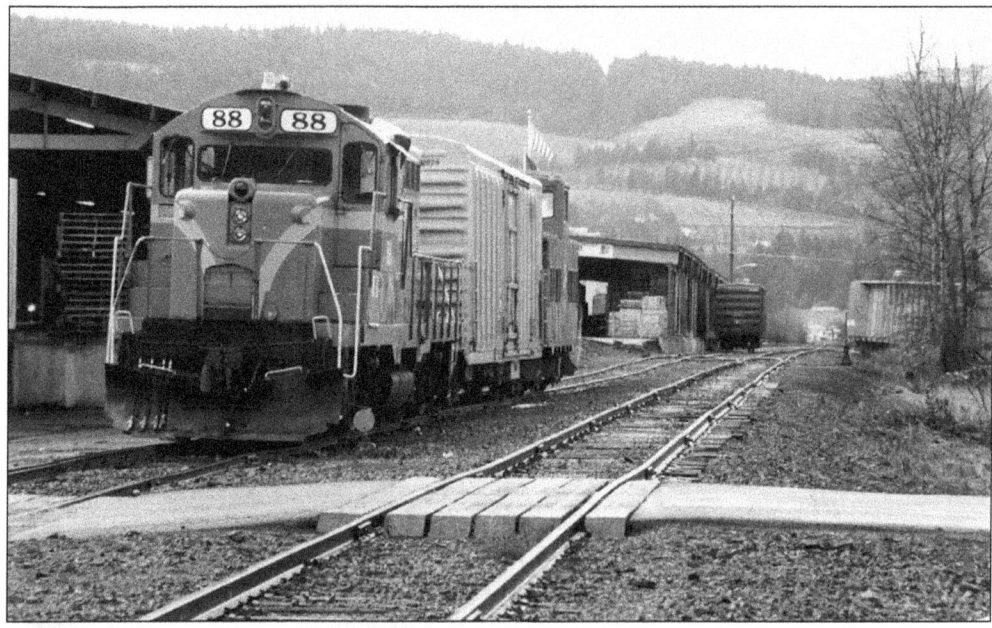

FREIGHT HAULER. Mount Hood Railroad GP9 No. 88 idles at the Duckwall-Pooley Fruit Company siding in Odell, Oregon, while Duckwall employees load boxes of apples aboard the reefer car. Despite the flowery look of the shortline's locomotive—and despite the focus on excursion trains—Mount Hood remains an active freight hauler. Several fruit, lumber, and liquefied petroleum gas shippers line this scenic rail route. (Photo by D.C. Jesse Burkhardt.)

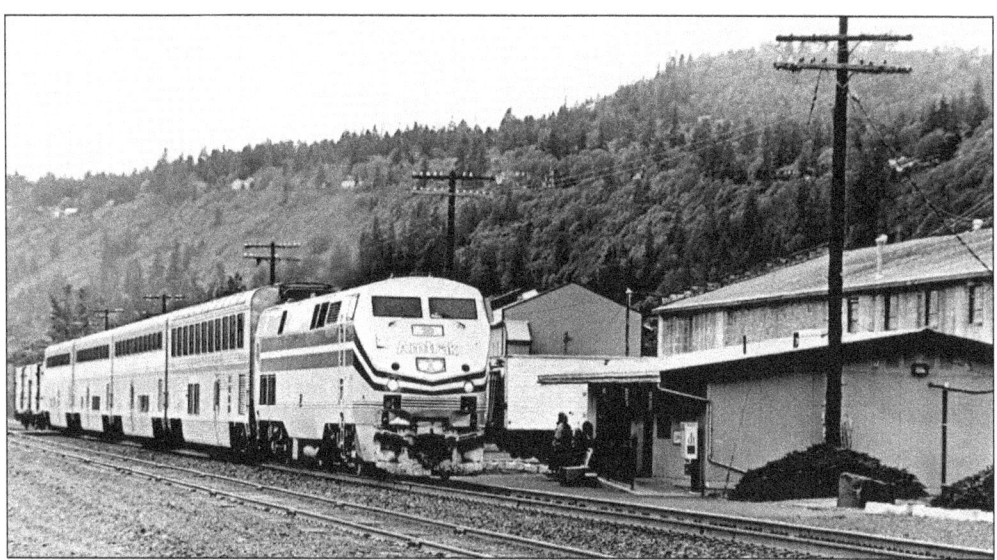

EMPIRE BUILDER IN BINGEN. At Bingen, Washington, an eastbound run of Amtrak's *Empire Builder*, powered by sleek new Amtrak No. 10, pulls to a stop at the small town's diminutive station on Depot Street to take on passengers. The station stop at Bingen has its origins in the rail line's construction. When SP&S requested a right of way through Bingen in the early 1900s, Theodore Suksdorf, founder of the town of Bingen and a key landowner, said yes—but with one condition: that all passenger trains thereafter would stop for the town's passengers. (Photo by D.C. Jesse Burkhardt.)

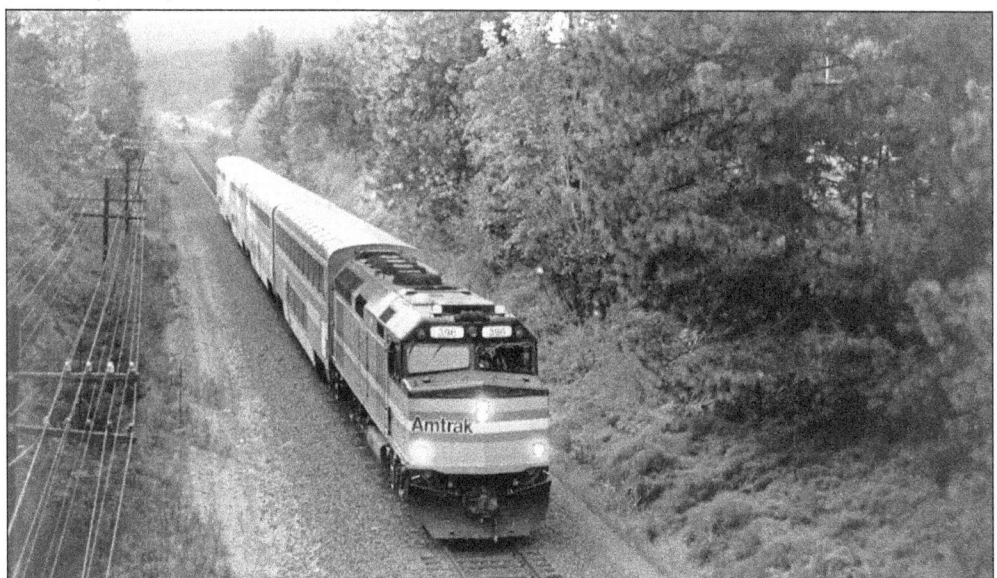

BOUND FOR SPOKANE. Amtrak's *Empire Builder*, pulled by a once-commonplace F40PH, roars eastbound through Home Valley, Washington, on October 2, 1994. The short train, which originated in Portland, runs on BN rails on its way to Spokane, where it will join with a second section of the *Empire Builder* that comes out of Seattle, via Wenatchee. After the trains link up in Spokane, the combined sections of the *Empire Builder* will continue on to Chicago. By 1996, the F40PH locomotives were being retired, and were rarely seen again. (Photo by D.C. Jesse Burkhardt.)

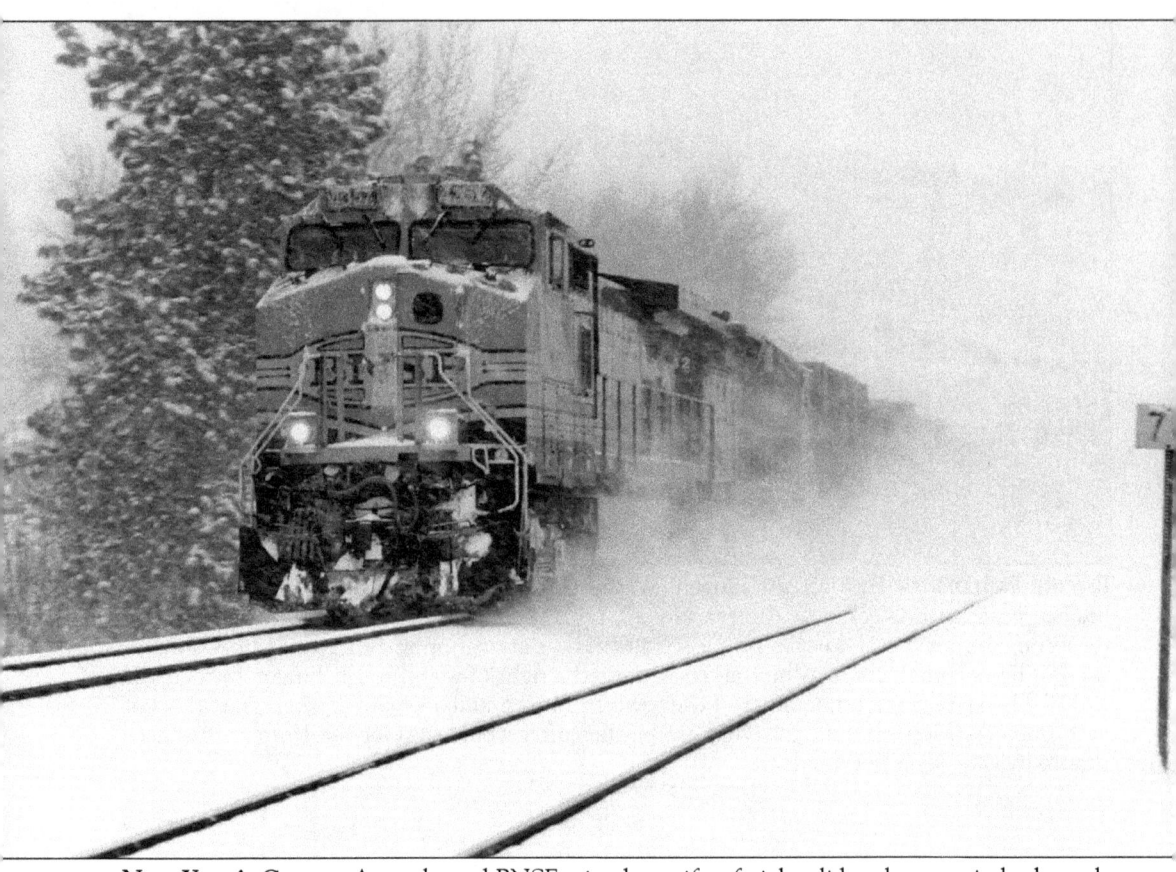

NEW YEAR'S CARGO. A westbound BNSF mixed manifest freight glides almost quietly through a blurring snowfall as it passes Milepost 76 on the railroad's Fallbridge Subdivision. Neither heavy snow nor national holidays—this photo was taken January 1, 2004—keep fast trains from moving goods through the Columbia River Gorge. This storm dumped about two feet of snow in the area, and with the snow blowing, visibility was limited to about 10 car lengths. (Photo by D.C. Jesse Burkhardt.)

www.ingramcontent.com/pod-product-compliance
Lightning Source LLC
Chambersburg PA
CBHW050543110426
42813CB00008B/2239